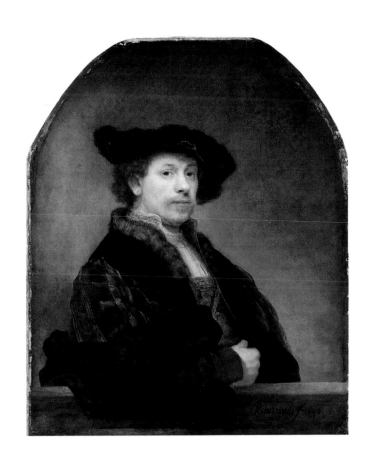

TRADITIONAL
OIL PAINTING

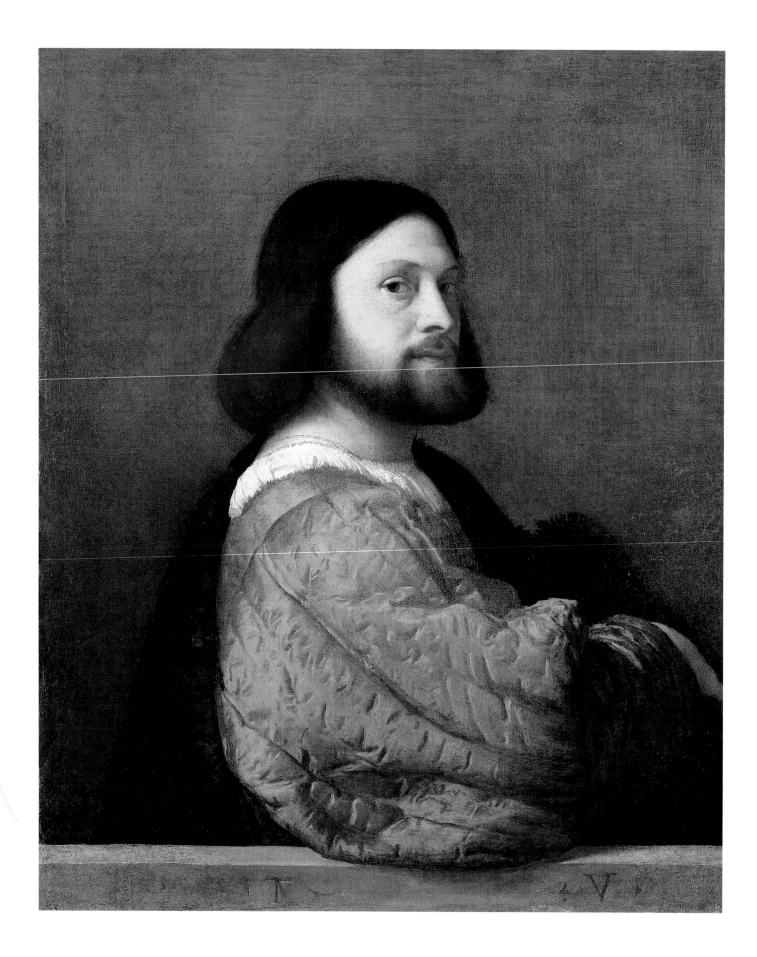

TRADITIONAL OIL PAINTING

ADVANCED TECHNIQUES *and* CONCEPTS *from the* RENAISSANCE *to the* PRESENT

VIRGIL ELLIOTT

WATSON-GUPTILL PUBLICATIONS | NEW YORK

Opening page:

REMBRANDT HARMENSZ. VAN RIJN (Dutch, 1606–1669), *Self-portrait at the Age of 34*, 1640, oil on canvas, 40⅛ x 31½ inches, National Gallery, London.

Rembrandt created this self-portrait at the height of his career. He seems to have deliberately referenced the composition of a few famous predecessors, including Titian's *Man with a Quilted Sleeve*, shown on the previous spread, thereby consciously placing himself in the tradition of the Old Masters with this striking image.

Photo Credit: National Gallery, London

Previous spread:

TITIAN (TIZIANO VECELLIO) (Venetian, circa 1488–1576), *Man with a Quilted Sleeve*, circa 1510, oil on canvas, 32 x 26 inches, National Gallery, London.

Photo Credit: National Gallery, London

Contents spread:

JOHANNES (JAN) VERMEER OF DELFT (Dutch, 1632–1675), *The Kitchen Maid*, circa 1658, oil on canvas, 18 x 16¼ inches, The Rijksmusem, Amsterdam.

Copyright © 2007 by Virgil Elliott
First published in 2007 by
WATSON-GUPTILL PUBLICATIONS,
an imprint of the Crown Publishing Group,
Random House, Inc., New York
www.crownpublishing.com
www.watsonguptill.com
WATSON-GUPTILL is a registered trademark
and the WG and House design are registered trademarks
of Random House, Inc.
Library of Congress Cataloging-in-Publication Data

Elliott, Virgil.
 Traditional oil painting: advanced techniques and concepts from the Renaissance to the present / Virgil Elliott.
 p. cm.
 ISBN-13: 978-0-8230-3066-8 (hardcover)
 ISBN-10: 0-8230-3066-0 (hardcover)
 1. Painting—Technique. I. Title.
 ND1500.E45 2007
 751.45—DC22

 2006035385

Designer: Christopher Cannon, Eric Baker Baker Design Associates

Every effort has been made to trace the ownership of and to obtain permission to reproduce the material in this book. The author, editors, and publisher sincerely apologize for any inadvertent errors and will be happy to correct them in future editions.

Printed in Malaysia
5 6 7 8 / 14 13 12

Acknowledgments

Each of the following people was instrumental, in one way or another, to the development of my understanding of drawing or painting, my attitude toward art and life, and/or deserve acknowledgment for having provided important information, help, or inspiration: Dollye McAlister Elliott, my mother and first drawing teacher; Geraldine Graham Bowman, who provided much-needed encouragement by buying artwork from a talented boy long ago; Annie Lore, my wife since 1988, and the model for several of my paintings; the noted illustrators Robert Fawcett, Albert Dorne, Austin Briggs, Stevan Dohanos, Al Parker, Fred Ludekens, Jon Whitcomb, and Harold Von Schmidt, whose instruction through the Famous Artists School correspondence course was very valuable; Ross Merrill, Mark David Gottsegen, Marion Mecklenburg, Joy Turner Luke, Rene De La Rie, Jaap Boon, Ernst Van de Wetering, the sculptor Korczac Ziolkowski, Paul DeLorenzo, Richard Ward, Melville Holmes, Damien Bartoli, my father, Virgil Elliott, senior; my editor at Watson-Guptill, Candace Raney; John Hagan, Iian Neill, Kate Fortin, Toshiko Beeman, Lee Parks Gooding III, Jon Gnagy, Russ Heath, et al., with sincere apologies to any whose names have escaped my memory. In particular, there is one teacher whose full name I have either forgotten or perhaps never knew, a man named Ken, who taught a painting class in the evenings at Turley Barracks, in Mannheim, Germany, in 1963, '64, and '65, where I was stationed as a young soldier. I failed to fully appreciate the value of what I learned in Ken's class until many years later, and one of my great regrets is that I am unable to give him the credit he deserves, due to my inability to recall his last name. Should Ken happen to read this, I would love to hear from him, and to be able to include his full name in the acknowledgments pages of any subsequent editions of this book or any other book I may write.

VIRGIL ELLIOTT, 2007

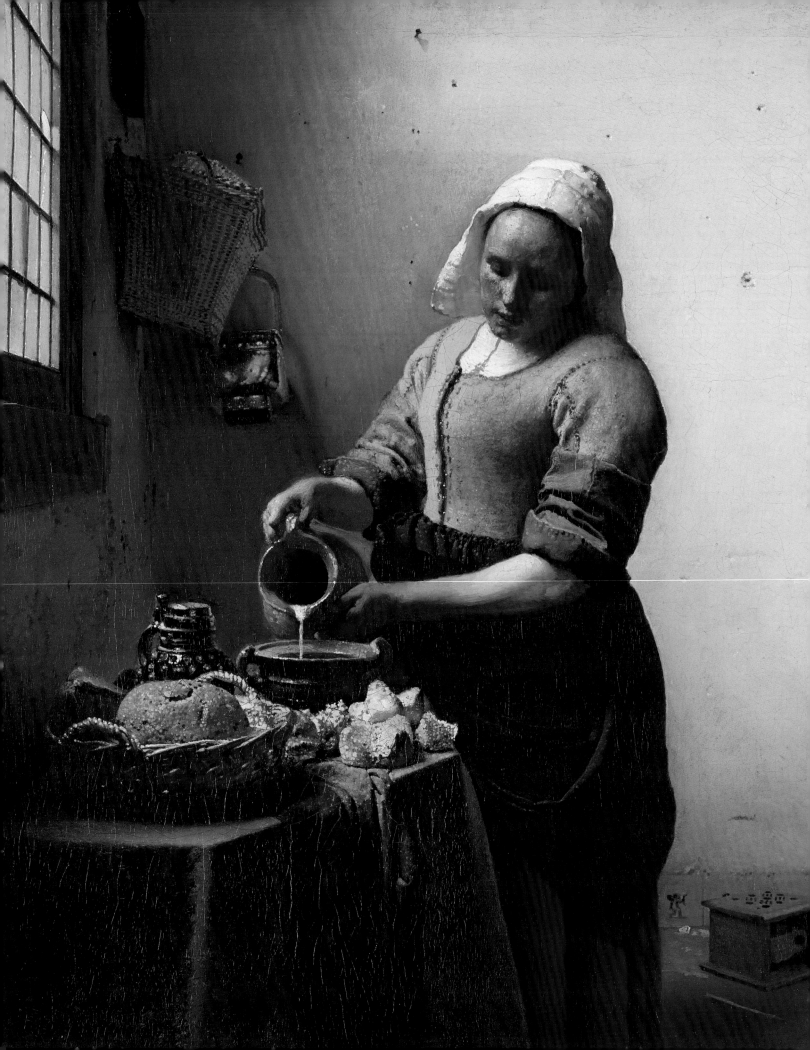

CONTENTS

AUTHOR'S NOTE

THERE ARE JUST A FEW POINTS that I feel should be made in the interest of clarification before the reader launches into the book proper, if I may be indulged the use of the first-person singular for just a bit. It was my initial intention to write the text of this book as clearly and descriptively as possible, so that there would be no need for a great many pictorial illustrations to put my points across, and to use examples from the greatest oil painters throughout art history, as many as my budget would allow, as illustrations for the points mentioned in the text. My own artistic contributions to the book, as I had originally envisioned it, were to be limited to demonstrations for which I could find no ideal examples in the works of the Masters, such as in step-by-step illustrations of some of the techniques mentioned. However, my editors have prevailed upon me to include not only more step-by-step illustrations than I had originally planned but also images of some of my own finished paintings. At their insistence I have done so, but reluctantly. I do not wish to appear so presumptuous or disrespectful of the great Masters as to put forth my own artworks as examples of excellence, I assure you, or to expect them to compare favorably to the greatest paintings of the greatest artists of all time. That situation could well serve to show me in a less than favorable light, to say the least, as it surely would with most living artists. The reader is thus provided some basis for evaluating the degree to which the author understands his subject, at least, and that is always an important consideration to be taken into account whenever one reads anything pertaining to art.

But to return to the paintings of the great Masters, in particular the ones shown in this book as illustrations: the reader is encouraged to consider all of the points raised in the text when looking at each of these paintings, and not just the point or points next to which the images appear. These paintings serve as excellent examples of many of the points covered or at least touched upon in the various

chapters of this book, yet it would present tremendous logistical and practical difficulties to reproduce each painting multiple times throughout the book wherever a principle or point raised in the text might bear on it, or vice versa. In fact, I will extend my recommendation to include not only the paintings reproduced in this book but all of the great paintings one can find in museums all over the world and in private collections and galleries, wherever the reader can gain access to them. However one can manage to do so, by all means go to those museums, *all of them*, make whatever sacrifices might be necessary to make it possible, and allow as much time as possible to study the great artworks wherever they can be seen. Reproductions are not a satisfactory substitute for standing before masterpieces and taking in the full impression of the originals with one's own eyes. Every serious artist should make these pilgrimages throughout his or her career, to charge and recharge the artistic batteries and keep the inspiration level high. There is much to be learned from the great Masters, and it is there to be read in their paintings. It is my hope that this book will help people understand a bit more about what they are seeing when they look at the paintings of the great artists throughout the history of oil painting, to provide some insight and some points to look for and consider. It would be unrealistic to expect any book to suffice to convey all of what can be learned from looking at and visually analyzing great art. The best we can hope for is that this one can serve as a guide to aid in the understanding of great masterpieces and what makes them great masterpieces, while one is looking at them and studying them firsthand.

I will stress the importance of placing greater credence on what we get from the artworks in direct viewing than on any words we might read about them, no matter who wrote them, and of paying particular heed to the impressions we get directly from the paintings themselves. For a work of art should stand on its own merits—or fail on its own shortcomings if it does not succeed in registering favorably upon the viewer's sensibilities, irrespective of what might have been written about it. The individual's quality receptors above all should be the determining authority in establishing an artwork's stature in each person's estimation. Quality is really the central issue, as it must be where art is concerned. Surely the greatest benefit art can provide to society is to uphold the banner of quality and never let it be lost sight of or forgotten.

Having expressed those important points as well as I am able with the unwieldy and imperfect medium of words, I will now abandon the use of the first-person singular for the rest of this book, since the book is not about me, and close this address with a quote of my own authorship from 1987, to wit:

"The human psyche includes many intrinsic qualities beyond the influence of fashion. Art that touches them will endure."

VIRGIL ELLIOTT
Penngrove, California, 2006

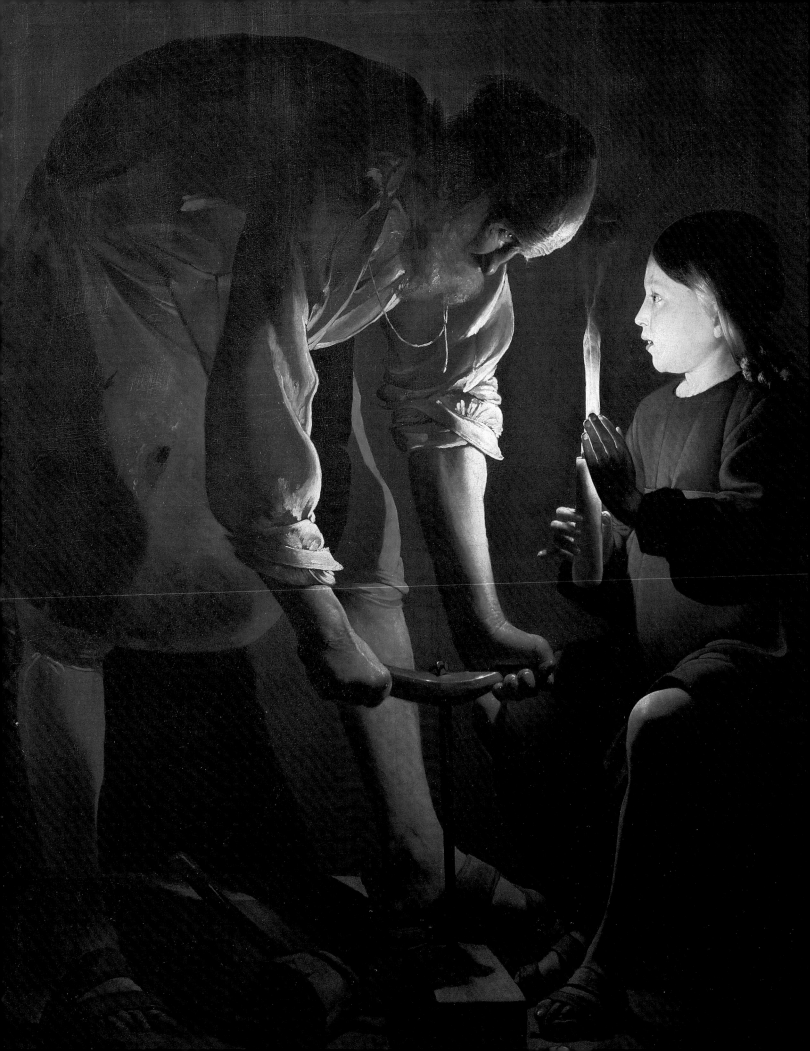

Introduction

ATTITUDES, HELPFUL *and* HARMFUL

IN MOST LARGE CITIES in the United States and Europe, there is at least one art museum in which can be seen, first-hand, oil paintings executed in centuries past by some of the greatest artists who ever lived. Upon viewing the best of these paintings, no one who has ever tried to paint can help but experience a profound sense of awe. The illusion of reality is so convincing in so many of these works that the subjects seem alive, about to move, about to speak. The textures depicted are so realistically rendered that it seems we could reach into the picture and feel the satin, velvet, brass, gold, or whatever is indicated, so skillful were these artists at creating their illusions.

The Old Masters, the Dutch "Little Masters," and the best of the French academic painters of the nineteenth century carried oil painting to its highest pinnacle of technical perfection.[1] Viewing their works is sure to instill a degree of humility in virtually any painter below Master level. "How did they do it?" is the inevitable question. How is it possible that mortal human beings, with a few simple paints and brushes, were able to create such lifelike illusions on flat canvases or panels so long ago?

For artists and aspiring artists, this experience is surely universal. One cannot help but be profoundly affected by it. But the ways in which people react to it, as regards their own personal motivations, tend to differ significantly from that point onward. One major school of thought concludes that the work of

the Old Masters, et al., is so sublime that to attempt to rival it is an exercise in futility, and possibly a form of artistic heresy. Often, those holding that view abandon any ambition they might have had of becoming painters in a realistic mode themselves and go on to pursue other artistic directions or other vocations. There are some, however, who become so inspired by what they have seen that a spark is ignited, an obsession kindled, which compels them to seek out the knowledge needed to create their own paintings, paintings that will, hopefully, instill a similar sense of awe in all who view them. This book is written for those who choose to pursue that goal.

In centuries past, the path for those obsessed individuals was fairly well laid out. Prior to the twentieth century, there was no shortage of well-trained artists, and most of them accepted students. Art was taught by artists, and many of the discoveries of each generation were passed along to the next. Anyone with an interest in and some aptitude for art could study with a Master, other circumstances permitting. The standards were not at all confusing as to who was, and who was not, a Master. It was apparent in the work. Artists' guilds, whose memberships were restricted to professional artists, called "Masters," conferred the status of Master on aspiring artists who had been well trained and could demonstrate mastery of the medium. Only a Master could go into the business of teaching art. No one believed for a moment that there was any point in studying with anyone other than a Master anyway. As Masters were available, the course was clear.

Things are not so cut-and-dried in modern times, as the reader has probably already discovered. There is still no shortage of teachers, but the requirement that one possess a high degree of technical ability to obtain a teaching position has somehow been lost. Furthermore, the distinction of Master has been conferred on so many graduate students (recipients of *Master* of Fine Arts degrees), and people who call themselves artists but whose skills are well below those of Masters of centuries past, that the word "master" has lost its meaning. One result of this is that the general level of art instruction suffered immeasurably during the twentieth century and has yet to recover to any appreciable degree into the twenty-first.[2] Too many aspiring or would-be artists have been either thwarted entirely or at least been severely hindered in the quest for the specific knowledge they sought—knowledge that would have enabled them to paint up to the standards once universally acknowledged as requisite for the designation "artist"—by the lack of art instruction comparable in quality to what was available prior to the twentieth century. As a consequence, there are precious few truly well-trained artists in existence today.

There is no reason to believe that proper instruction cannot still produce painters of ability equal to the great painters of the past. They were humans, not gods—extraordinarily talented humans, to be sure, but not beyond the range of possibilities of people today. Their works can surely be rivaled, and

perhaps surpassed, by artists of high intelligence and dedication, given sufficient study and diligent effort. Mental discipline is not an attribute unique to men and women of the past, although it is sometimes tempting to entertain such a premise.

The creative spirit must acknowledge no limitations in its drive to create great art. Destructive influences are everywhere. Many popular notions, attitudes, and fashions are detrimental to creative achievement, and the artist must recognize and conscientiously avoid them.

Most people are predisposed to failure by the wrong attitude. "I wish I could do that, but I can't," is a familiar saying, and a pathetic one. In many cases, the only reason someone cannot do a given thing is the *belief* that he or she cannot. Because the person believes it to be hopeless, no serious attempt is made. Erase that belief, and most people would be surprised at what they can actually accomplish. People tend to accept unrealistic assessments of their abilities without putting them to the test and seem to feel that if they cannot do something well the first time they try, they must simply have no aptitude for that particular thing and therefore cannot learn to do it well no matter how hard they might try. It is symptomatic of mental laziness.

Another harmful influence is the social convention that compels us to feign humility, to pretend that we are less than we are, in order to be well liked. The danger in such self-deprecation is that it becomes all too easy to fall into the trap of believing it. This may well be a contributing cause of the "I could never do that" attitude. It is destructive, from an artist's standpoint, because it denies reality. Arbitrary notions of one's personal limitations are rarely realistic. How desirable a quality is humility, or the appearance of it, faked in the interest of popularity, if it inhibits one from wholeheartedly pursuing worthy achievements, greatness, excellence? It must be recognized as potentially detrimental to an artist. Confidence is necessary to proceed in any worthwhile endeavor. Self-doubt can prevent one from making that first brushstroke.

Self-reliance is an essential attitude an artist must cultivate. One's own judgment must reign supreme over all other influences. Each work of art is, and should be, the individual expression of the unique artist who created it. Thousands of decisions must be made in the conception and execution of each painting. We cannot expect to create a masterpiece merely by following some step-by-step procedure prescribed by someone else. As students, these things are helpful, but as artists we must think our way through each painting, from beginning to end. The entire load is on us. The responsibility for the result, whether it be credit or blame, is ours to bear alone. It is common for people to look to authorities for guidance, and this is appropriate to some degree for students, but there is the danger of developing too heavy a reliance on the judgment of others, which can occur all too easily when one's instructor is highly accomplished and/or well respected and is overbearing in his or her teaching.

We must not relinquish our responsibility for what we are doing in deference to any authority, or our individuality and artistic integrity are in danger of becoming submerged or compromised, and we will then remain in the shadow of our mentor. The best artists have always surpassed their instructors. It is well to aspire to leave the nest and fly on our own, to soar to new heights, once we have mastered the basics with the help of our teachers (or without it, if that is the case).

An artist must possess the ability to be totally objective and should reject anything that interferes with the clear and objective perception of reality. Negative presumptions regarding one's abilities should not be entertained. As William Blake said so aptly: "If the sun and moon should doubt, They'd immediately go out." If evidence exists to support them, we should not presume that the limitations indicated are insurmountable. The fact that something is not easy does not justify the conclusion that it is impossible.

There is a common tendency to focus too narrowly on one particular kind of picture. Landscape, portrait, and still life are the most popular choices. All of these are given coverage in this book; however, the idea of neglecting any one of them in favor of whichever might happen to be our favorite should be emphatically discouraged, until we have learned to do them all well. Although the reader's interest in one particular genre may be keen, it must be recognized as a mistake to pursue a specialty niche before one has mastered all aspects of realistic drawing and painting. The result is always, and will always be, weak work that does no credit to its creator or to art as a whole. An artist should be well-rounded enough to paint any subject with authority. The same skills, powers of observation, and ability to design and execute a well-composed scene are required in all of these disciplines, if good results are the objective. And indeed excellent results ought to be the ultimate objective, if we really care about art. It is wise for portrait painters to master still life and landscape painting as well, because there will be other things in their pictures besides people, and those people may well want to be depicted out-of-doors. If those things and settings are not painted up to a high standard, the quality of the painting will suffer. In landscape painting, we face many of the same issues. There will sometimes be objects in the foreground plane that will require still-life skills to render convincingly. And the human figure in a landscape can provide reference for scale and, most important, can add visual interest. These possibilities are denied the landscape painter who has neglected to study the human form.

We cannot expect quality results from less than a wholehearted effort. An artist's life must be arranged around art, and anything that detracts or does not contribute must be sacrificed, if the highest degree of excellence is the goal. This includes attitudes and modes of thought as well as counterproductive personal and familial relationships, environments, and lifestyles. There are

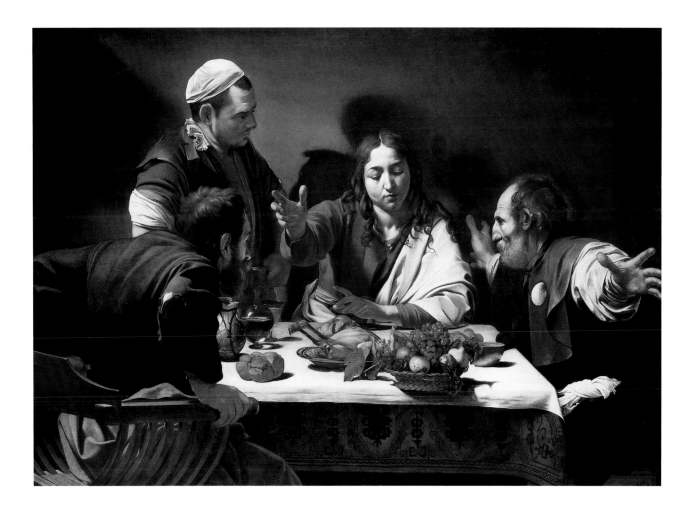

likely to be trials, tests of resolve, and temptations to abandon the pursuit of high achievement in art for a more comfortable situation. There is no guarantee that every artist who perseveres will reach his or her goal. What *is* certain is that those who do not will definitely fail.

Great art will not be created by the dilettante. Excellence in any endeavor will only be attained by those who simply will not accept anything less.

MICHELANGELO MERISI DA CARAVAGGIO (Italian, 1571–1610), *The Supper at Emmaus*, 1601, oil and egg tempera on canvas, 55 ½ x 77 ¼ inches, National Gallery, London.

Caravaggio is known to have worked from posed models lit with a single light source in order to achieve the striking naturalism that made him a controversial figure in his time.

Photo Credit: National Gallery, London

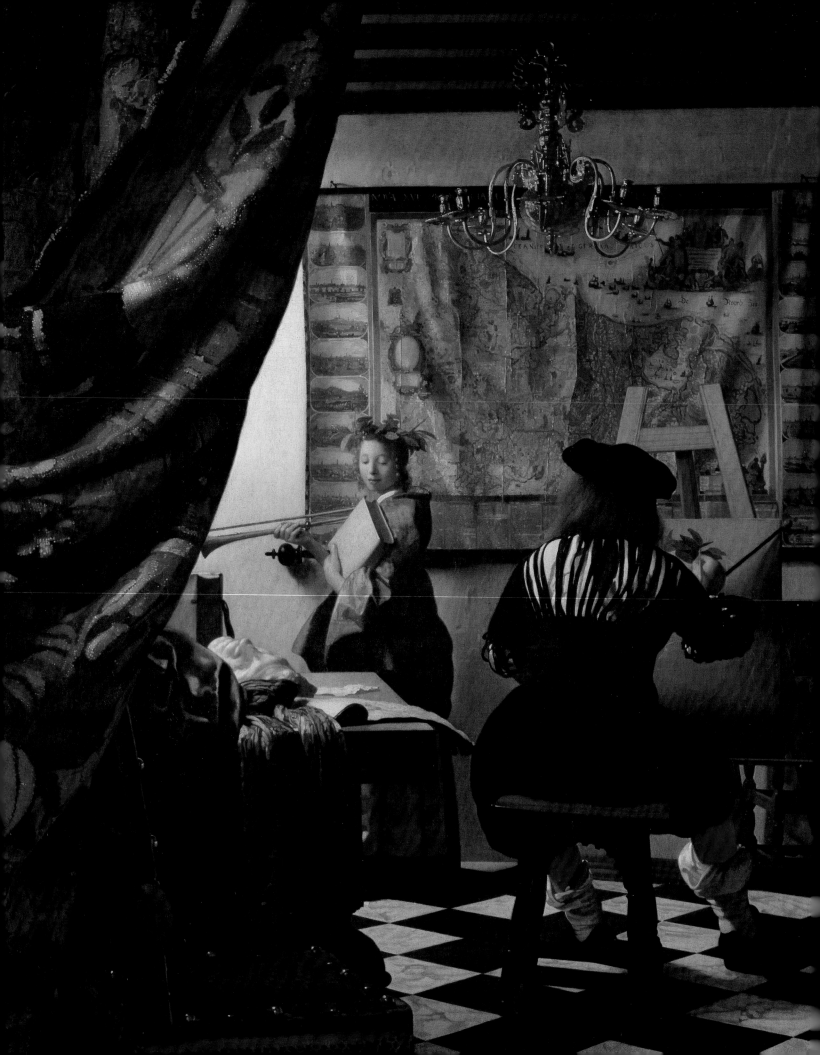

Chapter One

AESTHETIC CONSIDERATIONS

ALTHOUGH THIS BOOK DEVOTES a great deal of attention to techniques and materials, it would be a serious mistake to assume that that's all there is to great art. All the technique in the world cannot guarantee that an artist can be great if he or she has nothing to say. Great art depends heavily on content. It touches us emotionally, conveying a feeling directly from the artist to the viewer. No explanation from a third party is necessary. It tells its own story, or perhaps only suggests one, engaging the viewer's imagination and creating some degree of intrigue, showing us glimpses of fascinating worlds, which may exist only in the mind of the artist. It is magic.

But, as magicians know, magic is illusion, created by someone with a thorough working knowledge of the craft of illusion-making. Magicians begin with an idea, the illusion they would like to create; then, using very non-magical analytical thinking, they devise a way to make it happen. We are fascinated by the illusion partly because we are ignorant of the mechanics involved in creating it.

Painting is also a process of creating illusions. The artist creates the illusion of three-dimensional depth on a two-dimensional surface. A flat canvas or panel is transformed into space occupied by objects, or even people, with personalities, emotions, character—all done, not with mirrors but with paints and brushes, by one who has mastered the craft. Without mastery of technique, the most inspired individual cannot communicate creatively beyond a basic level. Technique is a tool. It is not the whole of art, but it is a very essential part.

Opposite:
JOHANNES (JAN) VERMEER OF DELFT (Dutch, 1632–1675), *The Art of Painting*, 1665–1666, oil on canvas, 47 ¼ x 39 ³/₈ inches, Kunsthistorisches Museum, Vienna.

In this painting, perhaps Vermeer's greatest work, we see mastery of three-dimensional composition, geometric perspective, selective focus, and a variety of textures rendered convincingly—all demonstrated compellingly in a remarkably lifelike scene that suggests a story. There is much to be learned from Vermeer. Mannequins were probably used for models in a live setup, to allow work from direct observation, until it was time to pose a live model for the girl's head and hands.

Photo Credit: Erich Lessing / Art Resource, NY

Art is valuable precisely because each artist is unique. Each has a story to tell, a point to make, a feeling to get across. This individuality is not taught in art schools, although instructors might encourage their students to find it. It cannot be gotten from books, seminars, sermons, or lectures. It is either already there, urging its host to find a way to express it, or it isn't, and it cannot be faked convincingly. A good instructor can influence students in such a way as to draw out the individual differences to some degree, but a teacher's main job should be to teach the vocabulary and let each student decide what to say with it.

The failing of so many art instructors in recent years is the overemphasis on expressiveness and underemphasis on any method by which the expression may be executed. Without technique, the inspiration is trapped inside. It can't get out. Its message cannot be shared. Posterity cannot record it. For all practical purposes, it does not exist. How frustrating it must be to have a Great Inspiration but lack the means to express it.

Style

Perhaps too much has been made of the need for originality and individual style in educational institutions offering art classes. In the early stages of an artist's development, it is more important to concentrate on mastering the skills that will be needed to facilitate self-expression. There is no real danger of an inspired individual with a strong personality losing any of his or her distinctiveness due to thorough training in the technical aspects of art-making. All too often, focusing too much on style and too little on skills results in a set of handicaps that place a low limit on what a person can effectively express through art. These handicaps are sometimes equated as if they were elements of a person's style, but that view is harmful and should not be encouraged.

It is indeed true that each artist's style is, and should be, unique; however, this idea is often used as an excuse for whatever is lacking in a given artist's technique. Style should be the result of choice, not of limitation. It should not be a concern at all for the student, whose primary goal must be to master every aspect of drawing and painting exactly what he or she sees, until it is all second nature. At that point, it might be appropriate to give consideration to what one's style is to be as a professional, but not until the lessons have been learned and learned well. With a full range of choices available, any choice one makes is valid.

Style will evolve naturally. As in Zen, the direct pursuit of this goal is pointless. It will happen when it is Time. Its Time will not be until all obstacles of perception and all limitations of technical ability have been removed. Then it will be there, as it is always there in each of us, awaiting the development of our ability to recognize and express it. Until we have mastered every aspect of our medium, there will be things inside us that cannot be expressed. These things are elements of each artist's individual style.

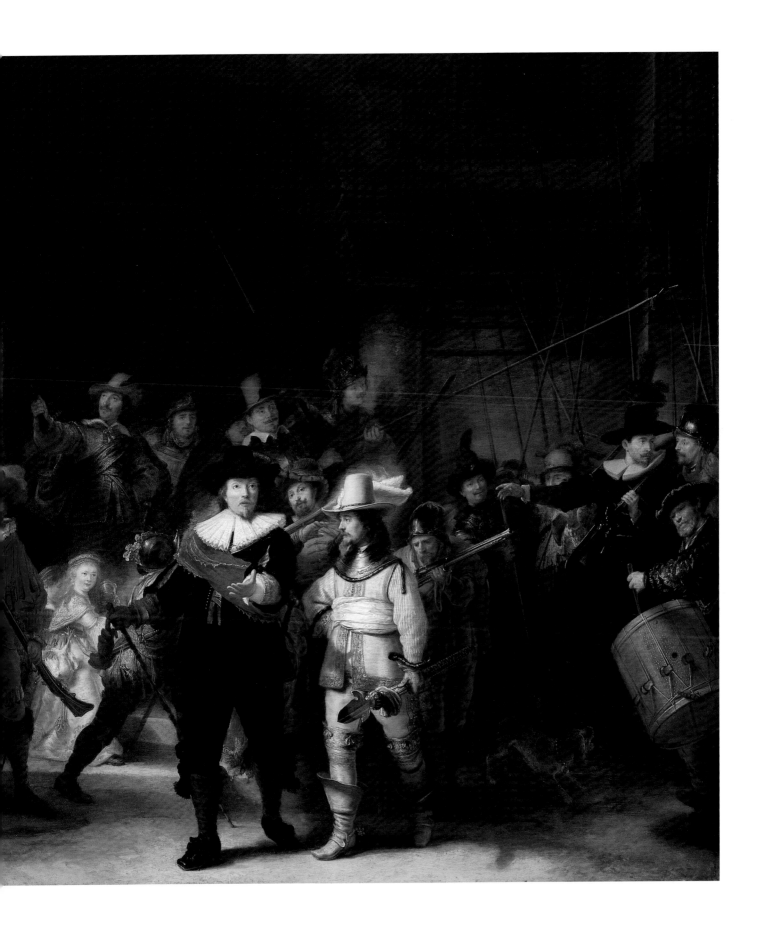

Composition

Composition in art is essentially the arrangement of intervals. The human brain reacts favorably to certain intervals, sequences, sounds, and shapes and unfavorably to others. Just as the composer of music must understand the influence of each musical possibility on the mood of the listener, so must the painter understand the psychological effect of the various possibilities of pictorial intervals in order to move the viewer in whatever way is desired. Intervals include distances between contours, increments of value contrast, and variations and interactions of colors—in fact, everything that goes into a work of visual art.

The most universally desired objective for a painter must surely be to arrest the viewer's attention and hold it as long as possible. The painting may well find itself on exhibit with many other paintings at one time or another—in a gallery, a competition, a private collection, or perhaps in a museum alongside the works of other great artists. In any case, we want *our* picture to dominate the wall. This may be accomplished in many ways. The most successful designs incorporate an area of primary interest, whose appeal must be effective at a fair distance in order to bring the viewer closer. Once the main focal point has been digested, a secondary point of interest, something of greater subtlety, should catch the eye and hold it a bit longer. Strategically arranged areas of secondary, and possibly even tertiary, interest should be orchestrated in such a way as to lead the eye from one point to the next and then back, eventually, to the area of primary interest.

Any compositional lines, intentional or otherwise, that lead the viewer's eye to the edge of the canvas are in effect leading it out of the picture and on to the next one, which is likely to be someone else's. The Great Masters always interrupt these lines with something to direct the viewer's eye back into the picture or diminish the focus and/or contrast so the line more or less dissolves before reaching the edge. As Western civilization teaches us to read from left to right, there is a tendency for the right border of a painting to exert a certain gravitational pull on the viewer's eye. It is therefore particularly important to avoid leading it to the right edge. Lines may lead into the picture from the bottom, if there are more than one, suggesting a sort of road guiding the eye to the area of primary interest, where the lines would converge if carried all the way in; but any line leading to the right edge will send the viewer out of the picture. The upper edge is likewise generally best avoided.

LINEAR ELEMENTS IN COMPOSITION

Lines and linear elements within a painting can add greatly to its appeal—or can ruin it, depending on the type of lines and how well they are employed. The most visually interesting lines are compound curves, or S shapes. Decreasing-radius curves are also pleasing. As a general rule, curves are more interesting than straight lines, diagonal lines are more appealing than verticals or horizontals, and straight lines that run horizontally are the least interesting linear element.

Previous spread:
Copy by GERRIT LUNDENS after REMBRANDT HARMENSZ. van RIJN's *The Militia Company of Captain Frans Banning Cocq and Lieutenant Willem van Ruytenburch* **(popularly known as** *The Night Watch***), seventeenth century, dimensions unknown, oil on panel, The Rijksmusem, Amsterdam.**

This copy shows Rembrandt's original composition before the painting was cut down in the eighteenth century when it was moved to the Amsterdam Town Hall, where the wall was too small for it in its original dimensions. (The Rembrandt original, as it appears today, is shown on page 97.) Notice how the extended arm of the figure toward the right edge of the canvas successfully brings the eye back to the center of the composition.

Opposite:
DIEGO RODRIGUEZ DE SILVA Y VELÁZQUEZ (Spanish, 1599–1660), *The Surrender of Breda,* **(also known as** *Las Lanzas***), circa 1625–1635, oil on canvas, 121⅛ x 144¾ inches, Prado, Madrid.**

Notice the way the lances are positioned relative to one another, and how the intervals between them vary. Imagine how much less interesting they would be if they were all absolutely parallel to one another and the same distance apart. The closer intervals between the four lances on the extreme right serve to deter the viewer's eye from exiting the picture. The turning of the horse's head to the left, and Velázquez's self-portrait looking away from the right edge, all help to direct the viewer's gaze back to the scene. The irregular intervals between the lances create a sort of rhythm, a sense of movement. Likewise with the positioning of the soldiers' heads. The diagonal banner points us to the main figures.

Photo Credit: Giraudon / The Bridgeman Art Library

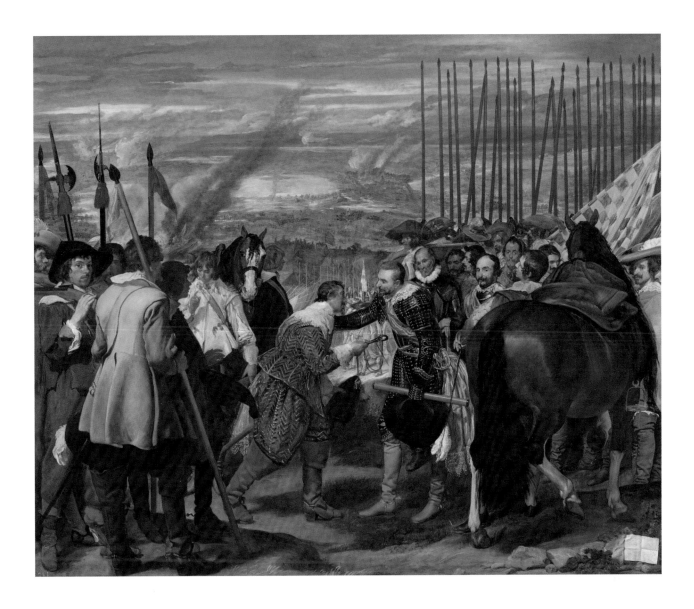

Parallel lines are usually not visually interesting, but when adjusted to introduce a certain degree of irregularity, they can set up an exciting sort of rhythm. Notable examples are the lances in Velázquez's *Surrender of Breda* and Rembrandt's *The Night Watch*.[1] These paintings illustrate that the intervals between elements are at least equal in importance to the elements themselves. Artful arrangement of intervals derives more from a sense of aesthetics than from any mathematical formula, although many attempts have been made to arrive at formulas to use as guidelines in their arrangement. This sense develops along with everything else an artist must learn in order to reach the higher levels. It is, simply put, a sense of what looks right and what does not.

There are, however, a few basic points that may bear noting here to help the student. First, right angles are less interesting than either acute or obtuse angles. Second, tapered shapes are more pleasing to the eye than shapes of unchanging

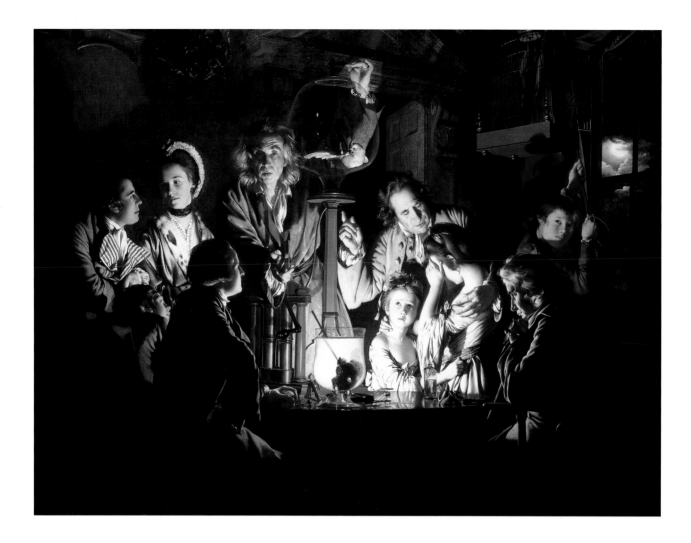

JOSEPH WRIGHT OF DERBY (English, 1734–1797), *An Experiment on a Bird in the Air Pump*, 1768, oil on canvas, 72 x 96 inches, National Gallery, London.

The scientist's face is positioned on the Golden Mean, as measured from the right edge of the picture. The face of the man to the right of center is on the Golden Mean, as measured from the left edge and from the bottom.

Photo Credit: National Gallery, London

thickness, just as parallel lines are less aesthetically pleasing than those separated by diminishing or variable intervals. And third, nature shows us very few truly straight lines. Given that fact, and the principles mentioned above, the artist would do well to carefully look for curvature in any line that appears to be straight and record or exaggerate that curvature. Straight lines are useful in "setting up" the curves, as they provide some variety to generate interest.

These principles are really just patterns that, for whatever reason, our brains react favorably to or unfavorably to, and the artist must be sensitive to which is which. Many attempts at analyzing them from scientific and mathematical standpoints have been made over the centuries, and some of those have proven more successful than others. One of the more important of these mathematical studies follows.

THE GOLDEN MEAN
Within a rectangular space, there are areas of greater strength and areas of relative weakness. Focal points, areas of primary importance within a painting,

gain added strength by being positioned at the strongest spots within the picture plane. These spots may be arrived at mathematically or intuitively. In one whose intuitive sense of composition is very good, the results of intuitive placement are likely to correspond to the mathematical device called the Golden Mean, or the Golden Section.

The Golden Mean is a proportion often found in nature and was probably first noticed by the ancient Greeks. It is based on the calculation by which a whole is divided into two parts of unequal size, the smaller of which is in the same proportion to the larger as the larger is to the whole. Finding the Golden Mean, or a close approximation of it, can be made somewhat simpler by using Fibonacci's Golden Number. Fibonacci's Golden Number, expressed as a decimal (rounded off to three places), is .618 of a given whole (or just under ⅝, which is .625). There are more complicated methods of arriving at the same point, which are explained in the adjacent sidebar, but for artists' purposes, the decimal will most often suffice. It may be rounded off to .618 when working down from the whole to the next smaller segment or from a larger segment to the next smaller segment or rounded off to 1.618 when working up from a smaller segment to the next larger one.

Most artists are not mathematicians and need not approach problem solving in the same way as mathematicians, so long as their senses are finely enough attuned to what constitutes visually pleasing proportions and intervals to bring them to solutions that work. Indeed, visual judgment should always reign supreme in matters of art. However, for the sake of more complete understanding, it is helpful to know the mathematics involved. The artist whose visual acuity is precise will be able to find the Golden Mean without resorting to any measuring instruments other than his or her eyes and brain.

We see examples of this proportion everywhere—in the spacing of tree limbs, in the lobes of leaves, even in our own bodies. For instance, in the bones of our hands, beginning with the last segment of each finger, each bone is approximately .618 of the next larger bone, until we reach the wrist. In situations such as this, where there are multiple segments, we may begin with the largest segment and then multiply its dimension by .618 to get the dimension of the next segment, then move sequentially down the line following the same calculations. The second segment is .618 of the first segment, the third segment is .618 of the second, and the fourth is .618 of the third. Note that .618 is a rounded-off number; it is not precise. The actual numbers vary slightly after the first three places beyond the decimal point, working with multiple segments, so .618 is essentially an average.

The Golden Mean is seen so often in nature that it becomes part of our intuitive sense of proportion, and pictures composed using this principle are in greater harmony with this sense and thus are more visually pleasing. The strongest

Fibonacci's Golden Number

The thirteenth-century Italian mathematician Leonardo Fibonacci (also known as Leonardo of Pisa) gave the Western world Arabic numerals. He is also known for the mathematical ratio referred to as "Fibonacci's Golden Number," or the Golden Ratio. This ratio is arrived at by beginning with sequential numbers and then adding two contiguous numbers in the sequence to get the next number. For example: 1, 1, 2, 3, 5, 8, 13, 21, 34, 55, 89, 144, 233, 377, 610, 987.

The ratio between each number and its preceding number varies slightly, but rounded off to three places beyond the decimal point it resolves to average 1.618. The exceptions are limited to the first few sequences: $1 \div 1 = 1$; $3 \div 2 = 1.5$; $5 \div 3 = 1.66666$; $8 \div 5 = 1.6$; $13 \div 8 = 1.625$; $21 \div 13 = 1.6153846$; $34 \div 21 = 1.6190476$; $55 \div 34 = 1.617647$; $89 \div 55 = 1.6180555$. From there on, it is 1.618, with less and less variation between the digits beyond 1.618. This ratio is a key proportion found in nature.

points within a rectangle are the points at which the Golden Mean from the vertical intersects with the Golden Mean from the horizontal. For example, if the dimensions of our canvas are 40 inches high by 30 inches wide, the Golden Mean of the vertical side will be 24.72 inches, arrived at by multiplying 40 by .618.[2] The Golden Mean from the horizontal, or 30-inch, side would be 30 times .618, which is 18.54 inches. By marking the vertical side 24.72 inches from either the top or bottom, and then drawing a line from that point across our rectangle at ninety degrees (parallel to the horizontal edge), we establish the Golden Mean of the vertical dimension. Then, by measuring 18.54 inches across the top or bottom of the rectangle (the 30-inch side) and drawing a vertical line across the picture plane from that point, we establish the Golden Mean of the horizontal dimension.

The points at which the lines thus established intersect are the strongest points within this rectangle. Pictorial elements positioned on these points gain added force by such strategic placement. There are four such points within a rectangle. The upper left of these is generally the strongest, although the elements of a picture can be orchestrated in such a way as to add strength to any of the others as well. As previously noted, the Western mind is taught to read from left to right, and this accounts for the greater strength lying on the left. (This may not be true for someone brought up in a culture whose written language reads from right to left.) It is also possible to establish subdivisions within the overall picture plane, based on the Golden Mean, and then to divide each into smaller and smaller proportions, according to our intentions, and create a much more complex composition, ad infinitum.

As regards strong spots versus weak spots within a rectangle, the weakest of all is the absolute center, meaning the point at which an X composed of diagonals connecting the corners cross one another. A subject centered side-to-side can be made to work by placing the main focal point *above* the center. This is done in more formal compositions, in which stability or tranquility is emphasized by such symmetry, most often with a triangular arrangement, but greater dynamic possibilities begin by placing the main subject at least slightly off to one side.

THREE-DIMENSIONAL COMPOSITION

Although most discussions of pictorial composition deal with the canvas rectangle as a two-dimensional entity, it is possible and desirable to take into account the three-dimensional illusion created by the use of perspective and design our composition based on the space indicated, not just on the actual flat surface of the picture. Johannes Vermeer provides an excellent example of this in *The Art of Painting*. The viewer's eye is led into the picture along an S-shaped course beginning outside the painting, sweeping past the foreground curtain on the left, to the artist seated at his easel, then back to the left, across the table with the white papers and the cast on it, to the brightly lit section of the wall and then rightward to the posed model. From there, the eye continues to the right

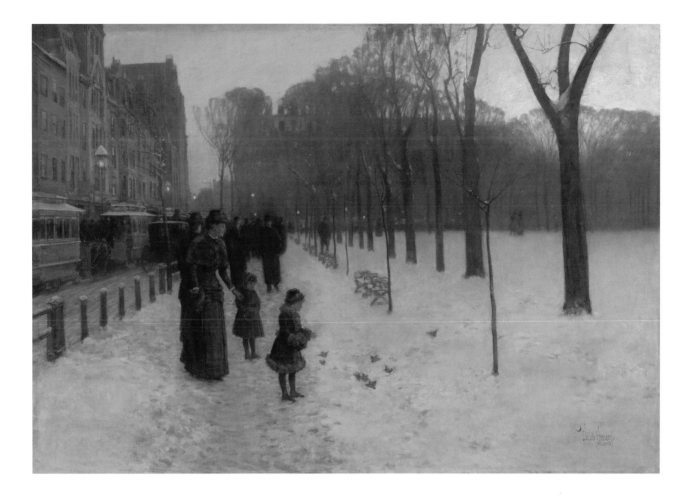

to take in the map on the wall and the chandelier. The easel in front of the map then returns our attention to the artist. The compound curve, or S, in this instance is not parallel to the canvas but flows into the space indicated by the geometric perspective and then carries us back out again as far as the main subject. The scene contains enough visually interesting material that we are compelled to take a second trip through, more slowly this time, to marvel at the individual elements of secondary and tertiary interest, to appreciate them more fully. This is perhaps the most sophisticated compositional concept yet devised, employed here with consummate mastery by Vermeer. Once we realize that we can design into the spatial illusion we create through the use of perspective, we transcend the flat surface of the canvas completely and open up a whole new world of possibilities.

THE PRINCIPLE OF THE STEELYARD

The "principle of the steelyard" is another compositional device favored by some painters. When this device is employed, an expanse of relatively uncluttered, open space is balanced against a denser concentration of objects, elements, or activity or an element of greater visual attraction, which occupies a smaller space. The weight of the larger area derives from the overall space it occupies,

CHILDE HASSAM (American, 1859–1935), *Boston Common at Twilight*, 1885–1886, oil on canvas, 42 x 60 inches, Museum of Fine Arts, Boston. Gift of Miss Maud E. Appleton, 31.952.

Notice the way the perspective and the compositional layout both direct the eye to a small area on the left side where more is happening. This is balanced against a larger area to the right, in which there is more open space. This is a good example of the steelyard principle of composition.

Photograph © 2007 Museum of Fine Arts, Boston

whereas the smaller area reads as having equal weight because of its greater density. The result is a sense of balance, yet one with more dynamic effect than if both areas were of equal weight by virtue of their occupying the same amount of space.

This device, employed with mastery, as in Childe Hassam's *Boston Common at Twilight*, provides considerable visual appeal to a pictorial design. The viewer's eye naturally travels across the open space toward the area of greater concentration of elements or activity. The center of interest is positioned in that region of the composition. Areas of secondary interest may be placed on the far side of the open space (as one possibility), opposite the center of interest, rendered subordinate to the center of interest in one way or another, inviting the viewer's attention to return to it after he or she has taken in and fully appreciated the main focal point. This extends the period of time that the painting will hold the viewer's interest and, ideally, will result in a second trip through the scene, and perhaps more—all of which will serve to make a more profound impression that will not be easily forgotten.

Variety

One of the key concepts in pictorial design is *variety*. Expressed quite simply, variety in all things is more interesting than having everything the same. There is a line to be walked between having too much sameness and too much difference. Sameness is psychologically reassuring, which is desirable up to a point but boring if carried too far. Its opposite extreme is where there is too much variety, too many different things all going on at once, with no organization to it. It is essentially chaos, or visual cacophony. An effective composition incorporates enough sameness to read as a harmonious, unified whole but also includes enough differences to keep things interesting.

Good design introduces key elements and shapes and then repeats them with variations. The similarity of these elements is pleasing by virtue of their familiarity, and at the same time the differences between them create a certain excitement, when done well. This principle has its parallel in music, and indeed in all artistic endeavors.

VARIETY IN SURFACE TEXTURE

In engineering compelling pictures, one of the devices good painters employ to gain and hold the viewer's attention is to create a range of differing textures of the paint itself. A variety of paint textures in a picture is more visually interesting than border-to-border sameness. Following the general practice of the Old Masters, areas of lesser importance are best painted more smoothly and simply, while the lights in the more important areas are painted more thickly. Impasto attracts the viewer's attention and can be a very useful device for the painter if it is employed selectively. The juxtaposition of the smoothly painted areas and the impasto highlights of the focal points adds visual interest to a

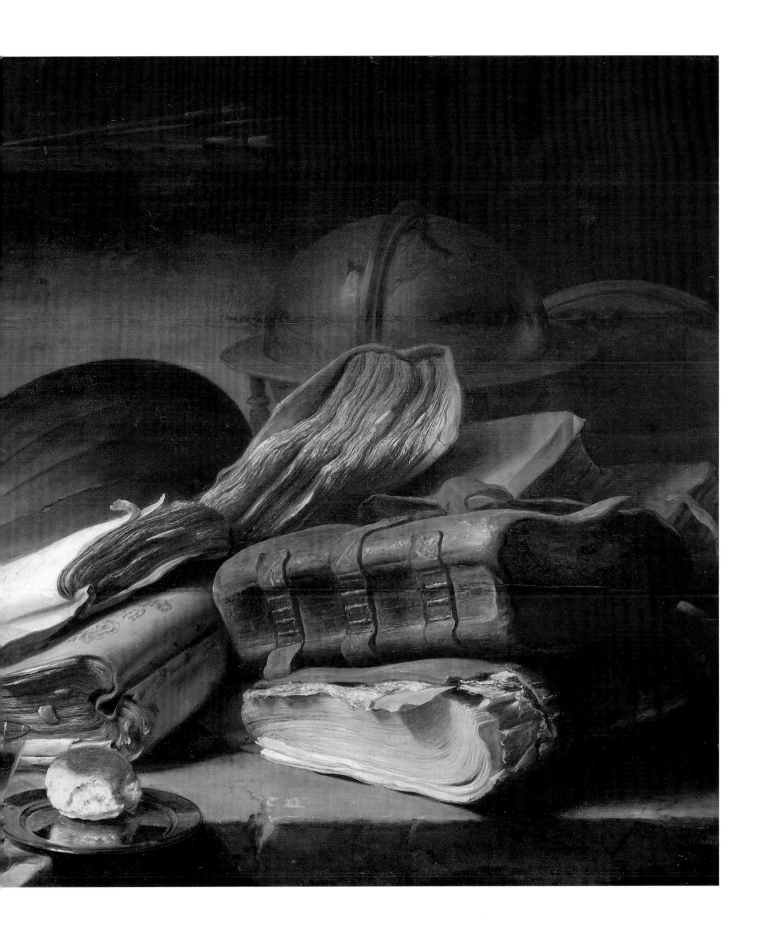

painting, creating more impact than is possible with either overall smoothness or overall impasto, as we see in the still life by Rembrandt's close associate Jan Lievens. The paint is quite thickly applied in the highlights on the metal pitcher, on the edges of the pages of the book, and on the white surface of the broken bread in the foreground, while all the dark and middletone passages are painted more thinly and smoothly, for a heightened effect of three-dimensional realism.

VARIETY IN APPARENT TEXTURE

Prior to the twentieth century, artists strove to introduce a variety of textures into their pictures, to the delight of virtually everyone who has, or has had, the pleasure of seeing these masterpieces. The soft skin of a young woman, the weathered skin of an old man, or the textures of satin, velvet, hair, fur, leather, wool, stone, wood, water, metal, etc.—all add a great deal of enjoyment to the viewing of a painting and function as elements of secondary or tertiary (or beyond) interest. Surely no one who has seen Gerard Ter Borch's rendering of satin cloth can fail to appreciate its realism and beauty. Similarly, Rembrandt and Jan Lievens very effectively incorporated gold or brass into many of their pictures, adding tremendously to their magic.

The visual appeal of a painting in which a variety of textures is indicated effectively is undeniable. These responses emanate from a deeper level of our aesthetic sense and are therefore beyond the influence of the fashion of the day. Viewers relate more profoundly to realistic-appearing imagery than to any other kind, and the more convincingly realistic it is, the more they are likely to be moved by it, especially if the content itself is meaningful and orchestrated in a masterly way. The keys to painting the various textures are addressed in chapters 4 and 6.

Mood

Perhaps the most important aesthetic consideration in a painting is the emotional content, or mood. This is what moves the viewer more deeply than anything else and is one facet of painting that is so personal and individual that it cannot be taught. Virtually all of the great works of art create a mood that the viewer cannot help but feel. This, more than anything else, is the mark of a masterpiece. More than technique, more than color, more than arcane theories or flashy brushwork, the emotional content is what separates great art from good art.

The most useful vehicle for creating mood is the human face. This is followed closely by the human form, including the hands, which can be positioned in such a way as to reinforce the mood projected by the face, or faces, or can create the mood independently, if the face is hidden from view. The mood expressed by a face in a painting has a profound effect on the mood of the viewer. It can arouse passions and can elicit feelings of sympathy, empathy, sadness, or joy. It is the single most powerful pictorial element at the artist's disposal.

Previous spread:
JAN LIEVENS (Dutch, 1607–1674), *Still Life*, circa 1620–1630, oil on panel, 35 7/8 x 47 1/4 inches, The Rijksmusem, Amsterdam.

Note the variety of textures realistically depicted in this still life—the leather of the book, the brass of the vessel, the wood of the lute, etc.

Opposite:
GERARD TER BORCH (Dutch, 1617–1681), *The Music Lesson*, 1668, oil on canvas, 26 5/8 x 21 5/8 inches, The J. Paul Getty Museum, Los Angeles.

Notice the variety of textures depicted in this fine painting. Gerard Ter Borch was one of the Dutch "Little Masters." In this instance, "little" refers to the relatively small size of the painting, which was the specialty of these masters.

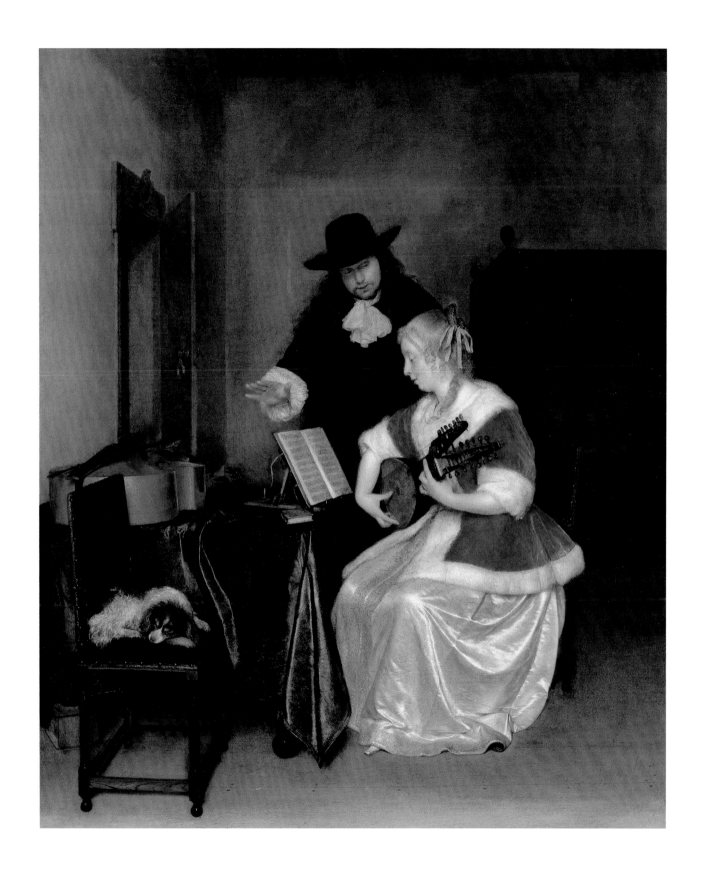

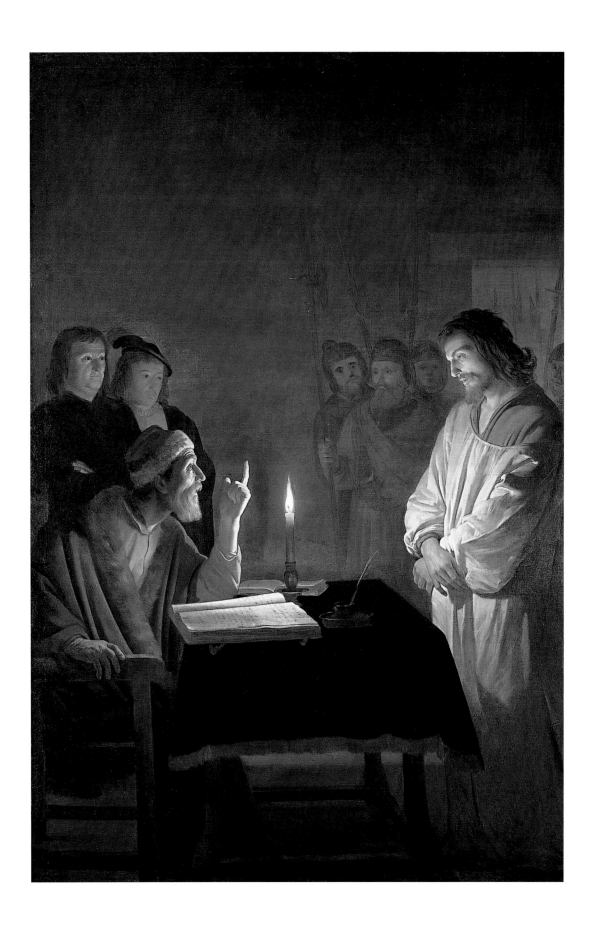

The position of the head, or heads, relative to the borders of the picture affects the way in which the viewer relates to the subject. In portraiture, the head of an adult is positioned in the upper half of the picture, to command respect. If the chin is below the midpoint, the dignity of the subject is diminished. A portrait of a child would warrant a lower position of the head on the canvas than would that of an adult. Leonardo preferred to point the face in a different direction than the torso, for dynamic effect. Much care should be taken in choosing the best possible pose for the desired purpose.

In landscape painting, the mood can be created through atmospheric effects, time of day, and other such conditions—mist rising from a tranquil lagoon at dawn, as the sun's early rays glow through the trees, for example, or a desolate desert scene at moonlight. Mood can also be created by the manner in which things are painted. Differing degrees of clarity or diffusion evoke different feelings, for one example, among many possibilities. These concepts apply to still-life painting as well. The objects depicted may be chosen for their symbolism and for the mood or feeling that they evoke. The spacing of the objects will also affect the mood of the picture. This principle is especially prominent in Asian art, wherein space is treated as an element of at least equal importance to the other subject matter—a concept that is no less valid in Western art.

Considerations of color are especially important. The color key (i.e., the color dominance, as discussed in chapter 5) has a great deal of influence on the mood of the picture, as does the value range, the composition, and even the size and relative dimensions of the picture. The subject of psychological ramifications of the various factors involved in painting, and especially composition, is quite complex, and much of it is intuitive. The best thing any book or teacher can do is to stress its importance and let the reader or student take it from there.

Before this chapter draws to a close, the matter of taste, elusive a concept as it is, should be touched upon. It is not the intent of this book to preach one particular kind of taste; however, taste is surely a relevant concern that ranks high among aesthetic considerations, and the reader must realize its importance to all artistic endeavors. Taste is best developed by much direct exposure to great art, which works its magic on those most receptive to it through a process that defies verbal definition or description. Thus it would be unrealistic, and perhaps futile, to go further in that direction than to simply emphasize the importance of taste, of quality, of the pursuit of excellence, as essential elements in art and to encourage the cultivation of good taste in all things. The hope is that the reader will recognize that the world already has too many bad and mediocre paintings and too few masterpieces and will then take great pains[3] to paint meaningful pictures and not add to the supply of dull ones.

GERRIT VAN HONTHORST (Dutch, 1592–1656), *Christ Before the High Priest,* circa 1617, oil on canvas, 107 x 72 inches, National Gallery, London.

Christ's facial expression and body language, and the effect of palpable atmosphere illuminated by candlelight, all contribute to the mood of this masterpiece by Honthorst. Candlelight is a special kind of light for creating a mood in a painting. The scale also plays a part, when the painting is viewed in person. The figures are life-size. The air of majesty suffers to some extent when the image is seen in reduced size in reproduction. Honthorst did many night scenes, and was known in Italy as Gherardo delle Notti.

Photo Credit: National Gallery, London

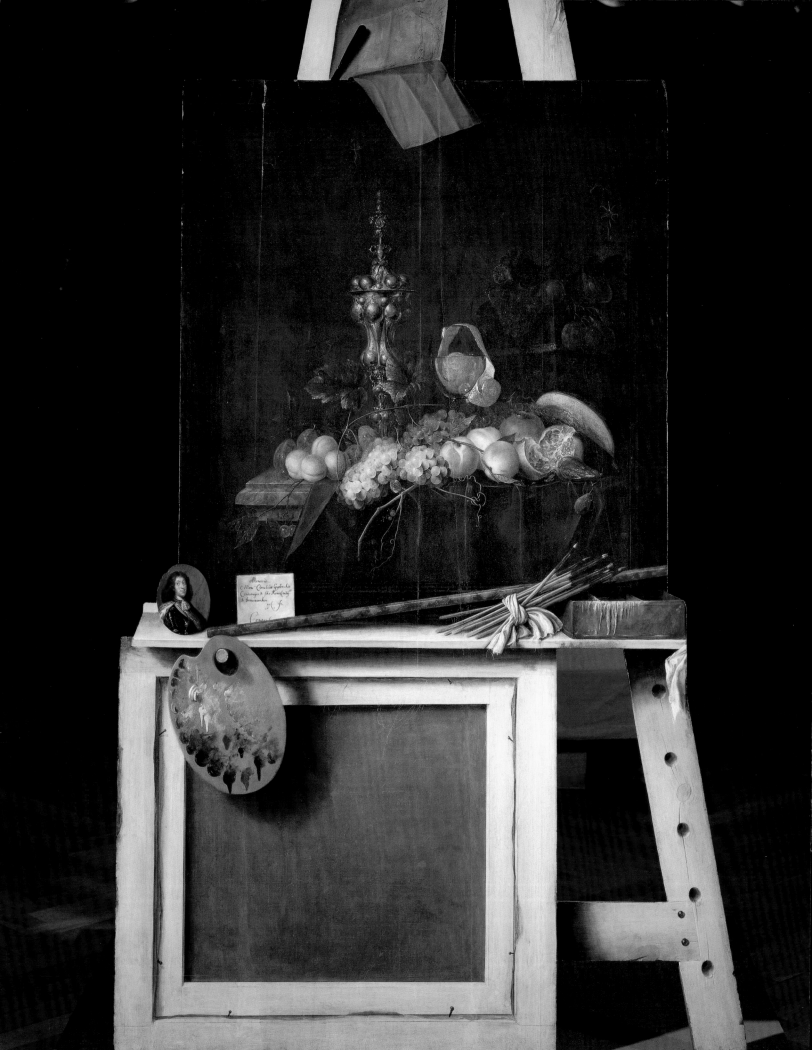

Chapter Two

The EYE *of the* ARTIST

AN UNFORTUNATE FACT OF MODERN LIFE is that the field of art is plagued by a great deal of misinformation, misconceptions, misunderstandings, and bad advice. The bewildering profusion of helpful hints, axioms, and Canons of Correctness offered by teachers and other artists, many of whom contradict one another, serves to foster widespread perplexity over nearly everything having any bearing on art. Thus the student/aspiring artist needs some criteria for evaluating advice from others. Art students must ultimately learn to trust their own eyes, their own perceptions, above all else, to avoid being misled.

In some cases, it may actually prove beneficial in the long run to experience confusion initially as the result of contradictory information from many reputedly authoritative sources. Since these sources cannot possibly all be correct, aspiring artists in search of knowledge must ferret out the truth for themselves. Out of confusion comes clarity. But where to begin? How do we decide which, if any, of our sources of conflicting information may be considered reliable? If we fall into the trap of being influenced by reputation, we are still in trouble. Suppose two or more equally respected individuals disagree on a given point, as is so often the case. There is no easy way out. We will have to think.

The degree to which a given artist has mastered the medium in question should be apparent in his or her paintings, and this might be seen as a reasonable means of assessing the advice of conflicting sources of information, as far as

Opposite:
CORNELIUS N. GYSBRECHTS (Dutch, circa 1610–1675), *Painter's Easel with a Fruit Piece*, 1668–1672, dimensions unknown, oil on canvas, Statens Museum for Kunst, Copenhagen.

This cleverly composed, unusual painting by Gysbrechts shows us a view of a seventeenth-century painter's equipment, including a painting on the easel. The depth of field is quite shallow, as is necessary for an effective trompe l'oeil illusion. The composition is pyramidal for great stability. It would be incorrect to refer to this as photographic or photorealistic, as it is actually more convincingly realistic than a photograph could be, when viewed in the original. This demonstrates what is possible with oil paints.

Photo Credit: Erich Lessing/Art Resource, NY

painting techniques are concerned. On matters of materials, permanence, and chemistry, however, it must be emphasized that this method may not be considered conclusive, and the conscientious reader is encouraged to put forth the effort necessary to obtain the most recent information from conservation scientists, paint chemists, and others in a position to know. New discoveries are made with such frequency in this field, thanks to the ongoing efforts of the conservation departments at the world's great museums and research foundations, that any book published on the subject, including this one, cannot be presumed to represent state-of-the-art knowledge beyond a few months of its date of publication. Thus the reader is urged to delve beyond this book to stay abreast of the latest developments and discoveries of modern science.

There is always the tendency to look for a way to make things easier, to obviate the need for intense mental activity—find a set of rules, a formula, a guru or mentor, a teacher or guidebook to show us a way to succeed without our having to tax our brains too much. This kind of thinking amounts to mental laziness, and is best dispensed with as early as possible. The process of creating high-quality artwork requires intense mental concentration at every stage. Every brushstroke deserves careful consideration; each shape, each color requires our continued scrutiny, until such point as we determine, at last, that we cannot improve upon any of them in any way, and our picture is finished. There is no place for mental laziness in this process. We cannot expect to end up with a masterpiece by relying on someone else's rules, formulas, or step-by-step procedures. Nor can we ever acquire the ability to create masterpieces without learning everything the Masters knew, and becoming Masters ourselves. This cannot be accomplished easily, and not at all if we expect someone else to do most of our thinking for us.

While rules, formulas, and dogma have their usefulness in the early stages of our artistic development, they must be seen in their proper context, as simpli-fications of much more complex truths, necessary to get us to the point at which we no longer need them. Beyond that point, they become useless baggage and must be jettisoned, just as the space shuttle jettisons its booster rockets to reach heights beyond those that the boosters had helped it to attain. It should be obvious that continued reliance on student-level rules will prevent us from ever progressing beyond student-level work. Any attempt to shortcut the process shortchanges the development of the eye. When we say "the eye" what is meant is actually the critical faculty of the *brain*. We must depend on this critical faculty—that is, the eye—to make every one of the thousands of decisions we must make in the course of creating a single painting.

Once an artist has reached Master level, any formulaic approach to working is not only unnecessary but harmful. It is diametrically opposed to creative, artistic thinking. The artist's eye, judgment, and aesthetic sense, and nothing else, should determine how that particular artist paints.

The artist must develop the ability to read all things with total objectivity in order to see the truth. This ability is what distinguishes the true artist from everyone else. The perceptions of others are influenced by irrelevancies. Those of the true artist are not. As artists, we must see things as they really are. Our sensibilities may direct us to alter what we see to fit what we would like to see in our art, as a conscious decision, but we must first possess the ability to see it in its true light, independent of all preconceived notions.

Once our powers of observation are developed to a high degree, the eye will tell us everything we need to know. The rules may still apply, in most cases, but it will be obvious why, and obvious when they do not (for there are always exceptions). Total accuracy and objectivity of perception are achieved only after considerable study and practice. The ability to observe is developed, increment by tiny increment, by the practices of drawing and painting from direct observation, with the greater gains resulting from drawing. Beyond this lies the development of the visual memory, enabled by practicing drawing what has been seen previously, looking only at one's drawing. Only when the brain cells are assigned the task of reading what the eyes take in, in greater detail than is called for in any other endeavor, do the powers of observation begin to develop beyond those of non-artists. The resulting heightened perceptivity is not limited to the visual realm but affects all aspects of one's consciousness. This carries the potential for putting the artist at odds with nearly everyone else.[1] Those who have not been trained to see cannot be expected to see things in the same way as those who have. Certain popular untruths are tolerated more easily by those who lack the vision to spot falsehoods in sharp focus. Perhaps this is one of the difficulties Harold Speed had in mind when he suggested that every conceivable obstacle should be placed in the path of the aspiring artist in the interest of discouraging all but the most dedicated.[2]

The eye of the artist—that is, the ability to see things as they really are—once developed, cannot be turned on and off like a faucet. It is always on, always showing the artist views often contrary to commonly held notions and sacred cows. This does not always make for harmonious relations with others, and it calls for greater discretion than may be always possible to exercise. When one is ignorant of the truth, there is no moral dilemma in not speaking the truth. However, when we can see the truth, if we pretend it is as others believe it to be, rather than the way it really is, we are being dishonest to some degree. If we speak out, and contradict cherished beliefs, we become unpopular, or worse.

Consequences notwithstanding, the ability to see with total objectivity is essential if one aspires to create great art. As in all great endeavors, there are sacrifices that must be made and hardships to endure. There is a downside. Some will feel that it is not worth it, and for them it is not. For those whose eye is already developed, it may be too late; in which case, read on.

Anna Bollein Queen.

Chapter Three

The IMPORTANCE *of* DRAWING

ALTHOUGH THE TITLE OF THIS BOOK correctly indicates that it's about oil painting, it is necessary to discuss drawing at this point in order to communicate its importance to oil painters. The reason this must be addressed is that many people, in their zeal to get to the fun of painting, begin attempting to paint in oils before they've mastered drawing. What invariably results is an inability to paint well, as the painter reaches a plateau beyond which no further improvement can occur. This is when the limitations of one's drawing ability manifest themselves as limitations in one's painting ability as well.

The only way to progress beyond this point is to go back to drawing and work to improve our powers of observation by working in the simplest medium before we complicate the issue with color and all the technical concerns involved in oil painting. Drawing develops the eye.

It might be interesting to note that visual artists seem able to learn music more readily than non-artists, and musicians likewise seem to have less difficulty learning to draw than non-musicians.[1] The reason must surely be that, in both cases, the powers of observation are already developed but with a different sensory organ as the source of the input. The signals are subjected to analysis by the critical faculty of the brain. If this faculty is already highly developed from having undergone an extensive period of training in one discipline, it becomes less difficult to adapt to another, similar, discipline in which the same faculty is needed. There are many examples of artists who excel, or have excelled, in both fields.[2]

The practice of drawing hones the perceptivity of the artist to a high degree and primes the mind for the next level of learning. For sculptors, the next level is the understanding of form in the third dimension. For painters, it is color. A painter must develop the ability to discern the slightest variation in hue, value, and chroma if he or she is ever to paint well. There are two basic approaches to drawing: line drawing and mass drawing. Both should be learned; however, they are different disciplines and should be mastered independently and sequentially, with line drawing first and then mass drawing. Mass drawing requires one to think more like a painter, thus it prepares one for learning to paint. But first, it is essential that the student or aspiring artist work to acquire a high level of skill and sensitivity in line drawing.

Line Drawing

Line drawing lays the foundation for learning in the visual arts. With this approach, the edges of forms are indicated with drawn lines. When one is first learning to draw, the emphasis should be on accuracy. However, as one gains facility with this aspect of drawing, a sense of gracefulness and beauty of line also begins to develop. This is an important element of pictorial design in art. Of course, we do not actually see outlines in nature, but beautiful linear design nonetheless adds tremendously to the aesthetic appeal of paintings, wherein the edges of forms take the place of actual outlines and perform the same function.

CORNELIUS JANSSEN VAN CEULEN (Dutch, 1593–1661), aka CORNELIUS JONSON, *Study of a Woman's Hands*, 1646, black and white chalk on blue paper, 7½ x 11⅝ inches, The J. Paul Getty Museum, Los Angeles.

This is an example of mass drawing by a seventeenth-century artist, with the lights rendered with white chalk. It was probably a preparatory detail study for a portrait, to serve as reference material.

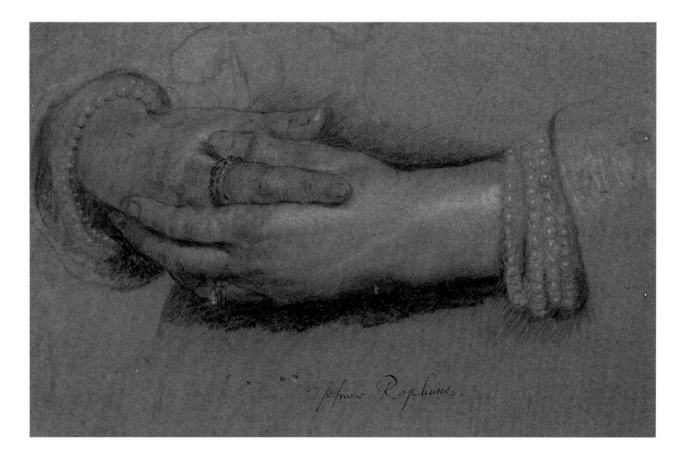

Within the outlines, the form is indicated through shading to indicate distribution of light, which is a secondary concern in line drawing, to be addressed only after the lines are attended to and adjusted as the artist sees fit.

The traditional tools for line drawing were principally sharpened sticks of charcoal and sometimes red, brown, or black chalk, often secured in a holder of some sort, with rolled-up bits of bread serving as erasers. Silverpoint and pen and ink also have a long history with line drawing. In modern times, graphite pencils with rubber erasers are more commonly employed. Carbon pencils are another tool well suited for line drawing, and charcoal remains a viable medium as well, as it erases easily and thus accommodates corrections.

Line drawing is the place to begin, because it develops one's basic ability to read contours. This is the first step on the road to becoming an artist, with many steps beyond that. All of the subsequent steps, however, depend on abilities and knowledge gained in the discipline of line drawing. A comparable analogy would be adding and subtracting as the first stage in learning mathematics. The importance of line drawing as a starting point in visual art cannot be overstated. As a form of art in itself, it carries the possibilities of great beauty and refinement on its own terms, as the best artists have demonstrated so well through the centuries.

Mass Drawing

The ability to read values—that is, lights and darks—is learned best in isolation, by a method of drawing called mass drawing. While line drawing is generally done on white paper with dark pencil or charcoal, mass drawing may be done on toned paper, with charcoal and white chalk. The drawing may begin as in line drawing, with charcoal, rendering the form in a linear fashion. The charcoal lines may then be gently wiped or blown off, leaving a faint image upon which to work. Shading is then applied, again with charcoal. The tone of the paper may be left to function as a middletone, and chalk used, at the very end, for the lighter lights. With this method, it is possible to produce beautiful works of art in much less time and with considerably less effort than when using pencil on white paper.

An alternate approach to mass drawing is to dispense with line altogether and instead begin by blocking in the larger dark shapes with a large stick of charcoal and adjusting as the image develops, adding or erasing wherever it might be necessary. Some instructors favor white paper over toned and then proceed to cover it with charcoal to supply the general tone before addressing the image. Lights are then indicated by erasing and/or wiping out, instead of rendering them with white chalk. Either way will work.

It is advisable to begin with simple forms that are strongly lit from one side, so there is a full range of light and shadow to observe and draw, and then increase the level of difficulty by small increments, progressing gradually to more and more complex shapes. The author has an antique set of wooden

drawing forms, consisting of cubes, spheres, cones, pyramids, eggs, and other geometric shapes. Comparable sets were widely used for teaching students to draw, back when the importance of an artist learning to draw was understood without any question.

After these simple forms have been mastered, the logical progression is to move to drawing plaster casts of human heads and other anatomical features. Casts made for these lessons are available from a number of firms. They are generally painted white and presented strongly lit to facilitate accurate reading and learning of values. After the student has learned to see the difference between shadow and light, it might be helpful to alter the lighting and repaint the cast a somewhat darker tone than white, to teach the student to read light and shadow within a narrower range of values (lights and darks) with greater subtlety. Cast drawing prepares the student for working from live models, which should be the next stage in one's training.

The main purpose of mass drawing is to develop one's perception of lights and darks (values), and to prepare the student for learning to paint in oils. As mentioned earlier, mass drawing bridges the gap between line drawing and painting in oils, which are two quite different disciplines. Oil paint, unless applied methodically, can result in a muddy mess. The best results are obtained when we proceed according to a system, working from dark to light. In mass drawing, we also work from dark to light, because charcoal erases more easily than chalk. The (white) chalk is not applied until all the necessary corrections have been made to the charcoal. In oil painting, also, corrections in the darks are less likely to turn "muddy" if no lighter paint is introduced into areas intended to be dark. As more correction is necessary in the early stages of creating a painting, it is best to delay adding the lights until the forms are reasonably well indicated by the darks. Mistakes in the early stages of the painting, with only the dark shapes applied, are best corrected by wiping out errors with dry cheesecloth, using it as an eraser. Thus, mass drawing teaches the correct sequence of applying oil paints and allows the student to learn to see values without the distraction of color.

To further ease the transition from drawing to painting, the student's first experience with oil paints should be as much like mass drawing as possible, with only black and white, and grays made from them, applied in the correct sequence to a surface primed a light gray. These gray oil studies are called *grisailles*. In this way, the student may become familiar with the working characteristics of the paint and brushes without becoming overwhelmed by the difficulties involved when painting in full color. Each stage should prepare the student for the next level of learning, following a logical, sequential progression, with each lesson representing a small increase in difficulty over the previous one. Color is most easily mastered after one has learned to read values well, and value is most easily mastered after one has become proficient at line drawing.

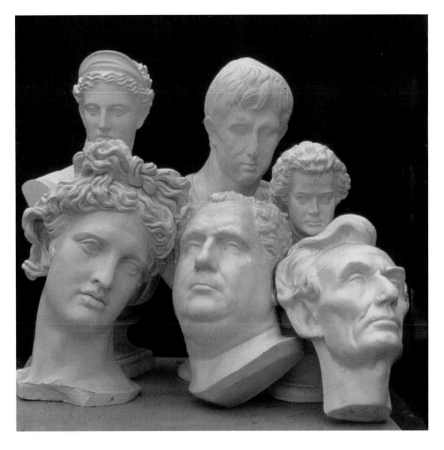

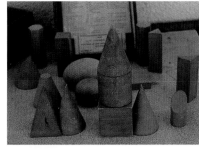

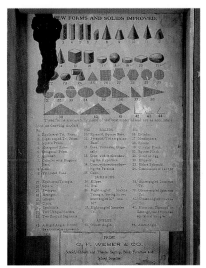

Mechanical Aids

Some artists and would-be artists use projection devices to circumvent the tedium of drawing. This is a mistake, at least for anyone not thoroughly trained in life drawing. While a certain amount of tedium is avoided by using mechanical aids, a great deal of the learning, which is the direct result of this tedium, is also missed. Anyone with a good eye can easily detect the sad results in works created with mechanical aids. When photos are projected and traced, the distortion of shapes, intervals, and spaces inherent in photography is transferred, intact, to the canvas. Usually the values are wrong as well, and quite often the color does not work, because the discipline necessary to master the finer points in painting have been avoided in the artist's desire for instant glory. For further discussion of the problems with photography, see The Photographic Image Versus Visual Reality, on pages 50–51.)

Some presumably well-trained artists claim to use projectors only to save time, perhaps to meet the demands of a pushy gallery director or agent. The results may well be less unsatisfactory with well-trained artists than with less-well-trained artists, because an artist with a good eye can correct for photographic distortion and may have a good working knowledge of value and color. The issue of whether the practice of tracing from projected photographs is legitimate is hotly debated among artists, but what cannot be disputed is that the artist

Above:
Antique drawing forms box label.

Top:
Antique drawing forms, intended for teaching students to draw, probably from the late nineteenth or early twentieth century.

Above left:
Drawing casts are inexpensive replicas of famous statues, or of parts of them, reproduced in plaster or lightweight automotive body putty, painted white. They have been in use for a very long time in the teaching of drawing.

who has trained by drawing from direct observation will be better equipped for artistic pursuits than one who has not.

Part of the uniqueness of art is that each artist sees the subject, and thus draws the subject, differently from any other artist. This is precisely why art is so highly prized. This uniqueness is compromised when one traces projected photographs. The individuality of the image thus drawn is diminished, as it is less easily distinguished from the work of others who also trace. It is also likely that the artist's ability to draw will atrophy somewhat from disuse, or, at best, will not improve.

A case has been made recently for the use of other optical devices, such as the camera obscura and the camera lucida, or "lucy." This dialogue has corresponded with much speculation that such devices might have been used by some of the Old Masters. These instruments utilize mirrors and/or prisms to cast images from their field of view onto a flat surface, allowing the contours of the projected images to be easily traced, and perhaps the shadow patterns too, if the light and the subject can remain stationary long enough to be recorded. The camera obscura consists of a dark chamber through which a small opening, with or without a lens, admits light from the outside. This light carries with it the image of the scene in view. The camera lucida is a smaller device utilizing a prism that allows its user to look at the drawing paper with one eye and the "lucy" with the other. The image then appears to be on the paper and can be easily traced.

In light of the fact that many excellent artists have mastered freehand drawing in our time, it would appear pointless to suggest that the Old Masters needed such devices in order to do as well as they did. For an artist who can draw, such things are unnecessary. For anyone who cannot draw well, the use of such crutches will interfere with the further development of drawing ability, which equates precisely with the ability to observe and understand what one is observing. Whereas a well-trained, experienced artist may be able to use these devices without necessarily incurring undesirable consequences, students and artists below Master level are best advised to avoid them entirely, in order to develop their perceptive powers to the fullest. All such crutches should be regarded in the same light. The bottom line is that a good artist does not need them.

Sight-size Drawing

There are a number of methods for teaching drawing. One popular approach in certain circles is the sight-size method. Sight-size drawing is the method wherein the easel is positioned in such as way as to facilitate the drawing of the subject exactly the same size as the subject itself appears from the artist's chosen vantage point. This vantage point, perhaps marked on the floor with chalk or a piece of tape, should be far enough away from the paper or canvas to allow the artist to see the entire drawing or painting at once and to also see the subject at the same time. The side-by-side comparison between the subject

and the drawing makes it very easy to spot any errors, which can then be corrected before they can throw off subsequent judgments. All angles and proportions are rendered exactly as they are read or measured from the observation (vantage) point. Measuring tools often employed in sight-size drawing and painting include a plumb bob suspended from a string held in the hand; a stick, pencil, or paintbrush held at arm's length; and sometimes even a clear plastic ruler. The drawn image can be compared to the actual subject from the artist's observing spot, as they appear next to one another from that spot, at exactly the same size and shown from the same angle of view.

When a student is able to spend a great deal of time on a drawing of a cast or other stationary subject in an unchanging light, the sight-size method works very well and the end result is likely to be a highly accurate drawing. This boosts the confidence and shows the student how well he or she can do under ideal circumstances. This level of accuracy then becomes the benchmark against which all subsequent studies will be compared, and the student is compelled to strive mightily. The sight-size method is particularly useful in teaching students whose study of drawing began in adulthood rather than in childhood, to help them make up for lost time and to give them confidence as well as to develop the eye.

For drawing the subject at life size, using the sight-size method, the easel must be placed next to the model or subject, and the drawing or painting surface must be large enough for the entire subject, life size, to be rendered on it with sufficient room around the subject for a pleasing composition. The artist marks a spot on the floor some feet away, equidistant from the easel and the subject, from which all critical judgments will be made. This vantage point must be far enough away from the easel and the subject, ideally, to allow the entire picture to be seen in one glance, along with the view of the subject, for simultaneous comparison. While standing at the easel, the artist looks only at the picture, not at the subject. The subject is only observed from the viewing spot, and each stroke of the drawing[3] is planned, one by one, from that spot, and then looked at critically from that spot to assess its accuracy after it has been applied. Using this method, the artist will get a fair amount of exercise.

The sight-size method may be used for drawing on a reduced scale as well, simply by placing the easel where the image of the subject is the right size for the paper or canvas we intend to use and drawing it the same size as it appears at that distance. This method is otherwise the same as has already been described. The difference is that the image is less than life size, with the degree to which its scale is reduced determined by the distance of the easel and the observation spot from the subject—the greater the distance, the smaller the image. Everything is still drawn exactly the size it appears to be, as seen from the observation/viewing spot. This is the variation most commonly used in classroom settings, in which many students share the same model and cannot place their easels next to the model stand, because of space constraints.

There are pros and cons with the sight-size method, and its limitations should be understood and acknowledged. It is best employed as an aid to students in the early and intermediate stages of learning to draw. If relied upon too heavily beyond that point, it can, and often does, become a crutch. It does not help a person learn to record the subject in an expeditious enough manner that it can be used in real-world situations, where neither the subject nor the light can be expected to hold still for very long. Other lessons, involving shorter poses and/or briefer sessions in situations where sight size is unworkable, help develop other faculties and abilities not addressed in sight-size drawing, and these exercises should be included in any art training curriculum, along with longer poses, cast drawing, lessons in perspective [4], anatomy, and drawing from memory.

The serious student should be encouraged to always carry a small sketching kit and to draw at every opportunity and under every conceivable set of circumstances. The resulting drawings are less important than the experience gained and the skills and perceptive powers thus developed. Even doodling is beneficial. The key to the advancement of the artistic faculties is to draw every day, no matter what. The method chosen is less important than the fact that one is drawing.

Anatomy

Human anatomy is one of the basic fundamentals that every fully trained artist should know and know well. It is learned by drawing the nude human figure, in as many different configurations as we can find models to represent, in as many positions as we can induce them to adopt, from direct observation, ideally under the supervision of a good instructor who knows the subject thoroughly. It is important to include models we might not consider particularly attractive in our studies, as the objective is to learn human anatomy in more than just one or two body types. An artist should be versatile. Anatomy is also learned from drawing the skeleton, the skull, and, if possible, cadavers being dissected. [5] These lessons should be repeated as often as it takes for the student to gain a complete understanding of the human form.

Anatomical texts, which show the bones, the muscles, the points at which one muscle is overlapped by another or inserts under another, the position and shape of each muscle when relaxed and when tensed, and so on, are also helpful. It is important to know and understand the structures and the working of the human body well, so we know what we are looking at, what we are looking for, and so we have a firm foundation of knowledge on which to base any deviation from what we see when we wish to improve upon it or to work from imagination to any degree.

Hands deserve special attention. Their anatomy is complex, they are able to assume many different shapes, and they are expressive features whose gestures add greatly to the aesthetic appeal and mood of a picture. We read the hands

as we do the face: to gain insight into a person's character and emotions. The student should study hands until he or she can draw them from memory and stored knowledge in any conceivable position hands are able to assume. Likewise the entire body. It is always a mistake for art students to give short shrift to the study of anatomy. The benefits gained from such study extend beyond the limits of the subject matter itself. If we are serious about art, we will learn all of the basics well. Anatomy is one of the basics.

Memory Training

Andrew Wyeth tells an interesting story of his student days, with his father, the illustrator N. C. Wyeth, as his instructor. Every day, the elder Wyeth would set up a human skeleton on a rack and tell his son to draw the skeleton. Andrew would draw the skeleton. This went on for what might have seemed like an unreasonably long time, day after day after day, until one day his father locked the skeleton in the closet and said to young Andrew, "Draw the skeleton." Andrew found that he could indeed draw that skeleton, without having to look at it. This is the kind of training that brings one to know anatomy well enough to render the human form with authority. It is essential to the mastery of drawing. And mastery of drawing is essential to the mastery of painting.

As in the Wyeth anecdote, drawing from direct observation should always precede drawing from memory. It helps to log information into the memory banks that can then be called upon at some point or points in the future and is an extremely valuable experience for an artist in so many ways, and for so many reasons. Once one is well schooled in drawing from life, further benefits can be derived from doing drawing exercises designed to train the faculties of the visual memory. The first exercises should be simple ones, using simple objects and short intervals of time between the observing and the drawing. As this becomes easier, more complicated shapes are selected as subjects, and then slightly longer intervals between the observing of the subject and the commencement of the drawing of it, extended bit by bit, as the student's ability advances.

The abilities artists gain from this kind of training are of immeasurable value. It frees us to a great extent from the limitations of the subject matter before our eyes and opens up possibilities bounded only by the limits of our imagination. This is the true key to artistic freedom: master drawing. Draw, draw, draw!

Chapter Four

PRINCIPLES *of* VISUAL REALITY

THE GREATEST ART moves the viewer in a positive way, touches perhaps dormant sensibilities inherent in human nature, and awakens and fortifies man's better qualities. Great performances in all the arts accomplish this goal. A well-written operatic aria, for example, sung brilliantly and with feeling by a virtuoso soprano or tenor, can move an audience profoundly, raising the hair on necks and bringing tears to the eyes, leaving people gasping and choking back sobs of deeply felt emotion as they try to maintain their composure. Experiencing such profound appreciation for a masterly performance leaves one forever changed for the better. It cannot do otherwise.

Great literature provides many comparable experiences. In painting, it is possible to achieve the same thing. Rembrandt's *Judas Returning the Thirty Pieces of Silver* is an excellent example, shown on page 65. The depth of Judas's remorseful anguish is compellingly conveyed by his body language as well as his facial expression, and the viewer cannot help but be deeply moved upon viewing it. Compassion and sympathy are called forth as the audience feels the anguish of the subject, so eloquently is it expressed in the painting. Compassion, empathy, sympathy—these are all aspects of man's better nature. To change people for the better—what more noble purpose could an artist be called upon to fulfill? To what higher calling could we aspire? [1]

Opposite:
PIETER DE HOOCH (Dutch, 1629–1684), *A Boy Bringing Bread*, circa 1650–1665, oil on canvas, 29⅛ x 22¼ inches. Reproduced by kind permission of the Trustees of the Wallace Collection, London.

This is a fine example of the effective use of geometric perspective typical of Dutch artists of the seventeenth century. De Hooch has given it his own twist, in that the principal vanishing point for the floor tiles and other features of the interior of the room is also the diagonal vanishing point for the red and white tiles in the courtyard.

In each of the examples presented above, the means by which the experience is made possible is a virtuoso performance in an artistic endeavor by a Master of the discipline employed. While the focus of the performance itself is to make the audience feel whatever the artist wants it to feel, it must be stressed that the objective can only be successfully attained through a thorough understanding of every aspect of the art form involved, including the psychological effects produced by each possibility. A language must be learned and mastered before any great performance is remotely possible. In music, the language is music theory; in literature, it is verbal; in visual art, it is a thorough understanding of the principles of visual reality, coupled with heightened aesthetic sensibility and mastery of drawing and painting techniques. Why are the principles of visual reality so important? Because we live in a world of realistic images. We relate to realistic imagery. We even dream in realistic imagery. Of all the visual possibilities available to a painter, the only way to move our viewers to the utmost is to employ realistic imagery in our work. We may depict things that are not real, but if we render them in accordance with the principles of visual reality, they will read as if they *were* real and thus will be able to exert maximum impact on the viewer. This is the language by which we express whatever it is we wish to express, and through which our viewers will be able to receive the message. Our ideas, our meanings, cannot communicate if we speak in a language comprehensible only to ourselves. Thus we must use a language common to everyone who can see. Realistic imagery is that language.

The principles of visual reality are established by the way in which our vision works. The further one deviates from these principles, the less the work in question will resemble visual reality. In creating the illusion of reality, the artist depends heavily on representing the third dimension—in other words, depth or spatial recession. Spatial recession is successfully created when the rules of geometric perspective, atmospheric perspective, and selective focus are observed. A thorough understanding of the operative principles behind the illusion of spatial recession is of immense value to artists. Geometric perspective, atmospheric perspective, and selective focus are the first three principles of visual reality— the ones that apply to the illusion of spatial recession. Later in the chapter, we will address the nature of light, the fourth principle of visual reality. But first, discussion of the principles governing spatial recession is in order.

Geometric Perspective

Geometric perspective, which is often referred to as linear perspective (because it involves the use of lines in its construction) or simply as perspective, may be defined as the natural law that says the farther something is from our eyes, the smaller its image will be. In short, it is the geometric breakdown of a natural optical phenomenon. As simple as this sounds, the problem of how to convincingly render this visual phenomenon had baffled artists for centuries, until a mathematical approach was discovered in the early Renaissance.

The painters Tommaso Masaccio and Paolo Uccello, as well as the architect Filippo Brunelleschi, have each been credited with the discovery of geometric perspective. The Roman architect Vitruvius may actually have preceded all of the others named and may in turn have been influenced by someone still earlier, but the discovery does not seem to have reached painters until the early Renaissance. Whichever of these attributions is correct is less important than the fact that the discovery was made and that it created a major breakthrough in illusionistic painting. Once artists learned the system, they could indicate spatial recession more realistically than had previously been possible.

The system involves the use of vanishing points, points at which lines intended to depict parallel lines converge. These vanishing points are on the horizon if the lines are level. It is important to note that the horizon is always at the viewer's eye level. This is one of the most basic fundamentals of perspective. When two or more vanishing points are necessary, as in all but the simplest perspective problems, their placement may be worked out following the mathematical system, or, if we are working from life, by simply copying the angles we see and extending them to the horizon. The points at which the extended lines cross the horizon are the vanishing points. All lines parallel to the one used to establish the vanishing point will converge at that vanishing point. If there is any question as to their accuracy, the mathematical system may then be employed to double-check.

The mathematical approach should be learned and practiced until a point is reached at which the artist is able to visualize the scene in correct perspective automatically, without the need of actually drawing in the vanishing points and guidelines. The subject is taught to students of architecture but is not currently part of the required curriculum of fine arts programs in most universities. Fine arts majors may be able to take it as an elective. There are numerous books dedicated solely to the subject, the best of which are listed in the bibliography.

However one chooses to study this concept, the importance of mastering geometric perspective cannot be stressed too highly. It is imperative that any serious aspiring artist absorb this fundamental principle completely, if he or she is to ever create genuinely great art. It must become second nature, so thoroughly assimilated that virtually no effort is required to visualize it correctly. Errors in perspective are far too common in modern times. Such a flaw immediately destroys the illusion of spatial recession and prevents the viewer from receiving the artist's message.

In the simplest exercises in perspective, only one vanishing point is used, and it is placed arbitrarily on the horizon. A straight road on absolutely level ground may be indicated by drawing lines from points on each side of the road to the vanishing point on the horizon, where they converge. Suppose we want to add a line of telephone poles, or fence posts, running parallel to the

road and placed at regular intervals. The spaces between them must diminish as greater distance from the viewer's eye is indicated. The interval between the nearest pole and the second pole is established arbitrarily by the artist. The placement of the base of the third pole may be determined by drawing a guideline from the top of the first pole through the center of the second pole and extending it until it intersects the line running from the base of the first pole to the vanishing point. A vertical line drawn from the point thus established becomes the third pole. Its height is found by drawing a line from the top of the first pole to the vanishing point. The fourth pole could be located by drawing a line from the top of the second pole through the center of the third pole and extending it to the line connecting the base of the first pole with the vanishing point, and so on. This example is quite simple and should serve only as an introduction to the geometrical system of indicating three-dimensional depth on a two-dimensional surface.

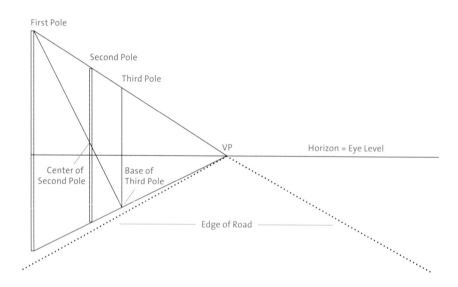

Figure I: The key to establishing the location of poles spaced equal distances apart in perspective lies in drawing a diagonal line from the top of the nearest pole through the center of the next pole, and extending it to the ground, which is indicated by the line connecting the base of the first pole with the vanishing point (VP). This gives us the position of the base of the third pole.

The system is not perfect, as it fails to take into account the curvature of the earth, but the earth is so large that in most situations the curvature is not apparent, and therefore geometric perspective's rules usually work quite well. However, the system does have its limitations, and it can become quite complicated in certain applications. Artists are generally not mathematicians, nor are they likely to be interested in approaching the scene from such an analytical, as opposed to intuitive, standpoint. For this reason, many artists, or would-be artists, are weak in their understanding of this fundamental principle. It is not terribly difficult to grasp, however, once we get past our initial aversion to mathematics, and it is worth the trouble one must put in to gain a thorough understanding of it. It is best approached initially with simple constructions as the first lesson.

SIMPLE CONSTRUCTIONS

Beginning with our basic premise, that the horizon is always at eye level, we proceed to the placement of our vanishing points. Let us begin with a simple cubic structure, representing a house in its simplest configuration. We may choose whichever angle of view suits us and draw a point representing the nearest corner of the foundation, the base of our structure, which we will call corner A. Then we draw a straight line from that point to the horizon, at whatever angle we choose. The intersection of that line and the horizon will be a vanishing point. We will call it VP 1. This line will represent the angle of the base of one of the walls. *(See Figure II.)*

Left:

Figure II: Point A represents the nearest corner of the house to be drawn. The angle of the line drawn from that corner toward the horizon, which represents the base of one wall, is then chosen arbitrarily. Vanishing Point 1 (VP 1) is established at the point where that line meets the horizon.

Below:

Figure III: This is a view from above, showing how optimal viewing distance is determined for a given picture. It must be far enough from the viewer's eye for the entire picture to be read in one glance.

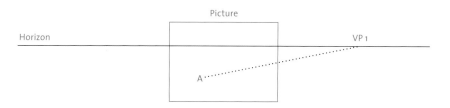

To determine where to place the next vanishing point, it will be necessary to first establish the station point. This is another choice for the artist to make, and, once made, it must be adhered to consistently throughout the picture for the perspective to work. The station point is the point on which the artist/viewer is standing when viewing the scene/picture. The distance from the canvas to the station point is called the optimal viewing distance. If we know beforehand where the picture is to be hung, we may make our decision regarding the optimal viewing distance/station point with those parameters in mind. If we do not know where the painting will hang, the important thing to consider is that there should be sufficient distance from the viewer's eyes to the picture to allow the cone of vision to encompass the entire scene at once. *(See Figure III.)*

Some artists establish the optimal viewing distance by doubling the diagonal dimension of the picture; others prefer to double or triple the vertical or horizontal dimension (whichever one is greater). Once the distance is settled on, we may use it to set our second vanishing point, as follows: draw a vertical line from the horizon to corner A, then extend that line downward until its length from the horizon is equal to the optimal viewing distance just established. This will be the station point, and it will be well below the bottom of our picture, as shown in Figure IV.

At least one of our vanishing points will also be outside the picture. If we have a large enough studio, we may work all this out on the floor, with the canvas laid flat, using nails or tacks for our points and strings stretched from them as our lines. However, this is sometimes impracticable, and the same thing can be accomplished more simply by drawing a plan in reduced scale on graph paper,

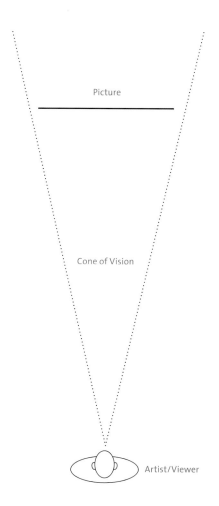

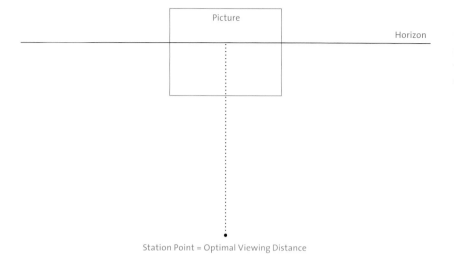

Figure IV: The station point is established, in the perspective diagram, the same distance below the horizon in the picture as the optimal viewing distance is from the picture.

where one inch can represent ten inches, or whatever scale works best for the picture at hand. Once we have our station point, we may draw a line from it to our first vanishing point, calling this line SP/VP 1. To find our second vanishing point, we draw a 90-degree angle from line SP/VP 1 at the station point and extend that line to the horizon. The point at which the line thus drawn intersects with the horizon will be the second vanishing point, or VP 2. *(See Figure V.)*

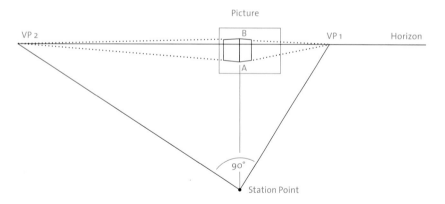

Figure V: With VP 1 established as shown in Figure II, and the Station Point (SP) established as shown in Figures III and IV, the second vanishing point (VP 2) can be located by drawing a line from SP to the horizon, at a 90-degree angle from line SP–VP 1. With two vanishing points, we can begin construction of our house.

We may then establish the other angle for the base of the wall of our house by drawing a line from corner A to VP 2. From corner A, we draw a vertical line to whatever height we deem appropriate for our walls, then connect the top (which we will call corner B) of that line to VP 1, then another line from corner B to VP 2.

Rex Vicat Cole, in his excellent book *Perspective for Artists*, recommends placing a cardboard square in the desired position on the ground or floor, when practicable, and then simply drawing it, using our pencil or other measuring stick to gauge the angles correctly and then extending those angles to the horizon to set the vanishing points. All lines parallel to one or the other angle of our square will resolve to the same vanishing points. This is the simplest method, but it is helpful to know how to do it from a construction standpoint as well.

When our point of view is such that the baseline of our square shape is parallel to the picture plane, we may work with a principal vanishing point (PVP) and a diagonal vanishing point (DVP). The principal vanishing point is found by drawing a line vertically from the center of the baseline of our square until it reaches the horizon. The sides of our square are found by drawing a line connecting each end of the baseline with the principal vanishing point, as we did in Figure I. The diagonal vanishing point will be on the horizon. It will be positioned the same distance from the principal vanishing point as the principal vanishing point is from the station point (optimum viewing distance). *(See Figure VI.)*

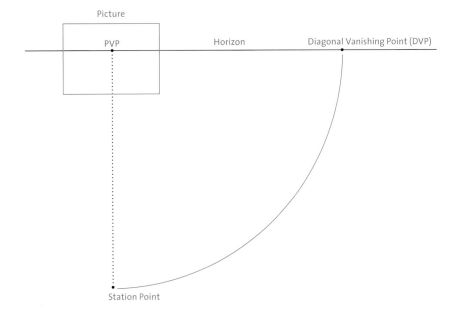

Figure VI: The Diagonal Vanishing Point (DVP) is on the horizon, the same distance from the principal vanishing point as the station point is from the horizon.

The diagonal vanishing point can be established either to the right or to the left of the principal vanishing point. When the diagonal vanishing point is to the right of the principal vanishing point, we establish the depth of our square by drawing a line from the left corner of the baseline (corner A) to the diagonal vanishing point. The point at which this line intersects the line from the right corner of the baseline (corner B) to the principal vanishing point becomes the right rear corner of our square (corner C). A horizontal line drawn from that corner to the point at which it intersects line A–PVP establishes the fourth

corner (corner D) and the back line (line C–D) and thereby completes the square. *(See Figure VII.)* All squares parallel to the first square will resolve to the same vanishing points, as illustrated in Figure VIII.

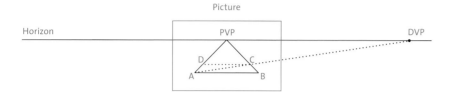

Figure VII: Line A–DVP establishes corner C where it crosses line B–PVP. A horizontal line leftward from corner C creates the back of the square and corner D.

A diagonal vanishing point represents a 45-degree angle in perspective and is therefore a useful device, where the vanishing points representing 90-degree angles are too far apart to be easily workable. A diagonal vanishing point connects a front corner of a square with the rear corner on the opposite side with a diagonal. It is also possible to establish the perspective of squares and other geometric shapes whose front edges are not parallel to the picture plane by enclosing these shapes within squares formed by using a principal vanishing point and a diagonal vanishing point and marking the points at which the corners meet the outer squares.

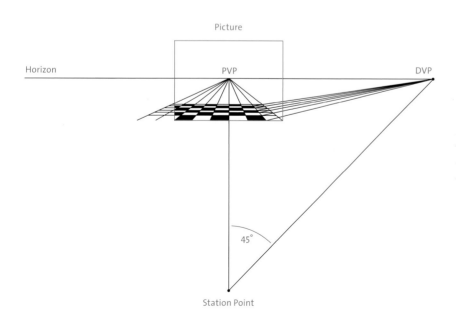

Figure VIII: This shows the method for foreshortening squares in a checkerboard floor, using a principal vanishing point and a diagonal vanishing point. The diagonal vanishing point is 45 degrees from line SP–PVP as measured at the station point. Thus the DVP is used to establish 45-degree angles across squares drawn in perspective.

CIRCLES

Foreshortening circles is a particular perspective problem for many artists, yet it is fairly simple once we understand the underlying principles. A circular disc seen edgewise at eye level reads as a horizontal straight line. The same disc/circle lying at our feet, directly below our eyes as we look straight down on it, is perfectly round. In between those extremes, it reads as an ellipse, and the degree to which it is "open" depends on its distance from the horizon, if it is lying level, or on its position relative to our eyes, if it is not level. Nearer the horizon, it is more "closed"—that is, closer to flat—and as it moves above or below the horizon it becomes more "open."

Drawing an ellipse to indicate a foreshortened circle—i.e., a circle in perspective—is simplified by first drawing a square in perspective, using a principal vanishing point and a diagonal vanishing point and then drawing the circle within the square. The first thing to draw is the horizontal line representing the base of the square in which we intend to enclose our circle. This will be the edge of the square that will be closest to our eyes. This is the line referred to as line B–E in Figure IX. The square in perspective is finished as previously described in the discussion of foreshortening squares. The circle will touch the square in four places: at the center of each side. The center of the square is determined by drawing lines connecting the diagonal corners with one another. These lines will cross at the center of the square. The centers of the right and left sides are found by drawing a horizontal line through the center of the square and extending it until it reaches both sides. A line drawn from the center of the base line (point G in Figure IX) through the center of the square (and on to the principal vanishing point, if it were extended that far, indicated as line G–PVP) will establish the centers of the front and rear sides of the square. These four points, the centers of the four sides, will be points on the circumference of our foreshortened circle.

Unless we have a way of establishing more guide points on the circumference of our circle, we will have to draw freehand arcs between these four points to make our foreshortened circle. However, there are ways of finding four more points to help us, for a total of eight. As shown in Figure IX, the baseline, line B–E, is divided in half by point G. We may then divide line B–G in half and establish point C at the midpoint between point B and point G. A flat square should then be drawn below the baseline, using line B–C as one side. This is shown as square ABCD in Figure IX. A diagonal line connecting corner A with point C becomes diagonal A–C. The length of line A–C must then be measured. That length is then used to establish point F and point H on the baseline B–E, by measuring from point G to the right the same distance as A–C to create point F, and from point G leftward that same distance (line A–C) to establish point H. A line is drawn from point F to the principal vanishing point, and another line is drawn from point H to the principal vanishing point. Line F–PVP will cross the diagonals inside our square at two points, and line

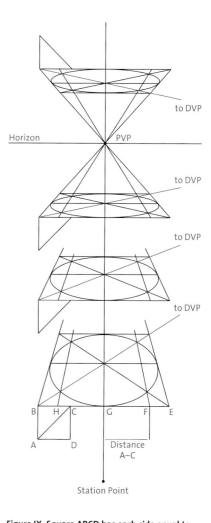

Figure IX: Square ABCD has each side equal to one-fourth the baseline (line B–E) of the square in which the circle is enclosed. The diagonal dimension line A–C is used to establish points F and H as measured from the center of line B–E. Lines F–PVP and H–PVP create four more points on the circumference of the circle where they cross the diagonals.

H–PVP will cross those diagonals at two more points inside the square. These four points will be on the circumference of our foreshortened circle. We now have eight guide points to help us draw the correct ellipse for representing our foreshortened circle.

See Figure X for another method of establishing those same eight points on the perimeter of a circle drawn within a square. This method involves drawing a two-dimensional plan of a square, finding the center by drawing the diagonal lines across it, and then using a compass to draw the circle inside the square. Vertical lines are then drawn from the points at which the circle crosses the diagonals and extended to the top and bottom of the two-dimensional square. The points on the top and bottom thus established correspond to point F and point H in Figure IX. Our foreshortened square may then be drawn in perspective, using the top of the two-dimensional square as the baseline and the foreshortened circle enclosed within it following the method described previously, using the eight points of reference thus established.

A bit of practice will allow the artist to draw the correct curvature in connecting those eight points, and a bit more will enable the drawing of the entire ellipse freehand, in correct perspective. At some point we develop a "feel" for the decreasing-radius curves we see as curves foreshortened in perspective and for the diminishing intervals appropriate for indicating distance. This ability is what the art student must strive for. Note that distorted ellipses can result when the enclosing square is drawn from two principal (90-degree) vanishing points of unequal distance from the circle in question; thus it sometimes works better to use a principal vanishing point directly above the center of each intended circle and then use a diagonal vanishing point the appropriate distance from that principal vanishing point to find the rear of the enclosing square.

CYLINDERS

A common error when creating cylindrical shapes (such as a flowerpot) is to fail to have the bottom shape read as a more open ellipse than the top, when the top is closer to the horizon. Assume, for the sake of simplicity, that the cylinder is sitting upright on level ground, a table, or the floor, with the top just below our eye level. The circle at the top, represented by an ellipse, will be a fairly narrow ellipse, front to back, because we would be looking at it nearly edgewise. At the same time, the ellipse representing the circle at the bottom will be more open—i.e., less narrow, front to back—than the top ellipse, because we are looking down on it from above. This is because of the greater distance below the horizon of the bottom of the cylinder. It is easiest to see when the cylinder is made of transparent glass, which allows us to see the full ellipse at the bottom. But whether made of glass or some opaque material, we would draw it as if it were of glass initially, in order to establish the correct curvature of the ellipses, and then we could erase or paint over the parts of it that would not actually be visible in an opaque cylinder, owing to being hidden behind the front surface.

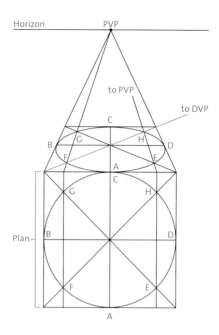

Figure X: This is a simplified diagram showing the same method as Figure IX, with only one foreshortened circle shown, for clarity.

Figure XI: A cylinder has a circle at each end, foreshortened in perspective. If the cylinder is sitting upright on level ground, the ellipse nearest to the horizon will be less open than the ellipse further from the horizon, as also shown in Figure IX.

So in our flowerpot example, what is *not* going to work is to have the same curvature for both the top and bottom ellipse. Each must resolve to the same horizon from its position relative to that horizon.

CLOUDS AND OTHER NATURAL PHENOMENA

Clouds must also follow rules of perspective, as their size and the intervals between them appear to diminish with greater distance. Waves in the ocean, and the intervals between them, follow these same principles. Geometric perspective applies to everything in a three-dimensional scene and consequently to everything in a scene of our creation that we intend to render as if it were three-dimensional. Easy examples would include lines of soldiers standing at attention, in formation; rows of trees all the same size; and dancers in a line onstage. It becomes more complicated when the ground is not level or the rows or roads are not straight, but these things can be worked out mathematically. However, the more artistic approach is to draw these things freehand, guided by a thorough understanding of geometric perspective, which enables an artist to visualize the scene on the paper or canvas in three dimensions before drawing a stroke. This becomes possible when the knowledge of perspective is committed to memory.

It is imperative that the student, the aspiring artist, apply the discipline necessary to learn the mathematics of the system so well that all awkwardness with its application disappears and ceases to interfere with the creative, intuitive processes so essential to art. Once the understanding of these issues becomes second nature, it becomes a help rather than a hindrance. The artist should then be able to "eyeball" the scene accurately, without having to actually draw the vanishing points and guidelines. Its parallel in music would be the learning of music theory: perhaps no fun at first, but great music cannot be created without it.

Atmospheric Perspective

As objects recede in space, they not only appear to shrink in size but they tend to lose detail, contrast of values, and intensity of color, and their edges appear less distinct the greater the distance from the viewer's eyes. This is the principle of atmospheric perspective. Some writers call it aerial perspective, but this is misleading, as the term *aerial* usually pertains to flying. The visual alteration of images over distance is the direct result of a certain amount of atmosphere between the eye and the object or plane in view. The atmosphere contains water vapor and its own density, which renders it somewhat less than totally transparent, adding a certain degree of whiteness to the air. Light renders the atmosphere white. The more air we must look through to view something, the more atmosphere we see between it and our eyes, and the more the image is altered by it.

An optical illusion is created by the presence of a semitransparent white between the eye and any color darker than white, which alters the color in question in

the direction of blue and lightens the value. This may be one way of explaining why the sky appears to be blue. The sky's blue is created by the blackness of space being viewed through a layer of semitransparent white atmosphere.[2] The white is the atmosphere illuminated by the sun. At night, without the sun's light, the atmosphere is no longer white, and the blackness of space becomes visible. Note that the sky is always lightest just above the horizon. This is the greatest distance we can see at ground level, which is where the atmosphere contains the most (white) water vapor and the greatest density. At the horizon, the density of the atmosphere renders it more opaque and, thus, whiter. As we look up, we look through thinner air, which is less opaque, and the sky is bluer and darker. This is why distant objects and planes appear lighter, bluer, and less distinct.

The same phenomenon can be produced with paint. The process is called *scumbling* and is accomplished by applying a thin veil of white paint semi-transparently over a layer of (dry) darker paint. The optical result in paint is the same as in the air. Translucent white over black reads as bluish, just as light gray smoke against dark trees reads as blue. Note that the same smoke may appear to be brown when a white cloud is behind it, a reverse of the scumble phenomenon.

THOMAS COLE (American, 1801–1848), *View near the Village of Catskill*, 1827, oil on wood panel, 24½ x 35 inches, Fine Arts Museums of San Francisco. Gift of Mr. and Mrs. John D. Rockefeller 3rd, 1993.35.7.

Distance is indicated very convincingly in this fine landscape by Thomas Cole, following the principle of atmospheric perspective. The atmosphere alters the colors and values, more so with greater distance.

Dark over light increases apparent warmth. This is the principle at work in glazing, that is, the application of darker transparent paint over a lighter passage. Glazing and scumbling are discussed at length in chapters 5 and 6.

In painting, atmospheric perspective can be rendered directly, in one step, using opaque paint exclusively, at least in the distance and middle ground, to make those areas appear lighter, bluer, and less distinct the further back they are. Specifically, and increasingly, white and blue paint are added, edges are softened, and details are suppressed by working wet paint into wet paint, while contrast between light and shadow is diminished as the distance itself increases. The effect can also be achieved, perhaps slightly more convincingly, in a two-stage process whereby the same procedure is used as in the one-step method except that the area of greatest distance is rendered very slightly darker than the desired final effect. The illusion is then completed in the second step by scumbling a thin film of white or light gray over the dried paint of the first step in the areas of the greatest distance. The illusion of depth can be further enhanced by painting the deepest foreground darks and shadows, and *only* these foreground darks and shadows, in transparent glazes over a relatively lighter underpainting or primer. This creates the highest degree of clarity and simulates the minimal amount of atmosphere present between the shadow and the viewer's eye, as appropriate, in the immediate foreground.

The combined, systematic use of glazing, scumbling, and opaque painting allows the painter to create the illusion of depth to the highest degree possible. However, the successful rendering of spatial recession depends even more heavily on observance of the principles of geometric and atmospheric perspective than it does on expert paint handling. Sophisticated painting techniques serve the illusion of reality best when employed in accordance with the natural laws that govern the way the human viewing apparatus perceives the three-dimensional world. No amount of painterly finesse can compensate for any failure in those important areas. Some of these issues are easier to grasp than others, and the next one to be discussed is perhaps the most difficult of all.

Selective Focus

There is a third principle, called the principle of selective focus, that also bears on the visual perception of reality. Closely aligned with atmospheric perspective, selective focus is the phenomenon whereby our eyes, directed by the brain, register the highest attention to detail on whatever we consider most important within our cone of vision. In designing our painting, following this principle, we must simplify whatever is of lesser importance and render it in softer focus than the areas of primary importance. Hard edges should be used sparingly and for specific reasons. To use too many sharp edges will destroy the illusion of reality, as it does not correspond to visual experience. Our eyes cannot focus on more than one small area at a time. Everything else appears duller and less distinct.

By following this principle, the artist can assign greater importance to key elements in the picture by rendering them in sharper focus and adding more detail and can arrange things in such a way as to lead the eye from point to point to hold the viewer's attention for as long as possible. Areas of secondary and tertiary importance may also be rendered in sharp focus in certain instances, but they must be made less noticeable than the primary subject by their positioning on the picture plane and by being arranged in such a way as to have less contrast of values, lower chroma colors, or whatever other means will render them less noticeable from a distance. Orchestrated in this way, areas of secondary and tertiary importance do not compete with the area of primary importance for the viewer's attention. The main focal point is emphasized not only by sharper focus but by greater contrast of light and dark, by higher chroma color, perhaps by its juxtaposition with contrasting hue accents, and especially by its strategic placement on the canvas. Other elements in the picture may also direct the viewer toward the main focal point.

If one had to choose between painting everything sharp or everything soft, the soft option would allow for a more convincing illusion of reality. We all, at times, see everything in soft focus, as it takes a certain amount of effort and direction from the brain to focus the eyes on anything. It is not possible, however, to see everything in sharp focus at once; thus, a view painted in such a way clashes with our experiences in viewing the real world. It is easy to fall into the trap of painting items in sharp focus, for as we move our attention from what we have just painted to what we will paint next, each element indeed appears to us in sharp focus. The temptation to paint it as sharply as we see it when focusing on it is very strong but must be resisted, or we violate the principle of selective focus, and the illusion of reality of the overall scene will be compromised for the sake of superfluous detail. It is helpful to squint when observing elements that we deem to be of lesser importance, thereby throwing the eye somewhat out of focus, and then paint them as they appear when squinting. If the painting requires a sharper focus on certain parts of the scene, it is still advisable to begin by squinting, in order to read the larger, more general shapes, and then add whatever detail is desired after we are certain that the big shapes are correct.

We must constantly consider how our picture will appear to its viewers at first glance. It must register upon their sense of sight just as the scene itself would, or they will not be drawn in to look at it more closely and will never appreciate the fine work we may have put into the details. A picture must be designed to work as a visual whole. It must be more than a collection of details assembled at random. If elements of lesser importance are not simplified, the viewer may become confused as to what the subject, or focal point, of the picture is. To see something in sharp focus, the brain must direct the muscles within both eyes to simultaneously adjust their respective lenses to focus on that object, and other muscles must guide the position of each eye to allow both to converge

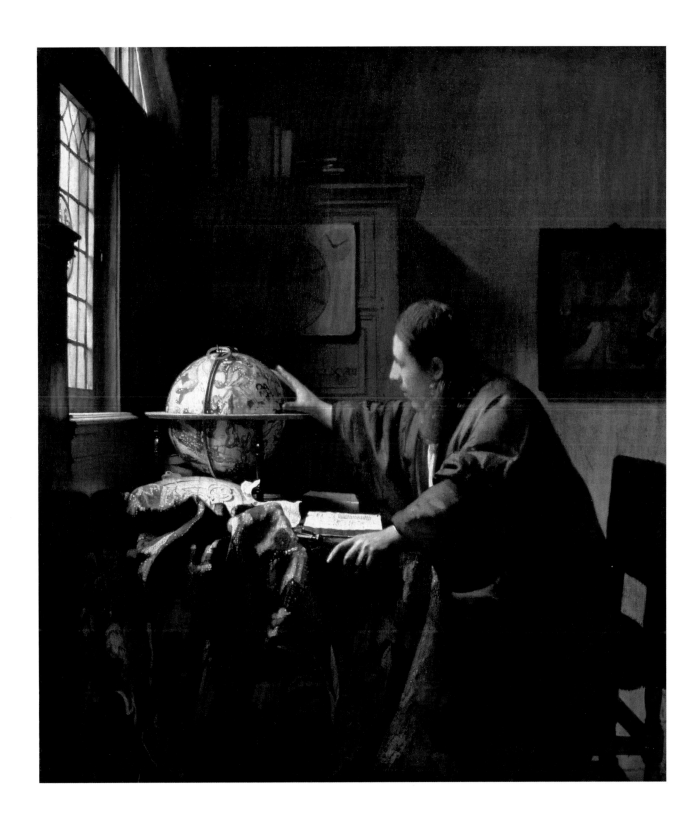

on that same object or surface. This involves a certain degree of effort. Thus this action is only triggered by the brain when it deems something of sufficient importance to warrant it. By rendering a given object or surface in our painting more sharply, we are indicating to the viewer that this particular thing is important. Hence the term "*selective* focus." This concept is essentially what the old Dutch painters referred to as "houding"—i.e., the unification of the various elements in the picture into a cohesive scene that reads realistically.

As artists, we should not just paint what we see; we should paint what we want to show to our audience, selecting only that which is worthy of such special attention and then presenting it as it appears at its most appealing, or making it more so if it will make a better picture. The viewer's attention is directed where we want it by the use of selective focus. If the visions we paint exist only in our imaginations, so much the better.

By understanding the principles of visual reality, one can render imaginary scenes convincingly real and perhaps transcend even the limitations of working from life. This is the mark of a Master. This level of ability can only be attained by working from life until the principles of visual reality are thoroughly absorbed. There is no shortcut.

The Nature of Light

In terms of mastering the principles of visual reality, it is just as important to have a thorough understanding of the nature of light and shadow as it is to know the rules that govern spatial recession. The surface shapes of three-dimensional forms are indicated by the distribution of light. Shadow is, in theory, the absence of light, but in reality there is light in shadow as well. Areas of what we perceive as "light" are generally illuminated by light rays that have traveled in a straight line from the strongest source, whereas shadows either receive their light indirectly, as the rays from the primary (strongest) source ricochet off nearby surfaces and bounce in behind objects that block the direct rays, or come in from secondary light sources that are weaker and/or farther away than the primary light source. Without secondary light or nearby reflective surfaces shadows would read as black. The dark side of the moon is an example of such a situation, though this is rare.

Two categories of shadows are often mentioned in artists' textbooks and classes—cast shadows and body shadows. Cast shadows are the shadows cast on objects or surfaces other than those that are blocking the light, whereas body shadows are the shadows *on* those objects that are in the light, on the surfaces where the light cannot reach—i.e., the dark side. The same principles apply to both types of shadow, so it really is not necessary to address them as if they were two separate matters.

A shadow is darkest in the zone just beyond the planes illuminated by the primary light source. This zone is called the shadow accent (sometimes referred to as

The form is developed through the distribution of light and shadow, as shown here on an egg. The single primary light source is on the right, slightly to the front. It registers most strongly where its rays strike the egg at the angle at which the greatest amount of light is reflected to our eyes. The highlight is actually the reflection of the light source. The degree to which it is diffused is determined by the texture of the reflecting surface; thus the artist who understands this will indicate the texture of the surface being depicted (mainly) by the way he or she renders the highlights. Light reflects from the table into the body shadow on the underside of the egg, and, since the egg is white, a second reflection, or re-reflection of this reflected light registers in the cast shadow as well. Note the softening of the edges of the cast shadow as distance from the egg increases. This is due to secondary light.

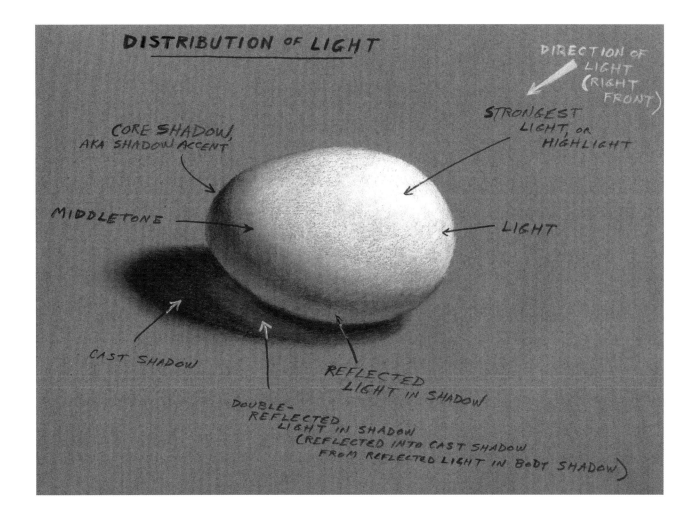

the core shadow) of the body shadow. The phenomenon of the shadow accent is best understood in scientific terms. Whenever enough light is present to allow us to see at all, there are light rays, of varying strengths, both reflected and direct, coming from many directions and often from more than one source. The strongest light creates what we consider light and middletone areas, whereas the rays from the weaker sources are only visible in shadow—in other words, where the primary light rays cannot reach. Whatever blocks the strongest (primary) light also blocks a certain amount of secondary light, and the closer the shadow is to the blocking obstacle the more of the secondary light rays are blocked from that area.

A good analogy is to suppose we are standing under an awning in the rain. Our head stays dry because it is closest to the awning. Our midsection on the other hand, may get a bit wet, and our feet undoubtedly will get wet, since they are so far from the awning. Likewise the wall under the awning will be drier the closer it is to the awning. If we substitute light rays for rain, it becomes apparent why the shadow accent is darker than the rest of the shadow. Less light means more dark.

Beyond the shadow accent, more secondary light is allowed to enter the shadow area, as it bounces off nearby objects or planes or comes in from secondary (weaker) sources. The farther the area is from the light-blocking obstacle, the more light will be admitted. So the shadow accent is most simply described as the zone of shadow between the primary light and the secondary light.

The shadow accent is a most useful device for describing interior planes— that is, the planes within the edges of the object being depicted—by its shape and by how sharply it makes the transition from middletone to shadow. A sharp change in angle will have a sharp transition; a more rounded form will have a softer transition. Once the artist understands this principle, he or she will look for the shadow accent and will use it to good advantage when drawing and painting.

The cast shadow follows the same principle as the body shadow (the shadow on the unlit side of the object in question), in that it is darkest at the edge nearest whatever is blocking the light. Its edge is also sharpest at that point and softens as it recedes because of secondary light rays reflecting into the edges of the shadow from surrounding planes or emanating from weaker or more distant light sources.

Moving from the shadows into the lights, meaning the areas illuminated by the primary light source, it is now time to address the middletones. The middletone is the area on the lighted side that is far enough from the angle of incidence of the light rays to our eyes that the body color of the object is least altered by the light. Thus the color of a given surface is seen at its highest chroma, or intensity, somewhere in the middletone. This is explained in greater detail in chapter 5. The highlight is the point at which the light from the primary light source bounces off the object and to our eyes the most directly. It will contain more of the color of the light source than any other area in the light. The highlight will describe the surface texture of the object being viewed by the degree of sharpness at its edge and by the contrast between its value and the value of the middletone. There will be a transition zone between the highlight and the middletone. The extent of this transition zone, again, depends on the texture and shape of the surface and on the intensity of the light from the source as it registers in the highlight.

It is necessary at this point to address the way in which color is affected in the shadow areas. Shadows are areas where the direct light rays from the strongest source cannot reach. If there were but one source of light, and no surfaces nearby to reflect light back into those areas, the shadows would be totally dark, and we would not be able to read shapes within them. However, as previously noted, situations such as that are rare, except in outer space. In reality, there is usually more than one light source and/or at least one nearby surface that reflects light into shadow areas. The color of the secondary light

source affects the color of the shadows. The color of nearby surfaces, which reflect light into shadows, is also cast into the shadows as an inseparable component of the reflected light. The body color of the shadowed surface is also an influence; however, its chroma will be lower (duller) than in the middletone for the same reason that its value is lower (darker). The reason is that there is not enough light in the shadow to reveal the body color at its full intensity.

The greatest influence on the color in shadow is usually the color of the strongest secondary light source. The best example is an outdoor scene on a sunny day. The main light source is direct sun, which is slightly yellowish. The secondary light source is the sky, which is blue. The color of the sky will be the strongest color influence, other than the body color of each surface, in all areas facing the sky that are not lit by direct sunlight. The sun's rays, striking directly, are so much stronger than the light of the secondary source (the sky) as to effectively overcome the color influence of the sky in those areas, replacing it in the high-lights with its own color plus white (because it is lighter by virtue of coming from a stronger light source). In other words, direct sunlight essentially "eats" the blue. When a cloud obscures the sun, the sky becomes the primary light source, and its color, blue, becomes an influence on the colors in the lighted areas. When the cloud moves away and allows the direct rays of the sun to again become the primary light source, all areas then in shadow retain the blue influence of the sky, except where the light from the sky cannot reach. In those areas, reflected color from nearby surfaces will have a stronger influence. For example, the underside of a white or gray fountain surrounded by a green lawn will register a certain amount of green in the body shadow areas, whereas the upward-facing areas in shadow will register the blue of the sky. The green is carried with the light from the sun as it bounces off the lawn and reflects into nearby surfaces. If the object in question has no color of its own, such as our white or gray fountain, this will be more apparent. If the object has its own body color, it will be influenced by the color of the secondary light rather than be replaced by it.

After the student has been exposed to these principles of visual reality, they will become more obvious, as he or she will be on the lookout for them in real-life situations. This is an important step toward becoming an artist. Once the principles are completely understood, the artist is freed from dependence on external sources. Nothing the imagination can conjure up will be beyond the artist's ability to depict on canvas. This in itself is still no guarantee, however, that an artist so equipped will be a Master, as he or she must also have something of interest to say. Inspiration is an individual thing that cannot be taught; one finds inspiration on one's own. However, all the inspiration in the world will not help, if the inspired person lacks the vocabulary to express it. A thorough understanding of the principles of visual reality is an extremely important part of that vocabulary.

The Photographic Image Versus Visual Reality

There is a difference between photographically reproduced images and the images recorded by the human brain and eye. The layperson—in fact, almost everyone—accepts a photograph as an accurate facsimile of visual reality. The trained eye, however, can spot the differences readily. It is imperative that all artists possess the highly trained eye, and anyone aspiring to become a legitimate artist must undertake to develop the critical faculty called "the eye," which, as we discussed earlier, is simply a shorter term for "power of observation."

The importance of understanding the aforementioned differences cannot be stressed too highly. The use of photography as an artist's aid is widespread, and it is very tempting to resort to the use of a camera to solve many of the problems artists encounter. Modern-day art students or aspiring artists often succumb to the urge to shortcut the learning process, and subsequently to shortcut the execution of their works as well, to the detriment of their art. Shortcutting the learning of art can only result in bad art, a commodity that currently floods the market.

This is not to say that the use of photography invariably leads to bad art. The well-trained artist, possessed of a good eye, a thorough understanding of the principles of visual reality, and the nature of light, can benefit from the use of photography. Such an artist will understand exactly how a photograph distorts values, colors, and shapes and will correct and adjust the images as he or she paints. But to *become* an artist capable of doing this, one must conscientiously avoid photographic reference material and work from life and from memory only, as a student, until the principles of visual reality are so thoroughly assimilated that it becomes virtually impossible to violate them. Only then will the distortions inherent in photography become obvious, and only then can artists successfully use such material without incorporating its flaws into their work.

How, then, does the photographic image differ from visual reality? Everyone can tell a photo from reality. The very differences that allow us to distinguish between the photo and reality *are* the differences between the photo and reality. We are able to perceive spatial depth when looking at a scene, but a photograph of the same scene fails to convince us that we are looking at anything other than a flat surface. Why? There are a number of answers to this question.

First, the camera has only one eye, and no brain. Additionally, its eye is constructed differently than is the human eye, which is a vastly superior viewing instrument. The range of values (lights and darks) that the camera is able to perceive simultaneously is much narrower than the value range our eyes can perceive. The camera's lens is of a fixed curvature and focuses by varying its distance from the film. The human eye has a flexible lens, which focuses by changing its shape, and the retina is much more sensitive than a sheet of film. The retina of the eye is curved, whereas the film in a camera, which corresponds

to the retina of the eye, is flat. This causes greater variability in the distances light rays must travel from the curved lens to reach the various spots on the film. The distance from the center of the lens to the center of the frame of film will be much less than the distance from the lens to the outer reaches of the film frame. There is also a great deal of variance in the angles at which the light rays strike the film. The result is distorted shapes. The distance traveled by the light from the lens in an eye to anywhere on the retina is fairly consistent, as is the angle at which the light strikes the retina.

Another difference between the human eye and the camera is the camera sees every edge within its focal range as a sharp edge and records everything within that range in sharp focus. The human viewing apparatus includes two eyes, each of which sees a slightly different edge (on a rounded form) and a brain as the receiver of the signals. The two edges merge in the brain, and our impression is a blur of varying distinctness, the degree of which depends on the shape of the surface at the edge and on the degree of importance assigned the area in question by the brain. The brain also performs an editing function on the raw input from the sensory organs, focusing attention on areas of greater importance and glossing over less important information. Without this function, mental concentration would be much more difficult. Then there is the distortion of shapes in photography that is the result of the difference between our eyes and the camera's lens and its mechanism of focusing, as well as its being the product of a single point of view (monocular vision). For the painted image to give the viewer the impression of viewing a scene with his or her own eyes, the scene must be painted from the viewpoint of a human being viewing the scene with two human eyes, not the scene as viewed through the single lens of a camera.

Color photography uses three[3] transparent dyes to print a machine's impression of a scene on white paper or on a transparent film (transparencies or slides).[4] An oil painter has over one hundred twenty pigments to choose from—some opaque, some transparent, some somewhere in between. The painter may also create optical illusions through superimposed glazes and scumbles, juxtaposing thinly painted areas with applications of dense, opaque impasto for a wider variety of visual effects than is possible with photography. The artist viewing the scene with his or her own eyes will see colors and optical effects beyond the capability of photography to record.

By relying on our own eyes and aesthetic sense (a sense the camera lacks), and working with the less limited medium of oil paint, we (artists) can produce images beyond the capabilities of photography—images that may even have originated in, or at least will have been improved on by, our own imagination. It is this factor, the artist's imagination, that makes each work of art unique. This is why art is sought after by collectors. Each piece is one of a kind. It is not mass-produced. It is not the product of a mass-produced machine. Art is cheapened when these qualities are compromised.

Chapter Five

COLOR

THE SUBJECT OF COLOR ACTUALLY BELONGS within the larger category "the nature of light," as color is, in fact, light, as was mentioned in the previous chapter. However, color is so vast a subject that it deserves a chapter all to itself. [1] This book concerns color as it pertains to art, and specifically to oil painting, and so the reader will be spared the usual scientific diagrams of light rays, etc. A certain amount of science is needed to adequately understand color, but every attempt is made here to keep it from becoming tedious.

Before we proceed, a few words must be said in order to place the information provided in this chapter, and indeed in this entire book, in its proper perspective. It would be very easy, and perhaps tempting, to take what is presented here as unquestionable truth and accept it as such without ever putting it to the test to see if it holds up. That is not the intention of this book. Art cannot be reduced to a formula or a formulaic approach, nor should it be. The artist should avoid falling into the trap of formulaic thinking. It is the antithesis of art. Dogma should never substitute for thought. To always do a certain thing the same way, out of habit, without careful consideration each time, is a form of mental laziness that places a much lower limit on one's capabilities than to "think on one's feet."

Things are in reality very complex, and simple sets of rules cannot do reality justice. Rules and formulas, including those given in this book, are not harmful as long as they are viewed in the proper context and questioned at every turn. By accepting what we are told, we learn nothing. By questioning the rules, we

Opposite:
PETER PAUL RUBENS (Flemish, 1577–1640), *Christ's Charge to Peter*, circa 1616, oil on oak panel, 54¾ x 45¼ inches. Reproduced by kind permission of the Trustees of the Wallace Collection, London.

Note how Rubens controls the chroma of the fleshtones in order to describe the forms. This is a great lesson in the effective use of grays in painting flesh of light-complected subjects.

learn whether they are true or applicable in a given set of circumstances, and why. New understanding grows from this process. This is the essence of art. The goal is to arrive at a complete understanding of the many complex factors that influence the way we see, so that every stroke, every choice we make as an artist, has a reason.

The Components of Color

Color has three main components: hue, chroma, and value. Hue is simply the category of color: red, orange, yellow, green, blue, and purple, for example. Chroma is the intensity of the color. A bright red, such as cadmium red or vermilion, straight out of the tube, is high in chroma, while the earth reds are low in chroma. Cadmium yellow is higher in chroma than yellow ochre. Neutrals—that is, white, grays, and black—are zero chroma. Value is the degree of light or dark of a color or a neutral.

This is the color classification system devised by Albert H. Munsell early in the twentieth century. Munsell assigned numbers to chroma and value in order to more accurately describe them in words. However, because analyzing something to death with words and numbers is counter to the artistic way of thinking, this book avoids using numbers for chroma in the interest of simplicity. Munsell's numerical system for values is quite simple and will be used when necessary for clarity. The value scale is from 1 to 10, with each tenth representing an increment of 10 percent light. Value 10 is the lightest, at 100 percent light. As such, 10 must be left off of value scales printed on white paper, since white light itself—i.e., pure light—is still lighter than white paper. The lower the number, the less light there is. See the accompanying chart. As for chroma, more general terms, such as "high," "middle," and "low," will suffice.

Since white paint is still not as bright as the lightest lights we are able to see in nature, we cannot duplicate with paint the entire range we see with our eyes looking at the real world. What we can do is try to match, as closely as possible, the degree of contrast between values, in order to create the illusion of reality. This is undoubtedly why so many of the Old Masters opted for deep, transparent darks in their paintings—to expand the range of values on the dark end of the scale in order to create the maximum contrast with their lights.

The Munsell system is the most widely accepted system of color classification today. The reader should note that while the Munsell system is quite complex, it is still a simplification of the even more complex visual phenomenon we call "color" and does not cover the full range of color sensations provided by nature. Nor does it adequately cover all the visual effects the artist is able to create— particularly when multilayer painting techniques, such as glazing and scumbling, are employed. A classification system is useful as long as we acknowledge its limitations but harmful if we consider it an absolute.

The Munsell value scale. Each step represents 10 percent light.

Color Wheels

Two different color wheels are commonly used by artists—the twelve-color wheel, which is the most popular wheel in current use for paint mixing, and the ten-color wheel, which is the one employed in the Munsell system. The paint-mixing wheel is the one most widely taught, wherein red is the complement of green, yellow the complement of purple, blue the complement of orange, etc. This is the wheel most often referred to when making simple mixtures of paints, if one is reducing chroma by adding the complementary hue. The paint-mixing complements are the hues directly opposite one another—that is, 180 degrees apart, on the twelve-color wheel. To dull a green, we may add a red, or vice versa. To dull a color means the same as to reduce the chroma or to mute a color. To mute a yellow, we may add a purple, according to this method.

In practice, this is not as simple as we are taught that it is, and the results are sometimes other than what we may have expected them to be. This is due in part to the fact that the twelve-color wheel is itself not perfect in its basic premises. Problems are also caused by differences in the tinting strengths of the two complements and in some cases to a too-drastic difference in value between them. Mixing complements of dissimilar value can create "mud." (Mud is created when greatly dissimilar opaque paints are mixed together, or too many pigments are intermixed in attempting to make corrections.) For example, yellow reaches its highest chroma at a very light value, 9 on the Munsell scale, while purple finds its highest chroma at a much darker value, in the range of 3 or 4. Yellows at the value of purple's highest chroma are already low in chroma, and are actually brown, whereas purples at the value of yellow's highest chroma are likewise quite dull, reduced in chroma by the addition of white, a neutral, necessary to lighten the purple. If our yellow is a cadmium yellow, its tinting strength is very high, and a value-adjusted purple will be very weak in tinting strength, thus quite a bit will be required to reduce the chroma of the yellow. As you see, this method can become quite complicated. This system works better for red and green, whose values at peak chroma are closer.

There are three other ways to achieve a lower chroma. The first method is to find a pigment that is already the hue and chroma we desire. In many cases, this is quite possible, thanks to the vast range of pigments available today, and it may be the preferred method, as a cleaner color sensation is possible with a single pigment than with any mixture of two or more. The second method is to add a neutral to the color whose chroma we wish to lower. Which neutral to choose depends on the desired value of the target color. For a value lighter than the paint in question, we may need nothing more than white, or a light gray. For a middle or lower value, we would use a gray made from black and white, except when the hue we are reducing is yellow. Yellow and gray make a green, and if we do not want to turn our yellow green, we must use a warm gray instead, made from raw umber and white, or, in a very warm picture, burnt umber or perhaps a deep ochre and white. This method is easier to

The twelve-color wheel (top) includes red-orange and yellow-orange. The ten-color wheel (bottom) used in the Munsell system differs from the twelve-color wheel by the absence of the steps between red and orange (which is called "yellow-red"), and between orange (yellow-red) and yellow.

control than the mixing of complementary colors, although there is no reason why both methods could not be used in the same painting.

There is yet a third method of reducing chroma, but the above examples are the only ones available to the artist whose understanding is limited to the twelve-color wheel. To explore the other possibilities, we must learn the ten-color wheel.

The ten-color wheel differs from the twelve-color wheel by the absence of the steps between yellow and orange (i.e., yellow-orange) and between orange and red (i.e., orange-red). This causes a shift in all the complements except blue and orange, which are directly opposite one another on both wheels. Thus on the ten-color wheel the complement of red is blue-green, and the complement of yellow is purple-blue. The complement of purple is yellow-green, and the complement of green is red-purple.

The ten-color wheel system works well for certain purposes, such as organizing color, determining complements for that purpose, and using glazing complements to mute colors. We may test this system by forcing ourselves to stare, without blinking, if possible, at a spot of red in a field of white for a minute or so, then at a field of white with no red spot. The after-image of the red spot will be blue-green. This is how the complements are determined. They are the true complements as established by the workings of the human viewing apparatus, which reads light waves to determine color.

The ten-color wheel seems to work better in the technique of glazing transparent color over other colors than does the twelve-color wheel, as the colors produced in this manner are never muddy. A given hue may be muted by glazing over it with its complement from the ten-color wheel without fear of creating mud. It is impossible to make mud with transparent color. Mud is a phenomenon unique to opaque painting. A true glaze is made from a pigment that is transparent by nature rather than an opaque paint thinned with a transparent medium. The latter is actually a semiglaze, sometimes called a halfpaste. (Glazes are discussed more in-depth in chapter 6.)

Many subtle nuances of color may be produced by glazing one color over another. If we have a green we would like to darken and mute at the same time—as in, say, a bit of foliage in the foreground that we would like to place in shadow— a glaze of a transparent violet would serve our purpose. According to the ten-color wheel system, the true complement of green is red-purple. Glazing over green with purple subtracts more of the yellow than blue from the green, leaving a bluish green in the shadows. Purple is the complement of yellow-green. Glazing one color over another reduces the visible amount of the complement of the glaze from the underlying color. Our green could be adjusted further toward blue by glazing with blue-purple. A blue-purple glaze would neutralize the yellow in the green and allow more of the blue to remain, as blue-purple

(or purple-blue) is the visual complement of yellow. The bluish cast in the shadows would be appropriate for a picture in which the primary light source is direct sunlight and the secondary light source is the sky.

An understanding of the ten-color wheel system and the technique of glazing greatly expands the range of effects at the painter's disposal. The reader should note, however, that a transparent passage reads as if the area in question is so near to the viewer that no atmospheric haze is discernible between it and his or her eyes. In light of that fact, using glazes anywhere but in the foreground interferes with the convincing illusion of three-dimensional depth. Its use in foreground shadows increases the illusion of three-dimensionality. It is quite effective to model our shapes opaquely and then deepen the shadows in the foreground slightly with a transparent glaze after the opaque modeling has dried sufficiently. The shadows of the middle distance and beyond should be left opaque for this device to work. The choice of the hue of the glaze should take into consideration that a glazed passage will read warmer than the same hue used opaquely. Ivory black, for example, will read as slightly brown if used as a glaze, even though it reads cool (i.e., bluish) when mixed with white. Light passing through a transparent warm or neutral color from behind alters the color in the approximate direction of red-orange. This must be taken into consideration when deciding what color to use in glazing.

Color Theory

The popularity of arcane theories regarding color requires that they be addressed here, simply to dispel some of the confusion they have created. Much has been made of color in shadow, to the point where many artists place greater trust in their pet theory than in what their own eyes tell them. Whereas there is a grain of truth in at least one of these theories, the general result is misunderstanding, which leads many painters to use garishly exaggerated color in the shadows in many of their paintings. Bright colors may have their decorative appeal, but placing them where they do not belong results in a less convincing illusion of reality. If this is the artist's conscious intent, all well and good, but if it is done out of ignorance of visual reality, then the artist has not yet learned to see well enough.

The most widespread theory, and the one closest to the truth, notes that the light source has color of its own, which registers in all areas illuminated by it to a greater or lesser degree. So far, this is correct. It goes on to say that the complement of the color of the light source will be present in the shadows, and here is where the misunderstandings begin. It is likely that this theory is the result of a misinterpretation of an observed phenomenon in the first place. When observing a white object illuminated by the sun in late afternoon (i.e., when the sun is somewhat yellow or yellow-orange), there is some yellow or yellow-orange in the areas where the sun's rays strike directly. It is also readily observable that there is blue in shadow. However, if we surmise that the blue in the shadow is

there because it is the complement of the yellow-orange or yellow of the sun, we are overlooking the real source of the blue: the secondary light source, which is the sky. If this observation of blue shadows convinces us that the theory is true, we may be apt to arbitrarily use shadow color that is complementary to the color of the primary light source and thus overlook the influence of the body color and the color of the secondary light source, to the detriment of our pictures. We should not operate from a standpoint of theory, especially when the theory contradicts what our eyes (our own powers of observation) tell us.

Once again, the greatest influence on the color of shadows is the color of the secondary light source. Where anything at all is visible in shadow, there is a secondary light source. Almost always there is more than one, and each will register its color as an influence on planes facing it, in the shadows. The color from the secondary light source will not supplant the body color of the object on which it falls, unless the body color is neutral, but rather, it will modify it. Furthermore, this color will only influence the parts of the object that face the secondary light source. For instance, the blue in outdoor shadows is only present in the shadow planes facing the sky, when the color of the sky is blue. Planes facing the ground will register the color of the ground reflecting into the shadows. If the ground is covered with green grass, those shadow areas facing the ground will show some of the green as an influence. If the grass is brown, then brown will reflect into the shadow planes facing downward. Let us imagine a white horse standing in a green pasture, with the sun off to one side, as in late afternoon. On the shadow side, the color of the sky is visible on all of the upward-facing planes of the horse, and the color of the ground, green in this example, may be seen on downward-facing planes. Those artists who pay more heed to the popular theory than to reality may not notice that the shadow on the belly is not blue.

Another consideration must be taken into account regarding outdoor sunlight. If we only acknowledge the color of the sun itself in the primary light areas, we may be apt to use more yellow or yellow-orange than is appropriate. In actuality, when the sun's position is high, the yellow or yellow-orange is some-what neutralized by the blue of the sky, whose influence is just enough to modify the sun's color, making it more white. Late in the afternoon this changes, as the position of the sun throws its rays at more of an angle through the atmosphere, gradually turning them more orange. This orange tone registers on the surfaces illuminated by it, more so than does the color of sunlight at midday. Direct observation readily confirms this, if we train ourselves to trust our own eyes more than what we are told. Therein lies the danger in studying color theory. Theory is theoretical, whereas reality is real.

White Balance

Most discussions of the color of light tend to overlook the fact that our brains include a "white balance" function, similar to that on some video cameras and

digital cameras, but far more complex. This faculty adjusts our perception of the color temperature of light sources and tends to neutralize it somewhat as it registers in our brains. As mentioned previously, the "warm" color of the sun is neutralized to some degree outdoors, where it registers on surfaces, by the "cool" color of the sky's light also falling on those same surfaces. The extent to which this neutralization occurs varies with atmospheric conditions. The contrast between the sun's direct light being warm and the sky's light being cool are most noticeable where both are present at the same time in clear atmospheric conditions (i.e., outdoors on a clear, sunny day). Absent these conditions, the light from the sky reads less cool outdoors because our white balance function automatically adjusts our perception of it. However, indoors, the outdoor light from the sky reads cooler coming in a window than that same light does outdoors on an overcast day because it is contrasted with warm secondary light typical of indoor situations. The simultaneous presence of both warm and cool light inhibits the brain's white balance function from adjusting as far in either direction and enables us to more readily notice the differences in color temperature between the primary and secondary light sources. Reflected color is the "wild card" in this equation, as it can be any color, any temperature, depending on the color of the surface from which it reflects and on the body color of the surface in shadow where it registers.

All of this can be considered a formula, but it is a far more complex formula than any of those in popular circulation among artists attempting to explain it. It is perhaps best not thought of in formulaic terms at all. Artists' interests are better served if this knowledge does not find its way into a computer graphics program but rather remains the exclusive province of artists who actually understand it.

Color as a Descriptive Device

Just as our perception of value is affected by the degrees of light as it is distributed across the forms on which it falls, so too is color affected. This is true in the shadows as well as in the areas lit by the primary light source, which are commonly referred to as the *lights*. The same basic principles apply in both the lights and the shadows because, as has been mentioned previously, there is light in shadow as well as in the lights.

CHROMA AS AFFECTED BY DEGREES OF LIGHT

When creating the illusion of three-dimensional reality on a flat surface, the artist must understand how color is seen on a given shape. If we paint a rounded red object the same shade of red everywhere within its boundary, the result is flat and unconvincing. In reality, light is not evenly distributed over the form; therefore, neither is color. In the shadows, there is not enough light to allow our eyes to read the body color well. The chroma of the body color is therefore lower in the shadows than in the middletone. The body color is registered in its full chroma only in the middletone, as the light "eats" color, causing the body color to lose intensity (chroma) in the highlight. Further, the primary

light source will contain color, and the color of the light will be present to some degree in the highlights, along with a certain amount of white. By painting our middletones at higher chroma than either the shadows or the highlights, we describe the form in the lighted areas more completely. Careful observation of our subjects with this idea in mind will help to clarify the operative principle. We may also learn a great deal from the way the great Masters have handled these issues, but in any case we must not neglect to study nature if we hope to gain a thorough understanding of the behavior of light as distributed across three-dimensional forms. The answers are all there to be beheld, before our eyes, if we know what to look for.

COLOR IN SHADOWS

The greatest influence on color in the shadows is the color of the secondary light. Secondary light may be light from a weaker or more distant source than the strongest (primary) light, or it may be light from the primary source that has ricocheted off nearby surfaces and into the shadows, thus becoming reflected light in shadow. Light reflects. Since color is light, color also reflects. This may be demonstrated easily, by placing a white egg on a colored tablecloth and lighting it from anywhere above. The color of the tablecloth can be seen in the shadow on the surface of the egg, on its underside. If the egg were lying on a green lawn, the reflected color in shadow would be green.

Suppose the sun is striking the egg from the side, leaving the other side in shadow. The upper shadow planes would contain the color of the sky, while the lower planes would register the color of the surface upon which it is resting. The light from the sky and the reflected light are both weaker than the primary light, in this case the sun, and therefore these areas are considered shadow. But because there is still light in our shadow, both sources are classified as secondary light, and each exerts its influence on the color of the planes facing it in the shadows. So it is, then, that the body color of an object is modified by the light in and approaching the highlight, by the shadow for lack of sufficient illumination, and by the color of secondary light in shadow.

An excellent example of the effective use of the principles just explained can be found in the undulating flesh seen in the paintings of the Flemish painter Peter Paul Rubens. The chroma of the flesh tones is controlled precisely to describe the angle of every square inch of surface by the artist's working into the wet middletone with a brush full of gray to indicate a turn away from the light or white with a little of the color of the light when indicating highlights or areas approaching the highlights. A stroke of a neutral, introduced into wet flesh color, reduces its chroma and indicates a change in contour, either toward the light or toward the shadow. In Rubens's painting, the shadow accent (in the flesh of light-skinned people) is most often rendered as a darker gray, containing very little color, perhaps only a touch of burnt sienna. Rubens and the other great Masters also understood the way light and color

Opposite:
PETER PAUL RUBENS (Flemish, 1577–1640), *The Entombment*, circa 1612, oil on canvas, 51⁵⁄₈ x 51¼ inches, The J. Paul Getty Museum, Los Angeles.

Here we see another example of Rubens's method of painting flesh. Rubens indicated the distribution of light through his control of chroma and value. Notice the way he has used grays to describe the forms of the body, in the divisions between the muscle masses. Reflected color in shadow can be seen on Jesus's right hand and arm, registering the red of the cloak. Passages of neutrals allow the colors to harmonize well.

reflect into shadows, as we can see in the images of their paintings provided here and elsewhere throughout this book. In the Rubens painting *The Entombment*, the red of the robe is seen registering on Christ's hand and forearm, as an excellent example.

Rubens often worked without models, relying on his understanding of anatomy and the nature of light to depict the images he saw only in his imagination. Such a complete understanding of the subject and of the principles of visual

reality frees the artist from the complicated business of setting up a scene and hiring models to look at while painting. At this level of mastery, the creative possibilities are unlimited.

The Relativity of Color

The perception of a given color is affected by what is near it. The same color can appear to be two different colors in two different paintings. In a warm painting it will look one way; in a cool picture it will look entirely different. Surrounded by darker values it will look light, and by lighter values it will appear dark. Once again, the reader is urged to read Josef Albers's book *Interaction of Color*. The fact that one color can appear to be another is why the practice of staying with the same palette of colors from one picture to the next, as so many artists do, is not necessarily the best approach.

The question is often asked, "What color do you use for so-and-so?"—blond hair or flesh are the most common queries—and a simple answer is expected. But there is no simple answer. If the subject is to be depicted as illuminated by warm light, one set of colors will work, but if the light is cool, an entirely different palette will be needed. Imagine the same subject lit by lamplight in one picture and moonlight in another. It should be obvious that we could not use the same set of colors for a moonlit scene as for the same scene illuminated by lamplight or sunlight. Neither would a sunlight palette work for a scene lit by an overcast sky, or a candle. The key word here is relativity.

Orchestration of Color

Orchestrating color in a painting is very much like composing music. The painter, like the composer, must use the elements at his or her disposal in such a way as to stir the emotions of the audience, to evoke a certain mood. We must understand the psychological effects of these elements in order to make good use of them.

Neutrals in a painting may be thought of as comparable to rests in music, and the brightest, highest chroma pigments as the highest, most beautiful notes our soprano can sing. We must allow our soprano to sing those notes, but only after the stage has been properly set for them, to allow the audience to fully appreciate their exquisite beauty. The effectiveness of these notes is lost if we attempt to construct an entire symphony of them. A beautiful melody loses its appeal if the spaces between the notes are eliminated or are not organized effectively. So it is that the master painter utilizes passages of neutrals and areas of lower chroma to set up the singing strokes of the most brilliant color, whose placement is strategically engineered for the greatest emotional impact.

Music is organized sound. Beautiful music is sound organized in such a way as to evoke pleasant sensations in the emotions of the listener. Without organization, it ceases to be music and becomes noise. Visual art must likewise be organized

with the intent to interest the viewer and convey a feeling or idea. Without organization, the effect can only be confusion. The audience will not listen to noise, nor tolerate visual confusion, given a choice between that and a more interesting sensation. We want the viewer's attention on our painting, not someone else's. No composer wants anyone to leave during his or her symphony. Thus we artists must understand the psychological responses elicited by each element, each device at our disposal, if we are to consistently create masterpieces.

A musical composition has a key. The key establishes which scales will work and which chords, which harmonies, and so on will not. In painting there is also a key. The key in a painting is the dominant hue. The dominant hue influences which colors may be used, at what level of chroma each color used may be presented, and the maximum proportion of the overall space a given color may occupy without disrupting the harmony of the picture. A simple way to set the key of a picture is to tone the canvas with whatever hue is to be dominant in the composition. The actual decision of which hue should dominate is best arrived at after several possibilities have been tried in small color sketches. When one stands out from all the others, the choice will be obvious. The toning of the canvas or panel may be a thin transparent layer over a light primer or an opaque layer of white primer tinted with the desired color. In either case, it should not be too dark or the colors applied over it will read duller. Value 7 or lighter for the toner will allow the colors to sing. There will also be a dominant chroma and a dominant value in the painting, if it is well organized. The dominance of each factor is established by virtue of its being used more than the others.

To create visual interest, there must be opposition to each dominant factor. If the entire painting were one hue, one value, and one chroma, it would not be interesting to look at. If a musician could only play one note, or one chord, or one tempo, no one would listen for long. Suppose the picture we are planning is to have a dominant hue of red or orange. This would be a warm dominance. Rembrandt preferred a warm dominance in his paintings, referring to reds, yellows, oranges, and browns as "the friendly colors." This reference indicates that Rembrandt understood the psychological effects of his colors on the viewer's emotions and selected the key that best fit his intentions.

Once we have selected the dominant hue, we must then select a dominant value. Do we want the mood of our picture to be deep and mysterious? If so, we might choose a darker dominant value. If the mood is lighter, a higher key ("key" in this case meaning dominant value) would be better, and so on. Suppose we prefer neither extreme for this particular picture and settle on a value 5 on the Munsell scale as our dominant value. Cadmium red is a high-chroma red with a value of 5. A fifth value dominance allows us to use red at full chroma somewhere in the picture, as an accent. This is why we select value 5 as our dominant value. If yellow were the dominant hue, a dominant value of 8 or 9 would allow full-chroma yellows to be used safely as accents, as yellow reaches its highest chroma

at value 9 (cadmium yellow). Blue approaches full chroma at value 4. With blue as the dominant hue in our picture, we would do well to choose a dominant value of 4 if we intended to use blue at full chroma anywhere in the picture. However, in the case of blue, it is a "restful" color, and full chroma is not necessary to achieve this effect. In fact it may even be disruptive, if not carefully controlled.

In choosing a dominant chroma, it is advisable to avoid the high end of the scale, as it is very difficult to maintain harmony with a high-chroma dominance. Then, too, nature seldom if ever provides us with a scene in which most of the colors are high chroma, and if our picture is to appear real, we cannot opt for a high dominant chroma. The better choice may be between middle and low chroma. Middle chroma will allow for a more colorful picture; low chroma dominance creates greater subtlety. Let us choose middle chroma as our dominance for this particular painting.

With a warm dominance, we may use accents of high-chroma orange or red, ideally in or near our center of interest. In so doing, we oppose the chroma dominance and create greater visual interest without destroying the unity of the picture. The use of high chroma must not be so extensive as to equal the area covered by middle-chroma passages. The challenge to the dominance adds interest, but the conflict must be resolved in favor of the dominant chroma for the picture to work. If the high-chroma red we have chosen for our accent has a value of 5, as some cadmium reds have, then the accent aligns with two out of three dominances, and harmony is maintained.

Accents of other hues besides the dominant reds or oranges will make the painting more colorful and thus more interesting. They should align with either the dominant chroma or the dominant value or, for greater unity, both. The area covered by them must be considerably less than that covered by the dominant hue. If we want to add a green, we may choose a middle- or low-chroma green, value 5, and it will make for a more colorful picture without creating color chaos, as long as the total area of green is noticeably less than the red and/or orange. It is within the dominant value, and at or below the dominant chroma level, so it will work. What would *not* work is a high-chroma green at value 3. This would "fall out of the picture," as it would not align with any of the dominances. It could be made to work if it were to align with only one dominance and cover an insignificant amount of space, but not if it were opposed to all three.

In a painting with a warm dominance, a neutral gray made with white and black will appear to be blue and can be used in its place. A gray intended to read as gray would have to be warmed by adding raw sienna or orange or be made with white and a brown, such as raw umber. If our painting has a cool dominance—that is, a larger area covered by blues and/or greens—the same

neutral gray that appeared to be blue in the warm picture will appear to be brown, even though it is composed of black and white. Browns are low-chroma oranges, yellows, or red-oranges. Gray reads as brown when surrounded by cool colors. A spot of neutral in a field of color will appear to be the complement of the dominant hue.[2]

Many possible combinations will work in creating color harmony. Quite a few books have been written on the subject, but in the final analysis it falls to the artist to develop his or her own individual understandings and to pay more heed to them than to anything anyone else has written. There are undoubtedly great possibilities waiting to be discovered in this fascinating universe. It is the artist's challenge to find them.

REMBRANDT HARMENSZ. VAN RIJN (Dutch, 1606–1669), *Judas Returning the Thirty Pieces of Silver*, 1629, oil on oak panel, 31⅛ x 40¼ inches, Private Collection, Great Britain.

This is the painting that brought the young Rembrandt his first critical acclaim. The atmosphere is highly charged with emotion, as the horrible anguish with which Judas is tortured comes through so powerfully that we are stirred in our hearts to feel compassion for the poor, miserable man. This mastery of mood goes beyond technique, and is the supreme defining attribute of Rembrandt's greatness.

Chapter Six

TECHNIQUES *of* PAINTING *in* OILS

FROM THE EARLIEST DAYS of oil painting, a number of oil painting techniques have evolved, following a progression that can now be traced with greater clarity and certainty than ever before. Over the centuries, artists have benefited from the experiments of painters who came before them and have added to the body of knowledge through the process of trial and error. From Jan and Hubert van Eyck, possibly the first innovators to paint pictures in oils, in the late fourteenth and early fifteenth century, to William Bouguereau, Jean-Léon Gérôme, Alexandre Cabanel, Jehan-Georges Vibert, and the other French Academic painters in the late nineteenth century, technical knowledge developed more or less continuously, as artists of each generation added their own discoveries and ideas to what came before.

The continuity of this process was interrupted around the end of the nineteenth century. Suffice it to say that art instruction from that point onward became a much more iffy proposition, as the great traditions of the previous several hundred years were shunted aside or scorned in favor of the lust for the new and novel. The unfortunate result has been that most living artists and would-be artists have received much more limited educations in the nuts-and-bolts aspects of art, and particularly painting, than their predecessors of long ago received and have had greater hurdles to clear as a consequence. Hopefully, this book will prove a little less cryptic (and more accurate) than the old manuscripts the author was compelled to seek out and decipher in his own quest for knowledge.

Opposite:
JOHANNES (JAN) VAN EYCK (Flemish, 1390–1441), *Arnolfini Portrait*, 1434, oil on oak panel, 32³/₈ x 23⁵/₈ inches, National Gallery, London.

This is among the earliest and finest examples of the Flemish technique, painted by the younger of the van Eyck brothers. Hubert (1370–1426) and Jan van Eyck are generally credited with being the main innovators of oil painting, perhaps its first practitioners.

Photo Credit: National Gallery, London

It is further hoped that it will find its way into the hands of others sharing the same obsession, and help to reestablish a stronger link with the great art of earlier times.

The Early Flemish Technique

The earliest oil painting method evolved from the earlier discipline of egg tempera painting, as artists sought ways to overcome the difficulties and limitations inherent in that medium. As this invention took place initially in Flanders, the method is referred to as the Flemish technique.

Among the essential elements of this method of painting are a rigid surface primed pure white and a very precise line drawing. The Flemish masters painted on wood panels (most commonly oak) primed with a glue-chalk ground, which allowed the more transparent passages to glow with warmth from beneath the surface of the paint and gave an extra degree of brightness to even the most opaque colors and mixtures. It should be pointed out here that one particular feature is common to all of the various methods of oil painting employed by the painters of old—they all involved the systematic employment of transparent, semi-transparent, and opaque passages in the development of the images.

As the early Flemish method did not easily allow corrections to be made once the painting was underway, it was necessary for the artist to work out the idea for the picture with sketches and studies done on separate surfaces before starting on the painting itself. Ideally, all of the pictorial problems were solved in advance, and the process of painting the picture involved simply executing an idea that had been completely developed before the first stroke was applied to the panel, following the predetermined plan. Central to this plan was a highly refined linear design, which formed the basis for the painting. This drawing, usually done on paper, was called a cartoon. Most often the cartoon was the same size as the intended painting, although it was sometimes scaled up to that size from an earlier, smaller drawing.

The design, once completed and refined to the artist's satisfaction, was transferred to the white panel by one of several possible methods. One such method involved perforating the cartoon, or a tracing of it, along its lines, then positioning it over the panel and slapping it with a "pounce bag," or sock filled with charcoal dust, which left dotted lines on the panel. The stencil was then removed, and the drawing was finished freehand. An alternate method was to cover one side of a piece of thin paper or perhaps vellum with charcoal, or with a thin layer of pigment and varnish or oil (which was then allowed to become tacky), and then use it as one might use carbon paper to transfer the drawing to the gesso-primed surface of the wood panel.

Once the drawing was transferred to the panel, it was probably finished freehand to correct any errors that might have resulted from the transfer process and then improved further in whatever ways the artist saw fit. The artist would

JOHANNES (JAN) VAN EYCK (Flemish, 1390–1441), *The Virgin of Chancellor Rolin*, oil on panel, 26 x 24 3/8 inches, Louvre, Paris.

Here we see how well van Eyck handled both geometric perspective and atmospheric perspective. The principle of selective focus was not understood by artists at that time.

Photo Credit: Erich Lessing / Art Resource, NY

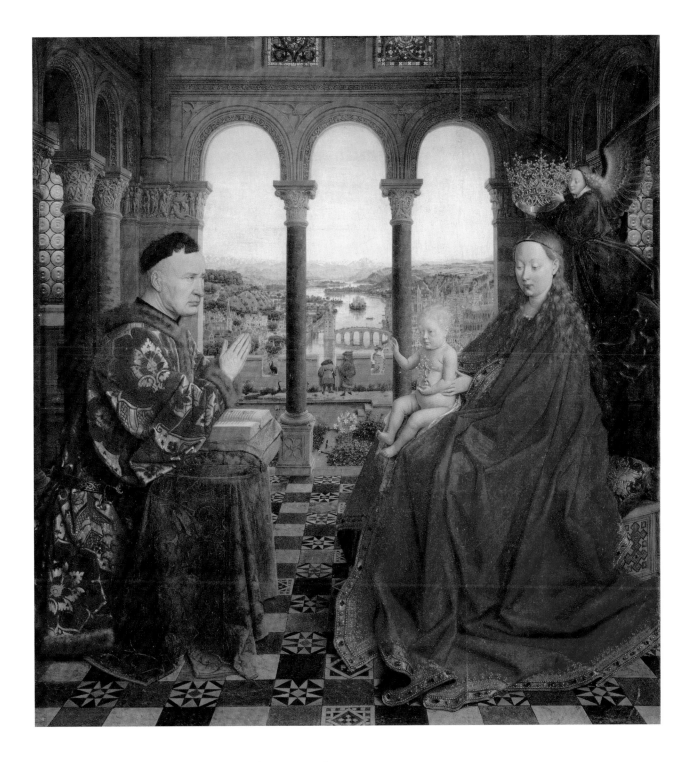

then strengthen the lines with ink or very thin paint, either egg tempera, distemper (glue tempera), watercolor, or oil, applied with a pen or small, pointed, sable brush and allow it to dry. The drawing was then isolated, and the absorbency of the gesso sealed by a layer of varnish. Sometimes a transparent toner was added to the varnish, in which case it was then called an *imprimatura*. The tone of the imprimatura set the key for the painting, making harmonization

of the colors easier and allowing for more accurate judgment of the values. A field of white tends to make everything applied to it appear darker than it is, until the white is completely covered, at which time it becomes apparent that the darks are too light. And when the darks are too light, generally the other tones are too light as well. By toning the isolating varnish so that the underlayer appeared somewhat darker than white (a warm tone was most commonly used), the artist could avoid or minimize this problem. The imprimatura could either be left to dry as an even layer covering the entire panel, or the lighter areas of the design could be wiped out with a rag wrapped around a finger while the imprimatura was wet.

The paints used by the early Flemish practitioners were made from powdered pigments ground in linseed oil. There is widespread speculation regarding whether other ingredients, such as resins, balsams, or various polymerized oils, were added, and the issue is not yet resolved. All opinions on this subject must be understood to be guesswork until scientific analyses have been completed on enough paintings from this era to settle the matter. In any event, the appearance of these pictures suggests that the brushing characteristics of the paints used by the early Flemish oil painters were *long*, rather than *short*[1]: paints ground in water-washed linseed oil exhibit long, rather than short, brushing qualities. (Water-washing of oils is discussed at greater length in chapter 7.) The addition of polymerized (sun-thickened or boiled) linseed oils also imparts long characteristics to oil paints, as does the addition of balsams and resins.

Long paints handle similarly to enamel and work especially well on smooth surfaces when applied with soft-hair brushes. Early Flemish painters used primarily soft-hair rounds, as can be seen in paintings of artists at work from that period. Some of these round brushes were pointed at the tip, some were rounded, and some were flat-tipped. Hog-bristle brushes were also used for certain purposes.

Once the isolating varnish or imprimatura is dry, painting commences with the application of transparent glazes for the shadows and other dark passages, in one method, or alternatively, with the filling in of the large shapes with their general colors, thinly applied. The painting is carried as far along as possible while the paint is wet, whichever variation of these methods the artist chooses to use, but is usually not finished in one sitting. Either large areas of color are applied after the shadows are laid in and worked together at the edges, or else the large expanses of color are laid in first, developed in a rudimentary manner, and then allowed to dry, to be refined later with glazed shadows and more opaque overpainting in the lights. The middletone colors may be either transparent, opaque, or somewhere in between, depending on the artist's preference. The highlights are added last and are always opaque, generally applied more heavily than the middletones. Several subsequent overpaintings may be applied after each previous coat is dry, if desired.

HANS HOLBEIN THE YOUNGER (German, 1497–1543), *The Merchant Georg Gisze*, 1532, oil on oak panel, 38 x 33¾ inches, Gemäldegalerie, Staatliche Museen zu Berlin, Berlin.

Holbein was among the northern European artists who adopted the early Flemish technique of painting in the sixteenth century.

Photo Credit: Bildarchiv Preussischer Kulturbesitz / Art Resource, NY

The preliminary composition was sketched in charcoal. It was then traced and transferred to a canvas. Here the charcoal line drawing is being strengthened with thinned burnt sienna alkyd-oil paint.

This shows the beginning of the color block-in of the background. The objective at this point is to cover the white with color. This is the quicker of the alternative ways of beginning a painting in the Flemish technique.

The color block-in stage continues. Next, the individual forms will be developed.

The form on the sleeve is being developed here with a transparent blue for the darker value, and mixtures of an opaque blue and white for the lighter values.

In this stage, the hands are being painted, along with the beginning of the shadow pattern on the face, with the model, Jo Adell, posing.

Facing page:
VIRGIL ELLIOTT, *The Fortune Teller*, oil on canvas mounted on wood panel, 36 x 24 inches.

The method employed might be considered a variant of the early Flemish technique. The darker darks were painted more transparently over the initial block-in colors, with the lights painted more opaquely. As a final refinement, judicious glazing was employed to intensify certain colors and to deepen the darkest darks.

Photo Credit: Dean Wilkendorf, The Lab, Santa Rosa, California

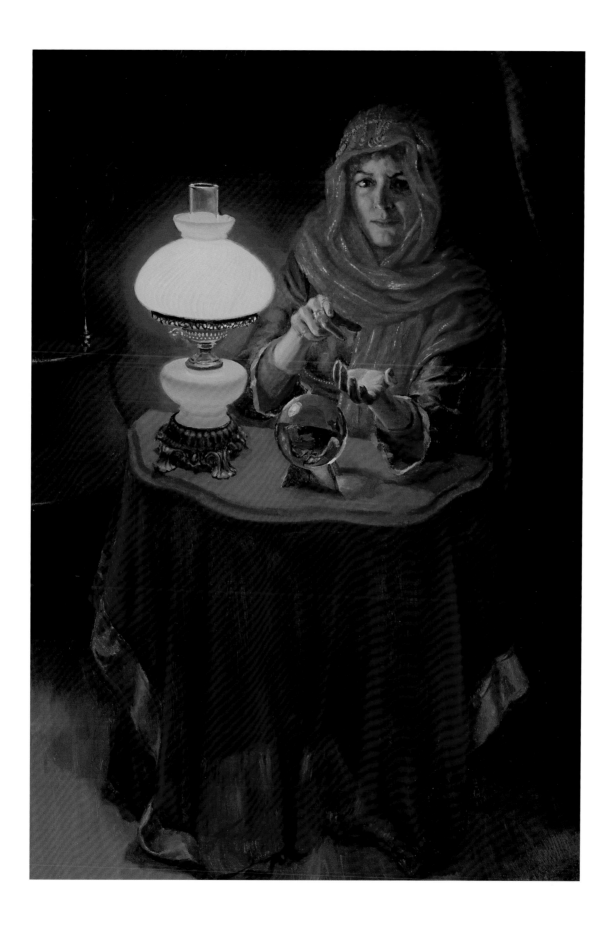

Some of the early oil painters also employed an underpainting of egg tempera, or egg-oil emulsion paint, to help establish the forms before painting over them in oils.[2] This underpainting could be in grays (grisaille) or in color. One method, held over from older, egg tempera practices, was to underpaint in green earth, leaving the white primer to represent the lights. Such an underpainting was referred to as a *verdaccio* in Italian. A variation would be to use white as well as green to develop the modeling of the forms more fully before overpainting in full color. A degree of subtlety was imparted to flesh tones with this type of greenish underpainting, which served to mute the superimposed reds, pinks, and yellows to a greater or lesser degree, depending on the degree of opacity/transparence of the overpainting layers.

In summary, the early Flemish method consists of painting transparent darks and opaque highlights over a precise line drawing on rigid wooden panels primed pure white. The paints were most likely of a long configuration. The innovations were the use of oil paint and the technique of glazing with transparent color, in combination with opaque painting. Paintings were generally small in size, owing to the difficulties involved in constructing, priming, and transporting wooden panels of greater dimensions. This method had its limitations, but it was a vast improvement over egg tempera, both in ease of execution and in the beauty and realism of the final result.

Although it originated in Flanders, word of the marvels of oil painting quickly spread, and it was soon adopted by the German Renaissance artist Albrecht Dürer, who is known to have traveled to Flanders and to Italy, and by Italian Renaissance artist Antonello da Messina, who studied in Flanders, according to Giorgio Vasari. Giovanni Bellini then (reportedly) learned it from Antonello, and taught it to Gentile Bellini, who then taught it to Venetian Masters Giorgione Castelfranco and Tiziano Vecellio (Titian). The Flemish painter Rogier van der Weyden, who was adept at painting in oils, came to Italy around 1449 and influenced a number of Italian artists, including Piero della Francesca. The use of oil as a painting medium was adopted cautiously by some, and derided by others, as anything new always seems to create controversy. Michelangelo preferred not to paint in oils (although there are a few oil paintings attributed to him) and reportedly ridiculed Leonardo for adopting it. Titian and other Venetian painters recognized its merits and soon added several innovations of their own.

The Venetian Technique

Titian and Giorgione, and/or their teacher, Gentile Bellini, are generally credited with originating what became known as the Venetian method of oil painting in the early sixteenth century. The Venetian technique is similar to the Flemish method in its use of transparent glazes for the darker darks, and for certain special effects, and in its use of opaque paints for the highlights, but it also differs from the Flemish technique in several important ways. It represents

Opposite:
TITIAN (TIZIANO VECELLIO) (Venetian, circa 1488–1576), *The Assumption of the Virgin*, 1516–1518, oil on canvas, 240 x 142 inches, Galleria Doria Pamphilj, Rome.

This is an excellent example of the kind of grand-scale paintings Titian was commissioned to paint, which we may presume compelled him to adopt stretched canvas as a support, and to devise a new method for painting in oils that would work well for large pictures.

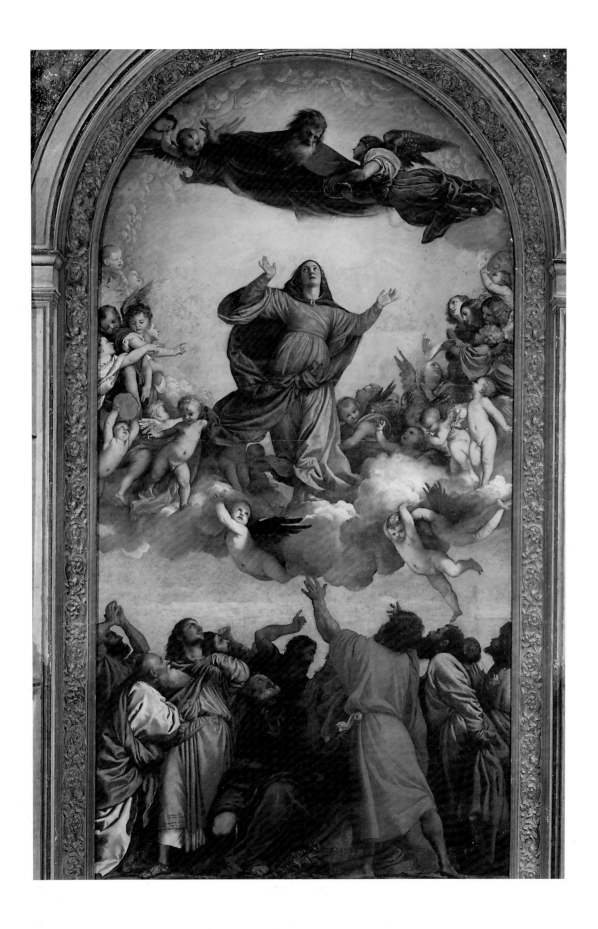

several evolutionary steps forward in the advancement of the capabilities of oil painting and of artistic knowledge and concepts as well. The technique proved to be so versatile that it was adopted and used to good effect by many artists throughout Europe in one variation or another for centuries. Among the Old Masters who used some form of the Venetian technique, besides Venetians themselves, were Peter Paul Rubens, Rembrandt, Johannes Vermeer, Frans Hals, Nicholas Poussin, Jacques-Louis David, Jean-Auguste Dominique Ingres, Jean-Léon Gérôme, and many other great Masters whose names are not well known today.

The Venetian method seems to have evolved from the early Flemish method out of necessity, as the church desired huge paintings of religious scenes for cathedrals, and wealthy dukes wished to adorn their palaces with similarly grand paintings of mythological themes and other subjects, including impressive portraits of themselves and their families in sizes much larger than the average Flemish panel painting. The difficulties involved in constructing and trans-porting wooden panels in the immense dimensions called for in the commissions for these huge paintings compelled artists to seek an alternative. Since Venice was a seaport, canvas was readily available in substantial sizes, its most common use at that time being for the sails of ships and boats. Canvas was soon adopted as the most convenient support for large paintings, as it could be rolled up and

JEAN-LÉON GÉRÔME (French, 1824–1904), *L'Eminence Grise*, 1873, oil on canvas, 27 x 39¾ inches, Museum of Fine Arts, Boston. Bequest of Susan Cornelia Warren, 03.605.

Gérôme was one of the nineteenth-century French Academic painters who used a variation of the Venetian technique. This painting appears to have been done over a gray underpainting.

Photograph © 2007 Museum of Fine Arts, Boston

transported and then reattached to the stretcher frame, or another of the same dimensions, at the painting's destination. However, the rough texture of the cloth created a need for certain adjustments in technique.

The gloss inherent in paints used in the Flemish method would have proven objectionable for large paintings, as it would render them hard to read if there were excessive glare reflecting from the surface. Thus it seems reasonable to surmise that Venetian painters might have endeavored to produce a less reflective surface. It is likely that they eschewed the use of polymerized oils, balsams, and resins, all of which increase gloss, and opted instead for simpler paints ground in raw oil only. The ideal paint would have been of a somewhat more short molecular configuration than the long paints of the Flemish. Scientific testing has indicated that Titian's paints were bound in linseed oil, with walnut oil reportedly found in only one painting. The Venetians surely would have found that stiff, hog-bristle brushes work better than soft-hair brushes in combination with short paint and rougher-textured canvas, which in fact they do.

The combination of large, stiff brushes, relatively short paint, and coarse canvas made the painting of hard edges difficult. Sharp edges occur quite naturally in the Flemish technique, with its soft-hair brushes, long paints, and smooth gesso grounds, whereas stiff hog-bristle brushes and shorter paints produce soft edges as a natural result on a coarse-textured primed canvas. We might presume that Titian (or perhaps it was Giorgione, his friend and collaborator, who died young) found the softer edges more to his liking and used them extensively, as they gave the visually agreeable effect of being slightly out of focus. The edges could be sharpened selectively, where desired, to call the viewer's attention to an area of greater importance or to describe an object whose edges were actually sharp, such as a starched collar, sword, or piece of paper or parchment. This perhaps inadvertent discovery of the visually pleasing aspect of soft and hard edges playing against one another constituted an important step toward the development of artists' understanding of the principle of selective focus. The systematic use of soft and hard edges together gave the Venetian paintings a more lifelike appearance and more closely approximated real-life visual experience than did the overall use of hard edges typical of the Flemish technique. It has been said that Titian might not have been quite as precise a draftsman as Michelangelo, who is reported to have criticized him for it.[3] If so, it's conceivable that Titian devised a technique that allowed him greater latitude for corrections, since he preferred not to begin with a carefully drawn linear design the way most artists did at the time but strove to develop his images in stages that allowed alterations to be made throughout the course of the painting process.

This technique involved the use of an opaque underpainting (or underdrawing, as some writers have called it, executed in paint with brushes right on the canvas), with the edges left somewhat soft and nebulous to allow for later

adjustments where necessary, which allowed the image to be developed in stages, as the painting progressed. Once the forms were established satisfactorily, the underpainting could be left to dry while the artist worked on other pictures. When dry, the underpainting could then be painted over, beginning with transparent glazes for the shadow areas, as in the Flemish technique, and developed further with opaque passages representing the areas of light, etc.

The underpainting, which is sometimes referred to as a grisaille if it is done in grays, generally works best when its darkest passages are painted somewhat lighter than the desired final effect, otherwise the superimposed colors will lose much of their brightness and depth.[4] Except for certain special effects, as in the technique of Rembrandt (discussed below), the texture of the underpainting should be as smooth as possible. Any brushstrokes not smoothed out before the underpainting is dry, or not scraped down before being painted over, will produce a problem area in the next stage. Artists who prefer visible brushstrokes should decide where to place them in the final stages of the painting, as accents.

In the Venetian technique, the underpainting, or certain parts of it, may be executed in opaque color, or, as has been mentioned already, in neutral grays. One popular variation was a monochrome composed of Venetian red and flake white. The underpainting palette is best limited to relatively lean paints (paints with low oil absorption), which are opaque and/or very high in tinting strength. High-tinting-strength fat paints (paints with high oil absorption) may be used if mixed with very lean paints such as flake white. The objective is to keep the underpainting leaner than the layers applied over it.

Color may be applied over the opaque underpainting initially as transparent glazes, which are then worked into while wet with opaque paints. In each stage of this method, the paint is worked together wet-into-wet until the desired effect is achieved or until the paint becomes slightly tacky, at which time it is allowed to dry thoroughly. This process may be repeated several times, if necessary, one layer over another, at the painter's discretion.

The highlights are placed last, applied wet-into-wet with a fully loaded brush. Impasto is often employed in the highlights, to produce the most opaque passages possible and to ensure that they remain opaque. Oil paints become more transparent with age. Therefore, for the highlights to retain their opacity over the centuries, they must be applied heavily. The illusion thus created is that of direct light falling on a solid surface, ricocheting from that surface to our eyes. It is not actually an illusion, though, as that is exactly what is happening. When the highlights are juxtaposed with the transparent shadows and deeper foreground darks, the illusion of depth is enhanced.

At some point, someone among the early painters working in the Venetian technique discovered that a light, opaque tone, rendered semitransparent by the

addition of a bit more oil, perhaps ground glass, and/or by simply scrubbing it on thinly with a stiff brush, applied over a darker area, produced an effect that could be put to good use. This lighter scrub in, which today we call a scumble, over a flesh tone produces the same effect as powder on a woman's face—that is, it made its texture appear softer. This is a useful device when painting the complexions of women and young people of both sexes. It is also useful for indicating atmospheric density over distance, or atmospheric perspective. Both glazing and scumbling create optical illusions, complex visual phenomena, that served to expand the capabilities of the limited palette of the early painters in oil and enhanced painters' artistic vocabulary fairly dramatically.[5]

Glazing is the application of a darker transparent paint over a lighter, usually opaque, underlayer. The optical sensation created by glazing is unique and cannot be obtained in any other manner. A sort of glow is created, and the color thus produced appears warmer in color temperature and more saturated (higher in chroma) than when the same pigment is applied more thickly and opaquely. The effect, in the darker passages, is that of a shadow seen at short range, with no discernible atmosphere between it and the viewer's eyes. The rich, golden glow in Rembrandt's dark browns was produced in this way.[6] Glazed darks appear darker than opaque darks, because the light rays are allowed to penetrate more deeply into the paint layer and are thus subjected to a certain amount of filtration before reflecting back out to the viewer's eyes. This effectively extends the value range possible with paints. Oil paints, indeed any kind of paint, are handicapped on the light end of the spectrum by the fact that white paint is never going to be as light as light in nature. And since light contains color, the artist must make the highlights darker than white in order to include color in them. This further limits the value range and makes it necessary to darken all the tones to some extent in the interest of maintaining the proper degree of contrast and relationships between each category of light or shadow. The Old Masters dealt with this by carrying their darks as far toward the dark end of the scale as they could, to create as wide a range of values as possible. This can only be accommodated through the use of transparent paints on the dark extreme. Transparent darks allow the expansion of the dark end of the value scale. Glazing can also be used for subtle modifications of color and to create a number of special effects.

Scumbling is essentially the opposite of glazing. A scumble uses a lighter opaque paint, spread thinly enough so as to become translucent, over a darker passage. The optical effect thus produced is cooler—in other words, very slightly bluer (except, of course, where the underlying color is already blue) and less saturated than the paint applied, as the underlying layer is not completely obscured and thus exerts its influence on the overall sensation. Scumbling is very effective in softening textures, such as soft cloth (such as velvet), youthful complexions, or the surface fuzz of a peach. It is very useful for indicating atmospheric haze over distant land planes and in the sky near the horizon. Overcast skies may be scumbled all over, as in Bouguereau's *The Broken Pitcher*, shown on page 106.

This drawing, created using charcoal, Wolff's carbon pencil, white chalk, and white conté on gray mat board, was executed in 1987 as a preparatory study for the painting of Annie Lore (now Mrs. Elliott).

Study for *The Songstress* with an acetate grid overlay for scaling up to a larger canvas size.

At this point, the linear design has been transferred to the canvas via grid; the drawing has been refined freehand, and then strengthened with thinned burnt sienna oil paint with a little ultramarine blue added.

This small sketch was executed quickly from imagination, to work out the color scheme for the larger painting.

Facing page:
VIRGIL ELLIOTT, *The Songstress*, 1988, oil on canvas, 40 x 27 ¼ inches.

This painting was painted using a variant of the Venetian technique employed by Giovanni Bellini. In the shadow areas, the color is thinly applied and transparent or translucent to a greater or lesser degree, depending on the degree of light, with the underpainting showing through and influencing the final effect, while the areas indicating direct light are painted opaquely in full color, over the gray underpainting. Stronger secondary light was painted with opaque paints into wet shadow glazes. Final refinements included both glazing and scumbling, as well as solid opaque painting.

Photo Credit: Laura Stilson

There are still more advanced and sophisticated tricks with the Venetian technique. The semiglaze, which can be transparent, semiopaque, or somewhere in between, is a very thin application of color to an area that is the same value as the paint being applied. Its purpose is to modify the color of a given area after that area is dry, as in the addition of a tiny bit of a brighter red tone to a cheek or nose or to allow subsequent wet-into-wet painting over an area where the paint has dried. It tends to soften unintended overly harsh transitions of tone from the previous sitting, if used properly, and thereby adds a higher degree of refinement to the image. A semiglaze is applied thinly, by scrubbing it on with a stiff brush, to lubricate the dry surface of the area to be repainted. Titian is reported to have sometimes applied glazes, scumbles, and semiglazes with his fingers, or perhaps he was wiping the excess away after having put too much on with a brush. Stippling (applying small amounts of paint in a dabbing motion with a flat-tipped brush held perpendicular to the canvas) is a

good technique for applying glazes, scumbles, and semiglazes, although other means work very well in skilled hands.

Ground glass has recently been found in the paintings of various Old Masters, including some of the Venetian painters of the sixteenth century: Rembrandt [7] and Velázquez presumably used it to add transparence to certain passages, such as glazes and scumbles. Just how widespread this practice was in those times is not known, but the discovery is an intriguing one.

The Venetian technique allows the widest range of possibilities of any oil painting method yet developed. Its systematic use of opaque passages, glazes, scumbles, and semiglazes stretches the capabilities of oil paint to the absolute limits and allows the artist the greatest latitude for adjusting the picture at any stage. The effective use of the optical illusions created by glazing and scumbling, combined with the control of painted edges (which simulates selective focus), enables the oil painter who has mastered these techniques to indicate three-dimensional reality more convincingly than is possible with any other technique.

It should be stressed that the wonderful results achieved by the Old Masters and other great painters were at least partially attributable, in many cases, to the preparations undertaken prior to their beginning work on the final canvas or panel. The concept for the painting, at least where more elaborate designs were concerned, was generally worked out in smaller drawings, sketches, and studies done on separate surfaces, to solve most or all of the problems to the artist's satisfaction before work began on the large canvas. This accounts for the impression most often conveyed by their paintings—that they were executed perfectly, flawlessly, and without the need of corrections. In truth, there were often corrections, but the major ones, at least, were usually done in the study stage before the painting itself was touched. The underpainting stage also allowed for alterations and adjustments before the finishing layers of color were applied.

For very large paintings, the Master would sometimes paint a *modello* first on a smaller scale to work out the composition and then turn it over to his apprentices to have the design transferred to the large canvas by means of a grid. (See page 80 for an example of how to use a grid.) The Master could oversee this process and might have corrected and completed each stage after the students and/or apprentices had done most of the work. In some cases, the smaller painting was done without color, to guide his assistants in applying the underpainting to the large canvas. Often the Master also drew and painted many supplemental studies, either to aid the assistants in painting the large picture or to solve some of the problems for himself, in the development of the concept for the painting. These practices were as much a factor in the excellent quality achieved in the works produced by these great painters as were the actual painting techniques they used so well.

FRANS HALS (Dutch, circa 1582/1583–1666), *Marriage Portrait of Isaac Massa and Beatrix van der Laen*, circa 1622, oil on canvas, 55 x 65 ½ inches, The Rijksmusem, Amsterdam.

This may be presumed to be one of Hals's commissioned portraits, in which he carried the faces and hands to a higher degree of finish than in the sketchier works for which he is more widely renowned. The faces, at least, appear to have been done in stages, in a variation of the Venetian technique, with underpainting and then subsequent development involving scumbling and perhaps limited glazing. Hals's special talent was to make his subjects seem like people we know and like, and the impression comes through that he seems to have liked them himself.

The Direct Painting Technique

The direct painting method differs from the Venetian and Flemish techniques in that the artist paints in full color from the very beginning, without any elaborate underdrawing or underpainting, and without resorting to the use of glazes or scumbles. All paints except the deepest darks are generally used as if they were opaque and are usually applied heavily enough as to appear so. The object, ideally, is to paint the entire picture wet-into-wet, from start to finish. Terms such as *alla prima* (Italian) or *premier coup* (French) are sometimes used for this technique, indicating that the picture is to consist of one layer of paint, applied all at once, in one sitting. In practice, this is not always possible, and great pains must then be taken to nonetheless make it appear as if the painting were done *alla prima*, if that aesthetic is the one preferred.

Many of the Old Masters employed the direct painting technique for sketches, to be used as visual aids when creating larger works in the Venetian method or a variant. Frans Hals was the first artist to use this technique for works other

JOHN SINGER SARGENT (American, 1856–1925), *Trout Stream in the Tyrol*, 1914, oil on canvas, 22 x 28 inches, Fine Arts Museums of San Francisco. Bequest of Isabella M. Cowell to the California Palace of the Legion of Honor, 1951.24.

This is a fine example of *alla prima* plein-air painting by a master of the genre.

JOHN SINGER SARGENT (American, 1856–1925), *La verre de porto (A Dinner Table at Night)*, 1884, oil on canvas, 20¼ x 26¼ inches, Fine Arts Museums of San Francisco. Gift of the Atholl McBean Foundation, 73.12.

than sketches, although some of the paintings for which he is famous today may still arguably be called sketches. Hals was proficient in more highly refined techniques as well, including the Venetian technique, as can be seen in his commissioned portraits of prominent, respectable citizens (at least in the faces).

The range of effects possible with direct painting was once much narrower than that of the Venetian technique. However, today's wider selection of pigments has expanded its possibilities considerably over what was available in earlier times. The invention of the cadmium pigments and synthetic ultramarine, among other new colors introduced in the nineteenth century, made direct painting a more viable alternative to the Venetian technique than it had been previously. The direct painting technique was elevated to legitimacy in the nineteenth century by Carolus-Duran, who was also the teacher of John Singer Sargent, and subsequently by Sargent himself, among others—most notably Anders Zorn, Cecelia Beaux, and Joachin Sorolla y Bastida.

Sargent's work in oils exemplifies the direct painting technique. His approach was not met with instant approval in France, but was appreciated much more during his lifetime by the British and Americans.

Individual approaches to the direct painting method vary greatly. Some artists prefer to begin in charcoal with a few quick guidelines sketched freehand on the canvas before beginning to paint, while others choose to begin immediately with the brush, sketching in the shapes initially with thin paint to indicate the shadow masses. Some painters tone the canvas beforehand with a very thin imprimatura, applied transparently over the white ground/primer, to "kill the white," which might otherwise influence them to paint their darks too light a value. Others prefer to paint directly on the white of the primed canvas. And still others tint the primer/ground to a value darker than white by adding paint or pigment to the final coat of primer/ground to create an opaque tone somewhat darker than white.

A toned ground or imprimatura makes judgment of values a bit easier. However, it is usually better not to make the tone too dark. Painting on an opaque primer darker than a value 7 on the Munsell scale will make the superimposed colors duller and will cause the painting to darken in time. It is better to use a white primer and add a transparent tone over it to lower the value initially, or to add a light opaque tone over the white primer. A transparent toner can be painted into immediately, while it is wet, or allowed to dry before commencing. To do so with the opaque toner, however, would not work as well, because it would contain white, which would lighten the darks painted into it. So it is best to let the opaque toner dry before painting on it.

As with the Flemish and Venetian methods, darks should be applied first, and thinly. The reason for this is that the design is indicated reasonably well with just the dark shapes and shadows, and corrections may be made without excessive paint buildup by simply wiping out mistakes with a rag or cheesecloth. The early stages of a painting are the most likely to require corrections, so it is prudent to begin thinly. This also allows a certain degree of transparence in the shadows, which is desirable on the dark end of the spectrum. Oil paint is most easily controlled by painting wet-into-wet, from dark to light, systematically. As the reader has surely discovered at one time or another, attempting to indicate a shape haphazardly, beginning with a middletone or light color, soon results in a sea of wet paint into which everything disappears as soon as it is applied. This is called mud. The mud experience has discouraged many would-be oil painters over the years. It is simple enough to avoid, if one proceeds methodically, following a logical progression.

It is advisable to begin the painting process with a substantial-sized brush and block in the large general shadow and other dark shapes first, before adding a second color. The major color shapes in the middletones and lighter shadows should be blocked in next, using another large brush. At this point we may work back into the shadows and add secondary light, reflected color, and shadow accents and then return to the middletones and add refinements there, saving the lighter areas and finer details for last. The lights should be painted

Virgil Elliott, *Italian Fisherman,* **2002, oil on canvas, 16 x 12 inches.**

This was a workshop demonstration, painted *alla prima* in one sitting. It began as a demonstration of how to do a color sketch, but it went well, and the students insisted on seeing the eyes put in. It was done with a limited palette.

more thickly than the darks. Large brushes cover more canvas in a given time, hold more paint, and allow the artist to paint much faster. The use of small brushes and the introduction of detail should be forestalled as long as possible. Many agreeable effects can be created through expert use of a large brush, especially in areas where one might be tempted to switch to a smaller one.

Facility in the direct painting method is developed by executing studies from life, meaning from direct observation of the subject. Since they are only studies, there is no pressure to create a masterpiece, and the student is free to experiment. After a bit of practice, the studies become more and more accurate, as the student's ability to perceive value and color is developed to a higher degree and the initial awkwardness with the brushes and paints is overcome.

It is helpful to isolate value in one's first attempts at painting in oils, working only with white and grays made with ivory black and white. Once the student is past the struggling-with-the-paint stage and has learned to understand values, color may be introduced a little at a time. The first colors to be added to the black-and-white palette should be yellow ochre (or raw sienna) and red ochre.[8] With these four colors it is possible to mix what appears to be a full range of colors. The limited palette is only effective in paintings that have an overall warm tonality, in which context grays made with ivory black and white appear to be blue. Greens are made from yellow and black, or yellow, black, and white, and violets are mixed from black and red, or black, red, and white. Browns are made from black, yellow, and red. An automatic unity is thus achieved, as the cool colors produced in these mixtures are low in chroma and cannot disrupt the harmony of the warm dominance created by the prevalence of stronger reds, yellows, and browns.

As the student becomes familiar with the limited palette, and more confident in its use, the palette is then expanded gradually by the addition of burnt sienna, raw umber, and cadmium red light, or cadmium vermilion. At the appropriate point, ultramarine blue is added, and so on, so that no lesson over-whelms the student with too much new to learn at once.

It must be stressed repeatedly during the early sketch sessions in oils that only the large shapes should be painted and large brushes used. No detail should be attempted until the student is able to judge the correct value, color, shape, and relative proportions of the large shapes of shadow and light accurately. By then, the powers of observation will have been developed highly enough that the rendering of detail will be easier, and, hopefully, bad habits will have been unlearned. Through this method of learning, one gains the necessary skills for painting well in oils, in any technique.

The direct painting method is the one most widely used in modern times. The vast range of pigments available today has, in great measure, narrowed

VIRGIL ELLIOTT, alla prima sketch of *Linda Morris, aka Ethnic Woman,* 2002, oil on canvas, 24 x 18 inches.

Linda has an unidentifiable ethnic appearance; hence, the title. This was painted as a workshop demonstration *alla prima,* direct painting, done while teaching a class.

The model is posed in a warm light. The general shape of the shadow is blocked in thinly on a coarse-textured linen canvas primed with white lead tinted with burnt umber oil paint for a light pinkish-brown. The shadow color is a mixture of flake white, ivory black, and raw sienna.

A dark, transparent brown is laid in for the shape of the hair. A cool gray is being scrubbed in for the background. So far, only large brushes have been used.

After a dark blue-gray is laid in to cover the ground in the shirt area, general middletones in the face and neck are applied, along with a few strokes for the moustache and eyebrows.

More dark is added for the hair, and for the darker areas in the shadows on the face and neck. A few strokes of darker blue-gray are made in the shirt.

The face is developed with the introduction of more light. One eye is wiped out in order to repaint it in a slightly different spot.

Opposite:

VIRGIL ELLIOTT, *Portrait of Stan Wells,* 2006, oil on canvas, 24 x 18 inches.

This portrait was painted from life, with no underpainting or preliminary drawing. Large hog-bristle brushes were used throughout, with smaller brushes brought into play only at the very end for adjustments in the eyes and nostrils. The cool gray background color initially laid in was replaced early in the process with dull greens made from yellow ochre and ivory black. Very little work was put into the shirt, which consists of just a few strokes laid into the blocked-in general shape.

Photo Credit: Dean Wilkendorf, The Lab, Santa Rosa, California

the gap between what is possible with it and with the Venetian technique. It is also possible to modify the direct painting technique by finishing off with glazes and/or scumbles after the painting is dry, but it then ceases to be direct painting. Some styles of direct painting owe their appeal to the painterly looseness obtained when painting very quickly with large brushes. For this type of painting, superimposition of glazes and scumbles would in most cases be inappropriate. In practice, the boundaries between techniques become blurred as artists combine elements of more than one method in pursuit of the desired effect. This is how new techniques are born.

The Bistre Method

The *bistre* method, sometimes called the "wipe-out method," is an alternative way of beginning a painting. Its name derives from the brown pigment that was originally used in this approach, but since that pigment is problematic from an archival standpoint, its use has fallen by the wayside in favor of more stable browns. As with some of the techniques previously described, it begins with a white-primed canvas or wooden panel. This approach differs from the others in that the artist begins by covering the entire canvas with a brown tone and then, using a rag, cheesecloth, or other tool,[9] wipes the paint from the areas intended to represent the lights. The image develops very rapidly in this manner, as the patterns of dark and light are established almost immediately. Corrections are easily made, either by adding more brown or by wiping out the lights where needed. From this point on, the artist can proceed in a number of different ways, utilizing procedures inherent to the Flemish, Venetian, or direct painting techniques.

The first and simplest option is to develop the brown stage to such a degree that it can serve as an imprimatura. Once the image is deemed satisfactory for this purpose, the brown layer may be left to dry and then later painted over in color. If this is the intention, high-oil-content browns (such as umbers) will contain too high a percentage of oil for optimal longevity. It is therefore advisable to add some flake white to the brown before applying it to the canvas, as the flake white will improve the pigment-to-oil ratio and add physical substance to the mixture. Rembrandt employed this practice (adding lead white to the browns of the initial lay-in), and thus far his paintings have generally withstood the ravages of time better than those of his contemporaries.

The second, and perhaps preferable, option after the lights have been wiped out is to paint the lights in opaquely while the brown is still wet. This would enable the artist to render the forms more solidly, using flake white and mixtures of flake white and brown for warm grays, or flake white with black for cool grays, in the development of the light areas with opaque paints. A more highly refined image is thereby created in monochrome. This may then be allowed to dry and used as an underpainting for the Venetian technique.

After the entire canvas is covered with dark brown oil paint, line drawing is done with a sharpened paintbrush handle used as a stylus, scribing the lines into the wet paint.

The light areas are indicated by wiping the brown from wherever there is to be light, using dry cheesecloth or other rag wrapped around a finger, cotton swabs, dry paintbrushes, or paintbrush handles.

VIRGIL ELLIOTT, *Working Steel*, 2007, oil on canvas, 30 x 24 inches.

This is the end of the monochrome stage. One could now proceed to paint with full color, wet-into-wet, or allow the monochrome to dry, and use it as an underpainting.

Photo Credit: Dean Wilkendorf, The Lab, Santa Rosa, California

A third alternative is to apply the uniform brown layer, wipe out the desired white areas as before, and then paint into the wiped-out lights in full color while the brown is wet, developing the picture *alla prima*, wet-into-wet. When taking this approach, it might be better to employ a slower-drying brown than raw or burnt umber, perhaps a deep brown ochre or a mixture of other pigments to create the desired tone. Alternatively, the initial tone could just as well be something besides brown, for that matter. The painting can then be finished in whichever manner suits the painter's intentions.

Innovations of Rembrandt

The seventeenth-century Dutch painter Rembrandt Harmensz. van Rijn, whom many consider the greatest artist of all time, learned all that was known about oil painting while still a very young man and then proceeded to add his own discoveries to the technical knowledge of his time. To this day Rembrandt's best works remain unsurpassed and serve as inspiration to those of us who paint. This being the case, any book on advanced techniques must address Rembrandt separately and at such length as the author's knowledge allows.

What technical information Rembrandt was taught may be discerned by examining the works of his instructors: Jacob Isaacsz. van Swanenburch and Pieter Lastmann. Such study immediately shows the genius of Rembrandt by the extent to which he so obviously surpassed them both and by how early in his career he did so. Nonetheless, his training under them was an important factor in his artistic development and should not be minimized, as both teachers seem to have possessed a working knowledge of the painting methods in use at that time. Various examples of Rembrandt's work show that he was not limited to any one technique but employed them all, the choice depending on which approach best suited the subject in question and for what purpose the painting was intended. His facility with all of the aforementioned methods of painting soon led him to combine aspects of one with another and to add innovations of his own.

Some of Rembrandt's paintings are on wood, executed in what appears to be essentially the Flemish technique, although painted more freely than was the norm with the Flemish; some small studies on wood panels were done in a variation of the direct painting technique; and some on canvas were created using methods similar to the Venetian and direct techniques. The first layer of primer for the panels is one or another type of glue-chalk gesso, sanded to smooth out the irregularities of the panel's surface. Subsequent layers might consist of finer-textured chalk bound with hide glue, or white lead oil paint. The final layer was usually covered with a transparent brown imprimatura, which creates the golden glow characteristic of his work. The majority of Rembrandt's canvases are primed with a double ground, the first layer of which is a red-orange ochre bound in oil, perhaps to fill the texture of the canvas, and the second a gray made from *lootwit* (lead white with chalk, ground in linseed oil) and one or more other pigments.[10] Clues as to Rembrandt's choice of primer may be seen in areas where

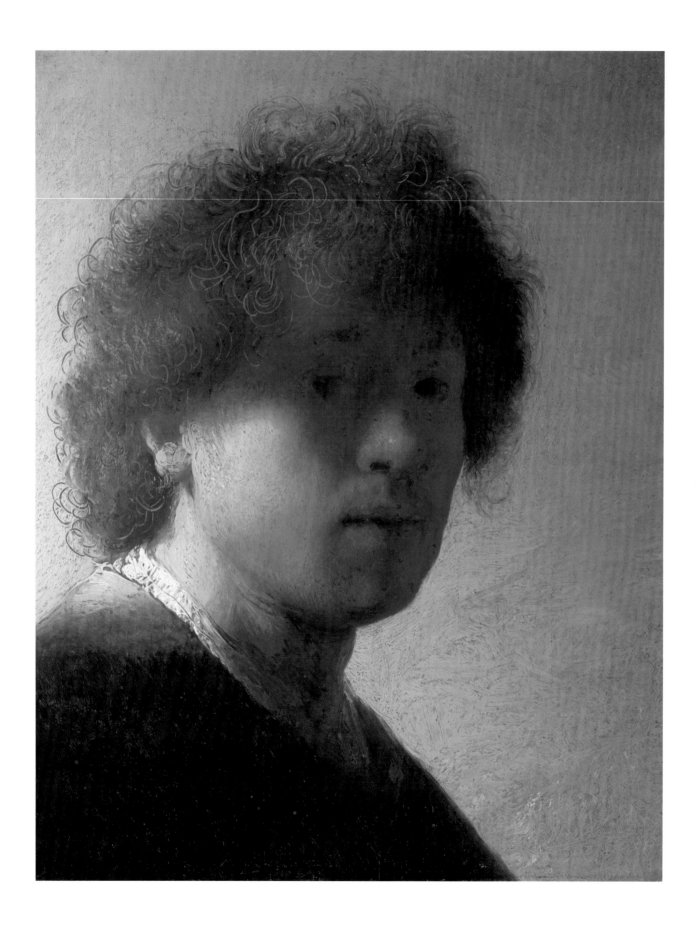

he has used a sharpened brush handle to scratch through wet paint in order to indicate bits of hair. This is evident in a very early self-portrait from 1628, now in the Rijksmuseum, and in many other portraits as well. The primers and/or imprimaturas thus revealed show that he followed no one single procedure but varied the choices, based on the effect he was after. The scratching with a sharpened brush handle into wet paint was one of his early innovations.

Rembrandt was an exceptionally versatile artist who did not follow the same procedure every time. It's fairly obvious, to the educated eye, that he thought his way through each painting, from the genesis of the idea to the last brush-stroke, never lapsing into a routine approach. From unfinished pictures, we know that, at least sometimes, he began in transparent browns, working in monochrome to establish the design of the picture, attending to the masses of dark and light. He often used opaque white for the strongest lights at this stage, in his version of an imprimatura.[11] This stage was apparently left to dry at this point before further work was done, although there may well have been exceptions. Over the dried brown underpainting, Rembrandt began adding color, working from the background forward rather than working over the whole picture at once. He exploited to the fullest the qualities of transparence and opacity, relying on the underglow of light coming through transparent color for many special effects, building up opaque lights more heavily for the brightly lit areas, sometimes modifying colors by means of subtle glazes, semiglazes, or scumbles, and arranging transparent darks and opaque lights to play against one another for maximum visual impact and depth.

Early in his career Rembrandt began building up the opaque passages in his lights more heavily and texturing them to take on the physical convolutions of the lighted surfaces of his subjects, most notably the skin textures of male subjects, including himself. Exactly how he created this texture is not known with certainty. It can be duplicated, or at least approximated, by building up a somewhat thick layer of opaque paint and then passing a soft brush over the surface while it is still wet. At some point Rembrandt began to superimpose glazes of red over these textured passages when they were dry and then wipe them off with a rag, leaving traces in the low spots to create an even more convincing texture of rough flesh. A contemporary once said that a Rembrandt portrait could be picked up by the nose.

As Rembrandt began to expand the effect of glazing over dried impasto to include other textures, he devised a method of employing two different whites—one for impasto and one for smoother passages. The latter seems to be composed of a high grade of white lead, ground in unheated linseed oil or, less frequently, walnut oil. The impasto white would have been the faster drying of the two, perhaps made so by the addition of chalk and/or ground glass (possibly finely ground smalt).[12] It was very lean and consisted mostly of white lead with a minimum of binder. He began applying it more and more

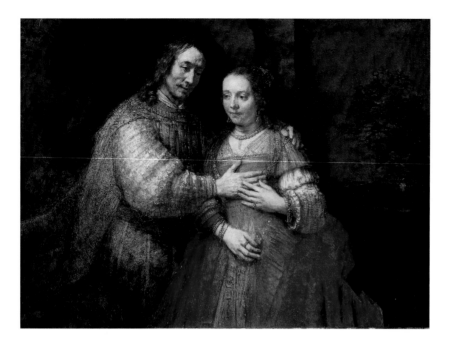

heavily as the first stage of a two-stage (or more) operation, which was finished with transparent glazes and wiping. This technique created fantastic special effects, the most extreme example of which is the man's glowing, golden sleeve in the painting referred to as *The Jewish Bride* in the Rijksmuseum in Amsterdam. This astonishing effect cannot be achieved in any other way.

Rembrandt used the same technique on the bride's costume in the same painting, but here the underpainting contains vermilion, which is deepened with a glaze of a red lake, carmine (cochineal), and ground glass bound with linseed oil. The red carpet on the table in *The Syndics of the Drapers' Guild* (sometimes called *The Dutch Masters*), also in the Rijksmuseum, was done in much the same way, but with an earth red probably used in place of vermilion. The impasto underpaint appears to have been trowelled on with a knife or some sort of flat stick and then sculpted before it dried.

It appears that Rembrandt worked into the underlayer with sharpened brush handles and other tools while the paint was soft and then allowed it to dry before applying the darker glazes. By wiping the glazes off as soon as they were applied, leaving them only in the nooks and crannies, Rembrandt was able to create a bas-relief effect of remarkable three-dimensionality. By glazing these areas again, this time with transparent yellows and/or browns, instead of ivory black, Rembrandt gave the textures a rich, sparkling, golden glow. In *The Night Watch*, Rembrandt used this method, but with less heavy impasto, for the ornate brocade work on Lieutenant Ruytenburch's yellow tunic.

Scientific analyses have provided some major revelations about Rembrandt's working methods and materials. A number of reports indicate that he added

Above left:
REMBRANDT HARMENSZ. VAN RIJN (Dutch, 1606–1669), *The Jewish Bride*, 1665–1669, oil on canvas, 47⅞ x 65½ inches, The Rijksmusem, Amsterdam.

This is the most notable example of Rembrandt's innovation of creating optical illusions through the use of glazes applied over thickly textured impasto underpainting.

Above right:
Detail from *The Jewish Bride*.

This close-up view of the man's sleeve shows the texture. Notice the remarkable effect created by glazing over the heavily textured impasto underlayers. This effect cannot be gotten in any other way.

body and transparence to his glaze-like passages by mixing in chalk and/or ground glass. The chalk functions as an inert, and essentially transparent, pigment when mixed with oil, and it also serves to enhance the drying characteristics of white lead and other paints. The glass most likely would have contained lead and/or cobalt, both of which are drying agents.[13] The glass, which likely also functioned as a bulking additive, among other functions, may have been ground leaded glass (crystal) or a low grade of smalt.[14] The latter is less blue and lower in tinting strength than the better grades of smalt, so it could be mixed with any color without altering its appearance noticeably. Rembrandt also appears to have used another blue pigment, azurite, as a drier, added to paints whose pigments normally dried more slowly in oils, including ivory black and madder lake in particular.

From the eighteenth century up until the last few years, painters and writers could only speculate on what sort of medium Rembrandt used to achieve his

REMBRANDT HARMENSZ. VAN RIJN (Dutch, 1606–1669), detail of *The Officers from The Militia Company of Captain Frans Banning Cocq and Lieutenant Willem van Ruytenburch* (aka *The Night Watch*), 1642, oil on canvas, 149⅜ x 178½ inches, The Rijksmuseum, Amsterdam.

Rembrandt sculpted the brocade trim on the lieutenant's yellow tunic with impasto and then glazed over it when it was dry. He wiped the glaze off from the high spots and allowed it to remain in the depressions for a heightened bas-relief effect. He may have done this more than once.

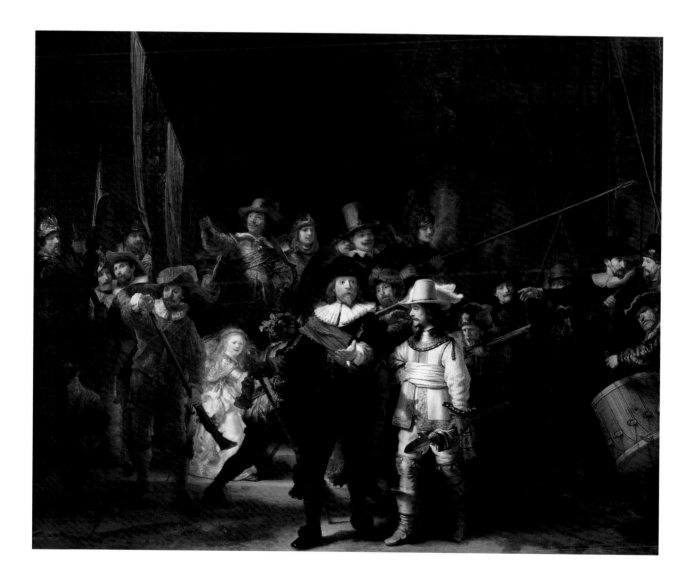

startling and unusual optical effects, with nothing more to go on than appearances. On this basis, just about everyone assumed that there had to be resins, and perhaps exotic blends of oils cooked with lead and/or various varnish resins, as media in Rembrandt's paints. Some suggested wax as another possible ingredient, again based solely on visual analysis. Modern science has recently made some discoveries that shed more light on this issue, and we now have a much clearer, albeit not totally conclusive, picture. The binder detected, according to the most up-to-date scientific analyses, is linseed oil in the vast majority of the many paint samples analyzed, with few instances of it being heat-bodied. Walnut oil was sometimes found, but in most instances it was linseed oil, with no wax, no resins, no exotic alchemy concoctions. In a few samples, some of the oil is reported to have been "heat-bodied," as in perhaps boiled or stand oil. It is possible that these were added to the paints in which he wanted a long brushing quality, and perhaps in some of his glazes. Reinforced with chalk for body, and ground glass for body, faster drying, and perhaps transparency, these appear to constitute Rembrandt's glazing media, as nearly as is discernible by the present level of scientific knowledge. A resin or balsam, as yet not identified as to specific type, but tentatively suspected to be pine resin, has recently been detected as the vehicle in one sample from the brown glaze on the man's sleeve in *The Jewish Bride*.[15] Subsequent tests may well bring new information to light that bears on Rembrandt's glazing media.

Rembrandt's palette consisted of a black (perhaps bone black or ivory black, less frequently charcoal), a number of earth colors (ochres, siennas, and umbers), Cassel earth, lead-tin yellow, occasionally vermilion, a number of yellow and red lakes, high-grade smalt (used as a blue), azurite, flake white (*schulpwit*—i.e., lead carbonate without chalk), and *lootwit* (lead carbonate with chalk). His brighter reds are more frequently earth reds, intensified with red lake pigments, although he sometimes used vermilion. Rembrandt often intensified and brightened his earth yellows with yellow lakes in the same way. In Rembrandt's method, the evidence indicates that drying was accomplished by adding fast-drying pigments to his mixtures where they were needed. The principal pigments used for this purpose were smalt, azurite, umbers, and white lead.

Innovative special effects aside, Rembrandt's basic technique was much the same as that of his contemporaries. He painted the lights most opaquely, employing thick impasto highlights from a heavily loaded, somewhat large, hog-bristle brush, while he rendered the deepest darks more transparently, adding dark opaque touches in those areas while the larger, transparent dark masses were still wet. He generally painted the lighter shadow areas with opaque paint but applied it more thinly than the lights. He adjusted edges for their proper degree of softness or sharpness while the colors on both sides of them were wet. The highly refined imagery of Rembrandt's younger days

gradually gave way to a rougher, more painterly finish in his middle and later years, perhaps owing to changes in his eyesight, but his basic methods of working remained essentially the same throughout his life.

Rembrandt probably had at least one life-size jointed mannequin, on which he would pose the clothes of his sitters. The mannequin, unlike a living person, would remain motionless for as long as was needed to paint the clothing, the folds of which would remain essentially undisturbed for days, or weeks, if necessary. By contrast, a live sitter would have to visit the bathroom, eat, sleep, move around, etc., after any of which the folds of the cloth would never be likely to resume their previous shape. The use of the mannequin may or may not have been Rembrandt's innovation, but it was, and is, a good idea regardless.

Technical issues, however, are not the essence of Rembrandt. Of the unique attributes that elevated him above all other painters of his time, perhaps among the most significant was his complete mastery of selective focus, or *houding*, as the Dutch term it. Rembrandt demonstrated mastery of that particular aspect of image making so completely that it set him apart from everyone who preceded him, and most of those who followed, with the possible exception of Johannes Vermeer of Delft, whose understanding of that principle was shown to equal Rembrandt's. There is a possible connection between them, in that Carel Fabritius, who had studied with Rembrandt, lived in Delft, and undoubtedly knew Vermeer. But beyond selective focus, Rembrandt had the most profound sensitivity and perceptivity into human emotions, an empathy that charged his portraits with the thought-provoking psychological depth that is universally considered his trademark, his most distinguishing characteristic. That is not something one can get from reading a book about painting.

We cannot expect to be able to rival the great genius of Rembrandt merely by following some of his procedures and using the same tools and materials he used. These are only a small part of his brilliance as an artist. At the core was his intelligence and artistic sense, his ability to constantly strive to improve upon what he had already done without losing sight of the original concept for the painting, and to devise techniques, on the spot, that would create the effect he desired. We might hope to achieve our own personal best results by adopting this same attitude toward our work, rather than by attempting to reduce to a simple formula the methods of a great genius whose works we admire and then following it, unthinking. This is not meant to disparage technique but to show it in its proper context. The more we know of technique, the more effects we have at our disposal to serve our creativity and inspiration in the execution of our finest conceptions. If there is anything remotely approaching a formula for creating great art, it might be stated as the combination of knowledge and intuition in a single endeavor, plus a lot of work.

The Technique of William-Adolphe Bouguereau

The nineteenth-century French academic painter William-Adolphe Bouguereau is widely acknowledged as having possessed a mastery of technique nearly equal to that of Vermeer at his best. Bouguereau's work is considered by many to represent the highest level of development in oil painting technique yet attained. Almost unanimously recognized by his contemporaries as the greatest painter of his time, Bouguereau has been a source of wonder for serious artists of every generation since.

Like the Old Masters before him, Bouguereau developed the ideas for his paintings through a series of sketches and studies. He first explored the idea for a given painting by means of small "thumbnail" sketches, called *croquis*, which he drew from imagination, in pencil, charcoal, or ink. He often refined, traced, and redrew these sketches with variations and other improvements until he settled on a basic design for the painting. Once he decided on an arrangement of forms and general composition, Bouguereau executed highly detailed studies, or *études*, from life of individual figures and other elements intended to be used in the final painting, which he posed according to the thumbnail sketch. The studies were variously done in charcoal and chalk on toned paper, oils in shades of gray, and oils in full color, executed in the direct painting method.

Bouguereau worked from direct observation in the execution of these studies, which he used as reference material in the final painting, as he also did in certain areas of the final painting as well. It is probable that he posed clothing on mannequins, arranging it carefully and perhaps rendering it immobile with a fabric stiffener when necessary to give the effect of being blown in a breeze. He hired models as needed for the flesh areas not covered by cloth, and had them pose nude for studies of the figure, in the poses needed for the painting, even when the figures were to be clothed in the painting. The purpose of this was to ensure anatomical accuracy. His studio included a greenhouse balcony, which allowed him to render the plants in his pictures from life. Many of the elements in his pictures were also the result of his own invention or were altered from what his eyes beheld—for example, his satyrs, angels, and flying cherubs.

Bouguereau also painted small color sketches of the entire composition, called *esquisses*, in which he introduced little or no detail, to try out different color harmony possibilities. He then drew a full-size cartoon in charcoal and chalk on heavyweight toned paper to further develop the composition and rudimentary modeling of the individual elements within it. This allowed him to see what the linear design for the painting would look like before he began to paint and allowed him to make any changes he felt would improve it.

Once Bouguereau firmed up the plan for the painting, he was ready to address the canvas. He had his canvases especially prepared to his specifications by his suppliers, primed with a ground composed mostly of white lead in linseed oil,

Above:

WILLIAM-ADOLPHE BOUGUEREAU (French, 1825–1905), color sketch for *La Vierge aux Anges* (aka *Song of the Angels*), circa 1880–1881, dimensions unknown, oil on canvas.

Bouguereau executed small sketches such as this one to work out color schemes and compositions. This was standard French Academic practice in the nineteenth century. This type of sketch was called an esquisse.

Opposite:

WILLIAM-ADOLPHE BOUGUEREAU (French, 1825–1905), *La Vierge aux Anges* (aka *Song of the Angels*), 1881, oil on canvas, 84 x 60 inches, Museum at Forest Lawn Memorial Park, Glendale, California.

This might well be the best example of Bouguereau's late technique, as demonstrated in this chapter, and perhaps represents his very best work. The figures are all rendered life size.

Courtesy Forest Lawn Cemetery Association

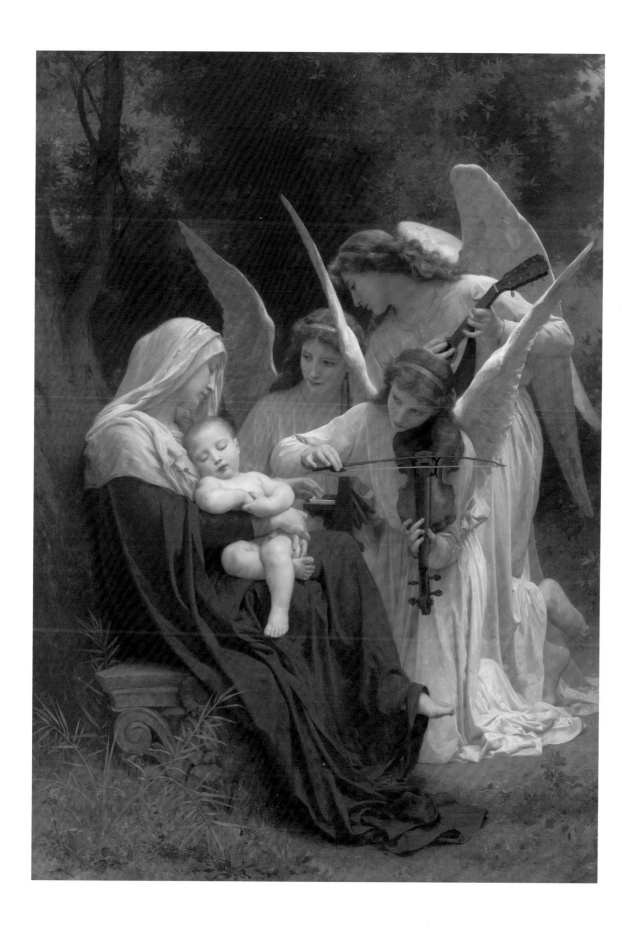

with the top coat usually tinted a warm opaque gray slightly darker than white. Upon this light gray tone, Bouguereau applied the design from the cartoon, by tracing. After refining the design freehand on the canvas, he strengthened it with ink and let it dry. Note that this method is, up to this point, nearly identical to that of the early Flemish painters, except that the drawing is transferred to a canvas rather than to a gessoed wood panel. Bouguereau's technique combines elements of the Flemish, Venetian, and French Academic methods with what are probably innovations of his own. The result was the most sophisticated oil painting technique developed to that point.

Over the inked drawing, Bouguereau applied a layer of copal varnish, to seal it and reduce the absorbency of the ground. A transparent oil paint might have been mixed with the varnish as a toner, to make an imprimatura, as in the Flemish technique. This isolating varnish was then allowed to dry. The next stage was the *frottie*, which consisted of the thin scrubbing-in of the darks with a brown tone, to indicate the patterns of dark and light in a rudimentary manner.

Once the *frottie* was dry, Bouguereau commenced painting in color, probably by blocking in the large areas, with little or no attention given to the modeling of the forms until he had covered all the large masses with paint. This stage was called the *ébauche*. It should be noted that Bouguereau is known to have sometimes varied this particular step, preferring instead to address one area at a time in a more piecemeal fashion, following practices more common in the seventeenth century and earlier in that regard. In his technique from around 1870 onward,[16] he filled in the flesh areas initially with an opaque tone, which appears in some paintings to be made from flake white, raw sienna, and perhaps a touch of burnt sienna or other color appropriate to the local middletone, but which could have been composed of combinations of other paints as well. The value of this tone is darker than the highlights and lighter than the shadows of the area in question, both of which Bouguereau applied in the next step, after the *ébauche* had dried. Of particular importance is that the color of the flesh tones is somewhat brighter—that is, higher in chroma—in the *ébauche* stage than it is in the final painting. Bouguereau probably used a palette knife to smooth the texture of the first layer of flesh tone while it was still wet, as was reported by one of his contemporaries after a visit to his studio.[17] Any rough areas that remained would have been scraped smooth before they were painted over.

Bouguereau used various driers to facilitate the quick drying of this layer in order to allow overpainting the next day. The most common of these driers consisted of linseed or poppy oil cooked with lead and manganese; another one was composed of poppy oil and copal resin without lead. Note that there are less problematic substances available today to use for this purpose. (See chapter 7.)

Bouguereau refrained from fully modeling the flesh tones and further developing the other forms until the final stage, called the *fini*. The *fini* was carried out

WILLIAM-ADOLPHE BOUGUEREAU (French, 1825–1905), *Love's Resistance*, 1885, black chalk and opaque watercolor, 13⅝ x 9¼ inches, Fine Arts Museums of San Francisco. Museum purchase, Achenbach Foundation for Graphic Arts Endowment Fund, 1971.19.

This is a Bouguereau cartoon, executed prior to beginning to paint the image on canvas. Solving compositional and pictorial problems in sketches and studies beforehand allows the painting process to proceed smoothly and progress quickly, with less need of correction along the way.

French Academic Method

In the interest of thoroughness, it is necessary to include the methods of the French Academics of the nineteenth century; however, the reader will undoubtedly notice some redundancy, in that there are many parallels between the methods of Bouguereau and those of the academic painters in general. There are also differences to be noted. Broken down into stages, the general procedures prescribed by the Academics in the development of a picture are expressed as follows:

Croquis: essentially a small thumbnail sketch executed from imagination, the purpose of which is to begin the process with a general design; usually done in pencil on paper.

Esquisse: a small color sketch in oils, also done from imagination, following the design of the *croquis,* to help the artist decide on a color scheme and better visualize what the painting might look like. No detail is attempted in the *esquisse;* only masses of color, broadly rendered in a simplified manner.

Étude: a study of each element in the painting that might warrant it, in isolation, executed in either charcoal, charcoal and chalk, oil grisaille, and/or full color in oils, with high detail, to be used as reference material in the painting of the larger, final, picture. These are done from direct observation of posed models, props, costumes on mannequins, or whatever is necessary in order to ensure that the images are accurate.

Frottie (sometimes spelled *frottis*): the monochrome blocking-in of the major masses of dark and light on the canvas itself, either over a drawing or in place of drawing, done in thin oil paint, usually an umber, scrubbed on somewhat summarily and sketchily to establish the design of the picture on the canvas. This was generally done from the reference material previously executed, rather than from life, although there were likely to have been exceptions.

Ébauche: essentially an underpainting to develop the image nearer to completion, in preparation for the final stage. More than one approach was used for the *ébauche.* Some artists (such as Nicholas Poussin, Jean-Auguste-Dominique Ingres) worked in grisaille in this stage, leaving color for the final stage, while they modeled the forms solidly with opaque grays; some blocked in general areas of color broadly, in color duller than the final intensity called for, in what has been termed "dead coloring," the intention being to bring up the chroma in the final stage where needed; and still others preferred to block in the color more brightly than the final effect desired and then tone it down where necessary in the last stage by going over it with duller color or grays. Each variation had its advantages, and it was up to the artist to determine which method would be best suited for a given picture. Regardless, the end result was generally smoothed out by scraping or by other means, to provide a smooth surface for the final layer of paint, and no detail or great refinement was introduced until the last phase.

Fini: the culmination of the process, wherein the images were brought into as full focus as the artist required, the forms refined, the modeling developed to finish, the accents and refinements of color attended to, details rendered, facial expressions adjusted, subtleties added, etc., by every means at the painter's disposal, including glazing, scumbling, and opaque painting both thick and thin. This stage usually required several sittings, each to further refine what had been done previously, until the desired effect was achieved to the artist's satisfaction. In the case of most of the French academics, the best results were obtained when working from direct observation as much as possible during this stage of the work. This author most often ends the process by looking at nothing but the painting itself for the final adjustments, with an eye to pictorial unity and harmony. It is probable that others work or have worked this way as well.

over the dried *ébauche*. The shadows of the flesh were grays, which appear to have been made from flake white, ivory black, and/or raw umber, with perhaps a small amount of burnt sienna, raw sienna, or other color appropriate to certain areas, mixed with a small amount of medium and/or applied thinly enough so as to become semitransparent. The color of the dried flesh tones of the *ébauche* can be seen through the shadow grays in Bouguereau's paintings where this method was used. Thus a complex optical phenomenon is produced that most closely approximates a shadow on flesh, at least in the soft, diffused type of light preferred by Bouguereau. He applied the middletones in the final

For this demonstration, a section of Bouguereau's *Song of the Angels* was chosen. First, a drawing on canvas was executed in charcoal. The charcoal line drawing was then strengthened with ink.

This image shows the *frottie*, or rudimentary scrub-in of dark patterns with oil paint. Raw umber was used here, scrubbed on thinly with a stiff, hog-bristle brush.

Next, a flat tone is laid in for the flesh and hair areas. This will serve as an undertone later.

The rest of the canvas is then covered with paint while the flesh and hair undertones are still wet.

The hair area is filled in with a dark mass of brown, after the previous stage has had time to dry.

Lighter tones are painted into the hair mass, wet-into-wet, using a somewhat ragged hog-bristle brush with very little paint on it. The strokes follow the direction of the hair, but only go as far as the light goes.

Location of the facial features begins. The inked drawing showing faintly through the dried flat tone serves as a guide.

Facial features are defined and shadows are laid in thinly over the dried underlayer. Shadow mixtures in this instance are grays made from flake white, ivory black, and green earth.

Flesh tones were made with grayish mixtures of essentially opaque paints applied thinly and translucently in middletones, while the shadow grays were wet, and then working into the lighter fleshtone areas more opaquely, wet-into-wet.

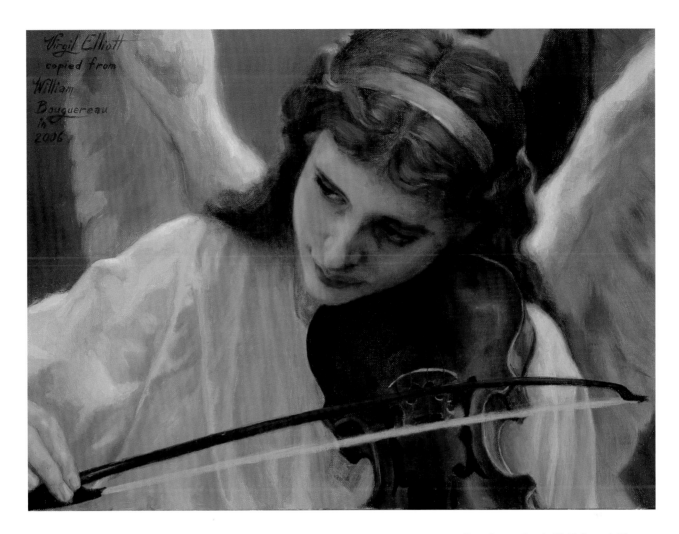

Virgil Elliott, *Angel with Violin,* **copied from part of William Bouguereau's** *La Vierge aux Anges* **(aka** *Song of the Angels***), 2006, oil on canvas mounted on panel, 12 x 16 inches.**

The hand (what there is of it) was painted more solidly than the face. Final refinements in the face followed the same procedures as described in the previous steps.

Photo Credit: Dean Wilkendorf, The Lab, Santa Rosa, California

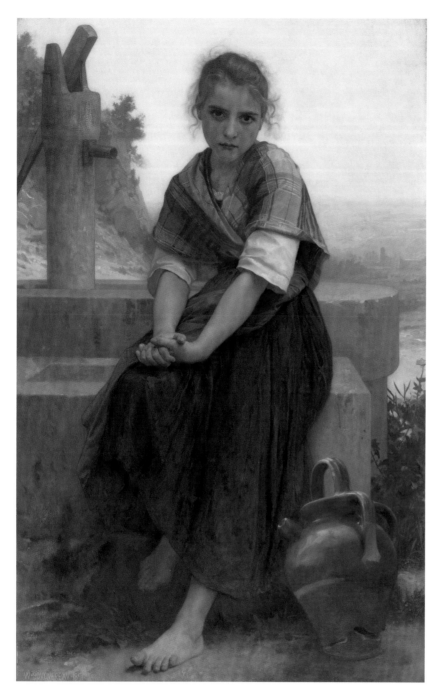

layer in varying degrees of opacity, depending primarily on the amount of light being depicted on the middletone in question. Opaque paints were used for the final middletones, but these were effectively translucent in some places owing to their thinness and perhaps the addition of a small amount of a transparent medium. The top layer of flesh tone was somewhat grayish, its translucence allowing the brighter underlying tone to show through to a greater or lesser degree from one area to another, creating an extremely lifelike effect.

In some of his later paintings at least, Bouguereau painted lighter areas somewhat thinly over the dried, darker undertone, producing a scumble effect—that is, a complex optical sensation in which light, opaque paint, thinly applied so as to read semi-opaque, allows the dried, darker underpaint to influence the final effect. The resulting sensation is that of increased coolness of color temperature, softness of texture, and a translucent quality very much like that of the youthful skin of light-complected women and children, if properly done. Bouguereau applied the lighter lights and highlights heavily enough to approach or reach true opacity in the flesh tones, with a degree of translucence evident in certain places in the darker middletones, and more so in the shadows. The effect, for which Bouguereau is renowned, is that of actual human skin, which is itself translucent in reality. He used touches of vermilion or other reds in the redder areas such as elbows, cheeks, and between fingers and toes. Flesh tones of fair-complected people are yellowish in some places and redder in others. Bouguereau observed and recorded accurately every subtle change in color and value over every millimeter of exposed flesh in his subjects. Veins are indicated with bluish or cool gray tones, always applied thinly and translucently, to a greater or lesser extent.

Bouguereau executed the rest of the painting in a fairly straightforward manner, with the deepest darks rendered somewhat transparently, the lightest lights opaquely, and the middletones generally opaque as well, all worked together wet-into-wet within each form and where edges of one shape meet another. He employed the palette knife for certain special effects and kept the paint layer thin in most places. He rendered overcast skies in two stages, the second being a lighter scumble.

Reproductions of Bouguereau's paintings give the impression of great smoothness. This is an illusion caused by the difference in size between the paintings themselves, where the figures are shown life-size, and the reproductions, which are always much smaller. It is apparent, on viewing the paintings firsthand, that there is a wide variety of brushstrokes and knife work incorporated into the images without blending. Like those of all great Masters, Bouguereau's brushstrokes look more like what they are intended to represent than brushstrokes.

The ability to render visions from the imagination convincingly is developed by years of drawing and painting from direct observation, until a point is reached at which the artist's memory banks contain all the necessary data to allow a high degree of inventiveness without compromising the illusion of reality. This is the mark of a Master.

Tips for the Contemporary Painter

Painting well is easier if one does not begin with a handicap. Many painters unknowingly handicap themselves at the outset by adopting a practice, or practices, that makes their task harder. The following tips should help the reader avoid many such problems.

WILLIAM-ADOLPHE BOUGUEREAU (French, 1825–1905), *The Broken Pitcher*, 1891, oil on canvas, 53 x 33 inches, Fine Arts Museums of San Francisco. Gift of M.H. de Young, 53162.

This is one of Bouguereau's late paintings, done in his usual manner of that period, as described in this chapter. Close examination reveals his method.

Photo Credit: Fine Arts Museums of San Francisco

Details from *The Broken Pitcher*.

Top:
This close-up shows the scumbled haze in the sky that ends just beyond the girl's hair. The scumble is lighter than the previous layer, and semi-opaque.

Bottom:
A close examination of the crease on the inside of the girl's right arm in this painting reveals the layer below the top layer, where Bouguereau has likely scratched through the wet grayish layer with a sharpened brush handle. The layer below the surface is brighter (i.e., higher in chroma) than the top layer, which is more gray, and ranges from translucent to semi-opaque to opaque.

The best palette is the same hue and value as the dominant hue and value of the painting. Glass works well on a tabletop or scrap of plywood, with a sheet of paper of the appropriate value and color underneath. This allows for the greatest accuracy in judgments of color and value. The paper can be changed as needed to correspond to whatever color is dominant in each painting. White palettes are best avoided, as all of the paints will appear darker on the palette than on the picture. Dried paint is easily removed from a glass palette using a scraper equipped with a razor blade. Edges of the glass should be taped, for safety. As glass palettes are quite heavy and somewhat fragile, their use is generally limited to the studio. For painting on location, the traditional wooden palette is preferable. It is best to paint wooden palettes a neutral gray in order to avoid having one's color judgments thrown off by the color of the wood. A small amount of raw sienna or raw umber should be added to a gray made from flake (or other) white and Mars or ivory black; otherwise the gray will be cool (bluish) rather than neutral. Copal varnish can be added to the paint used to tone the wooden palette, to render it impervious to solvents. When dry, a coat of copal varnish produces a slick surface that readily accommodates cleanup. In the absence of copal varnish, an alkyd resin oil painting medium or polyurethane may be substituted as an isolating coating. As for the size of the palette, there should be ample room for mixing many large piles of paint, if one wishes to cover much canvas in a day's painting session.

It is best to begin preparing each day's palette of colors by squeezing out a large pile of white and then softening it with linseed or walnut oil to the desired painting consistency—that is, approximately that of mayonnaise. Mixing time is saved by softening the white first, as all of the other tones in the palette will contain substantial volumes of white. If a short paint is desired, or slower drying, walnut oil is preferable to linseed oil. The need for medium is minimized or eliminated when the paints chosen are sufficiently fluid as they come from the tube to allow them to be controllable under the brush. This is the ideal situation. Paints from manufacturers who have refrained from adding too much stabilizer require little or nothing to be added to them in order to achieve an agreeable brushing consistency.

A drop or two of linseed or walnut oil may be added to a pile of paint on the palette the size of a large coin and mixed in thoroughly with a palette knife if a softer consistency is desired. This may be preferable to using mediums containing solvents, as solvent adversely affects the binding power of the oil. Alkyd mediums may be the exception to this, as alkyd resins have stronger adhesive strength than vegetable oils and can stand up to solvents a bit better. It is best to keep the amount of added medium to a minimum, in any case, for reasons discussed further in chapter 7.

After the white is softened, a range of cool grays may be made from white and ivory black. When working in color, and especially in portraiture, a range of

Virgil Elliott, *Melancholy,* **1987, oil on panel, 40 x 30 inches.**

The mood is the true subject of this painting. The model, Deborah Fields, was told a sad story and coached to portray the desired mood through her facial expression and body language. The flesh areas were underpainted in grisaille, following the Giovanni Bellini variation of the Venetian technique.

Photo Credit: Laura Stilson

warm grays, using white and raw umber, or white, ivory black, and raw sienna, may also prove helpful. Mixing time is saved by softening the white first, before mixing the grays and other tones that will contain substantial volumes of white. It is well when there is at least enough paint on the palette to accommodate a full day's sitting before we begin to paint. There will almost always be a greater need for white than for any other paint, unless we are painting night scenes. Thus it is a good idea to start out with a goodly amount of it on the palette. It might be theoretically possible for some painter, somewhere, to anticipate exactly how much of each color he or she will need for a given day's painting session, but it would seem unlikely. Time spent preparing the palette properly is time saved once the painting process is underway. One's train of thought may then remain focused on the development of the image, without the interruption of having to find the right tube, squeeze out more paint, and then adjust it to the right consistency when one runs out of a color that is still needed. It is sometimes difficult to find our place after such an interruption and to recall what we had been just about to do when we ran out of white, or whatever color. It's better to have too much paint on the palette than too little.

In laying out the palette, it may be helpful to isolate the transparent paints from the opaque, in order to use them systematically. Most painters arrange the pure colors around the edge of the palette and leave the interior space for mixtures. The main thing is to know where everything is, however one chooses to arrange one's palette, and to allow enough room for mixing whatever might be needed during the course of the day's painting.

When painting on a white canvas or panel, the white should be obliterated as quickly as possible. The reason is that the white of the ground will influence the perception of values, making everything appear darker than it is, until the white is covered. At that point, it may be necessary to reassess the darks to see if they are dark enough. To "kill the white" one might begin with a house-painter-sized brush, or several of them, and strive to cover the entire canvas with paint of whatever colors are appropriate to each major area as quickly as possible.

Large brushes allow one to paint more rapidly and also achieve many agreeable effects with less difficulty than small brushes. Large areas intended to be smooth will likely appear irregular if painted with small brushes. A large brush carries more paint and is able to cover more area per stroke than a smaller brush. With practice, a larger brush can be manipulated expertly enough to render the same effects as a smaller one, and often with more pleasing nuances. It is well to delay the use of small brushes as long as possible on a given painting. The large, general areas are best painted first. No details should be added until all the large shapes, colors (if working in color), values, and relative proportions are correct. These should be checked several times for accuracy before any attention is given to the smaller details.

VIRGIL ELLIOTT, *In the Wings,* 1991, oil on canvas, 40 x 30 inches.

This is an imaginary scene, the painting of which was facilitated by posing live models and costumed mannequins on a small stage constructed in the author's studio. This painting was done directly in full color with no underpainting. A small study was executed first, to work out the idea. The models were Will Wood and Annie Lore.

Photo Credit: Bob Hsiang

No matter what painting technique is employed, oil paints are most cooperative when applied from dark to light, wet-into-wet. This means we must begin with the dark shapes, which will establish the beginning of the image, and correct them as needed by wiping out mistakes with cheesecloth *before* adding any lighter values. This avoids mud. Once the darks are satisfactorily established, we may move to the middletones, to the secondary light in shadow, and gradually to the lights. Highlights should be added last.

When using transparent shadows and opaque lights, trouble can occur at the point where light meets shadow. Such problems may be avoided by painting an opaque dark at the edge of the transparent dark and fusing the edge between the two imperceptibly. The opaque dark must be either the same value and color as the transparent dark where the two meet or darker. The opaque middletone can then be fused with the opaque dark for a smooth transition. Peter Paul Rubens did this extremely well.

Using a different brush for each color will help avoid mud. It is especially important to use different brushes for opaque and transparent paints and for any colors that vary appreciably in any way. Brushes may be rinsed in safflower or walnut oil and wiped with a rag when necessary during a painting session, for changing colors, if more clean brushes are not near at hand. Vegetable oils can also be used to clean brushes at the end of the painting day, instead of solvents. It is best to follow with soap and water. The common practice of painting with an open container of solvent needlessly exposes the painter and anyone else in the room to vapors that are potentially harmful to one's health. It is quite possible, and preferable, from a health standpoint, to keep the studio air free of solvent vapors while painting in oils. This includes odorless mineral spirits, whose vapors are less easily detected by smell but are not to be considered harmless. The possibility of prolonged exposure is greater by virtue of the absence of objectionable odor.

It is not necessary to dip the brush in a cup of painting medium while painting. The medium is best mixed into the paint on the palette with a palette knife. An eyedropper is useful for adding the oil or medium to be mixed in with the knife. This method allows precise control over the amount of medium in the paint. The brush is not the best tool for this purpose, as it will invariably add too much medium and will not likely mix it in well enough. It will also waste paint and probably shorten the life of the brush by allowing paint to accumulate under the metal ferrule, from which it is difficult to remove. Once paint dries under the ferrule, the brush is ruined, or at best becomes useful only for painting ragged strokes, as the highlights in hair, or grass.

To minimize the likelihood of misjudging proportions, the artist's spot of vision should be larger than the subject on the canvas. This is best accomplished by working standing, if at all possible, at least an arm's length from the canvas

These are wooden palettes of assorted sizes, all painted gray for better judgment of colors and values. Larger paintings require more paint; thus, larger palettes.

A gray palette allows more accurate visual judgment of values than a white palette. Or, with a glass palette, any color of paper could be placed underneath, as desired. For working on a painting with a blue dominant hue, for example, blue paper underneath the glass would let the colors on the palette read much as they would on the painting. It is easier to clean off dried paint from a glass palette than a wooden palette, as it can be scraped with a razor blade.

and by cultivating the habit of stepping back often and viewing the painting from a distance. The field of view is a cone shape, with the pointed end at the eyes. The spot of vision is smaller nearer the eyes and larger as distance from the eyes increases. The canvas should cut into the cone of vision at sufficient distance so that the spot of vision is large enough to encompass the entire subject.

Mistakes are most easily detected at a distance and conversely are less noticeable the closer the eyes are to the canvas. The natural tendency for the artist who sits while painting is to sit too long and not view the painting from a distance often enough to detect errors before too much time is wasted detailing them.[18] It is frequently the case that a passage looks fine up close but will contain errors that only become apparent from a distance. The viewer's first glimpse of the picture will be from a distance. If it does not work well at that distance, no one will bother to come any closer.

The painting should be positioned at the proper height on the easel to allow a line of sight perpendicular to the picture plane, or the image created is likely to be distorted. When an artist draws or paints with his or her eye at other than 90 degrees from the center of the picture, the resulting image will be distorted when viewed from the correct angle.

Holding the brush by the end of its handle will give better control and allow a larger view of the picture at the same time. Oil painting brushes have long handles for this reason—to allow the greatest distance from the painter's eyes to the canvas while painting. This helps avoid errors in proportion. The tendency to hold the brush like a pencil is a holdover from learning to draw and is best reprogrammed for painting in oils. The closer the eye is to the canvas, the smaller is the spot of vision, making judgments of comparative size more difficult. Flaws invisible to the artist at a distance of twelve inches become obvious, and impossible to ignore, at ten feet.

Eating or drinking should be avoided while painting. While not all oil paints are as toxic as flake white, many are at least harmful in one way or another and should not be ingested, even in small amounts. Few painters are so fastidious while painting as to avoid getting paint on their hands and sometimes on their faces and clothing as well. It is safest to assume that all our painting materials are poisonous and that our hands, brushes, and knives are contaminated. When hungry or thirsty, we are wise to lay down our brushes and palette and then wash our hands thoroughly before eating or drinking. It may help to eat at a distance from, but in view of, the painting, as this provides an opportunity to evaluate what has been done and decide what to do next. The other reason to avoid eating while painting is that it connotes a certain leisurely attitude toward one's work, which is entirely inappropriate. Painting well requires the artist's undivided attention. It is extremely important that we always think about what we are doing.

Chapter Seven

OIL PAINTING MATERIALS

THROUGHOUT THE LATTER HALF of the twentieth century the primary focus in art instruction in many, perhaps most, colleges and universities was on creativity and expressiveness, with too little attention given to developing an understanding of the physical materials involved and their proper use. The prevailing attitude seems to have been that the childlike charm of the naïve or primitive attempts at art was more valid than a controlled, masterly approach, which, if pursued, would fatally compromise that very fragile quality. Innocence, once lost, could not be regained, so the thinking went. Rephrased, it essentially said that only those who *lacked* technical knowledge were capable of creating the greatest art. The Old Masters were considered an exception, products of conditions that existed in their times, which supposedly no longer existed.

This was a twentieth-century idea, and a destructive one to the field of art and especially art instruction, in many ways. Such illogical and harmful beliefs cannot be allowed to stand, if we care about the future of art. It is appropriate to revisit ideas periodically—both to reevaluate them to see if they still apply and to correct them in light of new circumstances or new information. The history of art is generally categorized in terms of centuries, each of which is recognized as distinct from all others in various ways. A new century has dawned, and the ideas of the last century need not be carried over into the new one.

Opposite:
ELISABETH LOUISE VIGÉE-LEBRUN, (French, 1755– 1842), *Self-portrait*, 1790, oil on canvas, 39½ x 32 inches, Uffizi, Florence.

Mme. Vigée-Lebrun is shown here at her loveliest, with brushes and palette in view.

Photo Credit: Scala / Art Resource, NY

It is well to take the best of what has gone before and incorporate it into what we do in the present and into the future and to discard whatever has not proven workable, or what has already been carried as far as it can go.

Knowledge should not be shunned, but eagerly sought. The ultimate measure of an artist's worth is the test of time. Our works cannot be expected to carry our expressions into the future if they do not survive us. Thus do practical considerations enter the picture, as paintings done without knowledge can deteriorate rapidly.

Oil painting, more than any other art medium, involves a certain amount of chemistry if the artist is at all concerned with permanence. Paints must be applied in a certain sequence or cracking can occur. Some pigments fade upon exposure to ultraviolet light. Some paints will yellow in the absence of light. Some popular oil painting mediums can cause paintings to turn dark, crack, and be very difficult to restore. Some currently widespread practices could lead to the peeling of the paint layer.

The reader may then wonder why anyone bothers to paint in oils, if it is so difficult and if there is so much to learn. There are a number of reasons. Oil paint allows the widest range of possible effects of any fine-art medium. Its colors and values do not change when they dry, as happens with water-based media. A properly executed oil painting will last for centuries, virtually unchanged, given reasonable care, and if problems do occur, conservators are well equipped to handle them, having had centuries to develop the techniques for dealing with the chemistry involved. Further, oil paint, in the hands of a Master, is capable of saying more than any other medium. It is considered the supreme fine-art medium, and justly so. While the challenges of mastering it are greater, so are the potential rewards. It may seem intimidating at first, but it is not terribly difficult to learn the fundamentals. Hopefully, the reader will find it fascinating. In any case, it is essential for the artist concerned with the longevity of his or her creations.

In the earlier centuries of oil painting, art students began as children and were apprenticed to working Masters. Their tasks would have included grinding the pigments, making paint, priming canvas, cleaning the Master's brushes, and generally preparing the materials for the Master's use. In the process of grinding the paints, the students became intimately acquainted with them, so that by the time they were allowed to use oil paints, they understood them fairly well. No one could become recognized as a Master without exhibiting a complete knowledge of every aspect of painting, including the proper methods of employing the tools and materials of the trade. This ensured that a painting done by a Master would stand a reasonable chance of holding up over time and not deteriorate once in the hands of the purchaser. Artists were concerned with the prestige of their profession. Shoddy workmanship was simply unacceptable.

It is ironic that many paintings executed within the last hundred years are in worse condition than paintings five centuries old. One major reason for this is the discontinuation of the older system, which placed great value on the craftsmanship aspect of art. This book is written in the interest of restoring that ethic where fine painting is concerned. And indeed ethics are part of it.

Works of art become family heirlooms. The buyer has every right to assume that the artist has taken the greatest pains to ensure the structural soundness of a work, so that it can be passed on to the next generation. When artists neglect to learn the correct application of their materials, works of art deteriorate prematurely, and it reflects negatively on all artists. The association between fine art and the concept of quality must not be overlooked. The high prices fine art can command derive from a connotation of quality. Quality includes not only the design, the imagery involved, but it should carry through to include the materials and the workmanship that have gone into the artwork. Thus it is of the utmost importance that artists understand the materials with which they create their art.

A final word of caution: The information contained in this chapter was current at the time of publication. However, things can change rapidly in the world of art materials. Science is continually coming up with new products and new discoveries, so what is current today may well be obsolete tomorrow, superseded by something better. It is strongly advised that the reader put forth the effort to determine what the current situation is at any given point.

A charcoal holder, with white chalk in the end opposite the charcoal. It is useful for mass drawing.

Supports

The logical place to start, in covering oil painting materials, is with the support. The choice most often comes down to cloth or wood, although copper has been used by a few painters as well, with no ill effects resulting from it. Since most oil painters will be working on cloth supports or rigid panels, those will be the focus of this discussion. There are advantages and drawbacks to consider with both options, and the well-informed artist will make his or her choice only after giving due consideration to the pros and cons of each possibility, from a standpoint of knowledge.

CANVAS

When a large surface is desired, canvas is generally the preferred option, owing to its lighter weight compared to wood panels and because it may be removed from its stretcher bars and rolled around a cylinder for delivery to its designated location. As discussed earlier, these were surely the reasons it was adopted for painting purposes in the first place.[1]

A number of different kinds of canvas are available. Linen was long considered the canvas of choice for works intended to last. Hemp was once used as well and is reported to be at least as durable as linen. Cotton can be expected to rot much

sooner than linen and should be used for studies only. The new polyester fabrics are considered very promising prospects at this point, but their introduction is too recent for anyone to know with certainty just how they will weather the centuries ahead. The expectation is that they will outlast linen, as (unlike natural fibers) they do not absorb moisture and are not susceptible to rotting. However, of the cloth supports, only linen has been subjected to the test of time.

Linen canvas is available in a variety of textures, from nearly as smooth as a wood panel to quite coarse. The choice would depend on the artist's idea for the painting and on the intended size. Heavier canvas is best for larger paintings and for when a loose, painterly effect is desired. A more refined technique would require a smoother canvas, perhaps double-primed.

The main drawback to painting with oils on stretched cloth is the increased likelihood of cracking of the paint layer, as the canvas will remain flexible, while the paint film will grow more brittle with age. And of course there is the rotting of natural fibers to consider as well. This most often begins at the edges of the painting surface, where the acids from the wooden stretcher bars come in contact with the cloth and initiate or accelerate the rotting process. The good news is that conservators have had a very long time to come up with ways of dealing with these problems, and if we could be certain that our paintings would all find their way to a good restorer/conservator before they had deteriorated too badly, our worries in that regard would be over. The currently favored treatment is relining, a procedure in which the old canvas is attached to a new cloth support of similar texture, usually with an isolating layer of archival paper between them, all adhered with a reversible adhesive. Also practiced in the recent past, and perhaps still in some cases, is the gluing of the canvas to a rigid panel. This immobilizes the paint layer and serves to mitigate the forces that cause brittle old oil paint films to crack.

A honeycomb aluminum panel as seen from the back. Canvas is glued to the front of this panel with a removable conservation adhesive. The rigidity of the panel should effectively mitigate the forces that cause cracking in oil paintings.

WOOD

The Old Masters[2] used panels made from various woods, including poplar and oak, for small and mid-sized pictures, and in some instances for larger ones as well. The advantage of painting on a panel is that the paint layer will not be subjected to as much flexing as is likely on a canvas, thereby eliminating the major cause of cracking. Cracks in old paintings on wood panels are mostly limited to cracks in the wood itself or in the seams between two pieces of wood in the same panel. Another cause would be the imprudent use of bitumen or asphaltum as a pigment. Both are known to shrink and crack if applied too heavily. They were used by some of the Old Masters as dark, transparent glazes for the deepest shadows.

Oil painters today have a number of different options for wood-based supports—all of which are much more predictable and less prone to cracking than the materials available to the Old Masters. Pressed-wood panels, which

are sold as Masonite or Presdwood, are seamless sheets that provide a smooth and sturdy painting surface. They may be used as painting supports up to the sizes that would be too cumbersome and heavy to be practical, and in fact are an excellent choice for certain situations, particularly small paintings to be executed in a highly detailed style.

Opinions are divided on whether tempered or untempered pressed-wood is the best choice for oil painting. The tempered variety is denser and more physically durable, but some kinds have been impregnated with a binding oil that could prove problematic. As some of the primers used for wood panels are water-based, the concern is that these primers may not adhere as well to at least some of the tempered pressed-wood panels. Some writers claim that scrubbing the surface with acetone, denatured alcohol, or lacquer thinner before priming will solve the problem. This may or may not prove desirable, as it could loosen the material at the surface, which could then result in discoloration of the ground subsequently applied, if it is not adequately sealed with an effective sizing. Once again, time will tell. An alkyd-based primer would not likely have difficulty adhering to tempered or untempered Masonite.

The back of a braced plywood panel with canvas stretched on the front. The braces are basswood; the plywood is birch. This panel was made by John Annesley, in Healdsburg, California.

Caution is called for, as there is considerable variation in the quality of these products on the market. Some pressed-wood products are manufactured in South American countries. These may not be suitable supports for permanent oil painting, as their ingredients are not known. Tempered hardboard (aka pressed-wood panels) from North American sources may be the best choice.

There are a number of potential disadvantages to working with the traditional type of wood panels. They may become infested with wood-boring beetle larvae, which eat the wood; they can also warp, split, crack, and come apart if constructed of more than one piece of wood. Pressed-wood may not be as attractive to the beetles and, lacking grain, would not develop its own cracks. It is worth noting, however, that the corners of pressed-wood panels are prone to crumbling if dropped, unless a framework is glued to the back as reinforcement.

Wood panels can also provide technical challenges. A panel is more difficult to paint on than canvas, as the paint tends to slip around more at first, whereas the texture of the canvas helps pull the paint out of the brush and holds it where it is laid. This difficulty is not insurmountable, and it becomes easier to deal with as the artist gains experience with it. In terms of restoration, wood panels don't provide any real benefit over canvas. While oil paintings done on wood generally don't require restoration as frequently as their canvas counterparts, when they do the difficulties involved in restoring them are usually greater.

Plywood offers an alternative to the contemporary painter that was not available to the Old Masters. Only the best grades of hardwood plywood, such as those employed in cabinetry and boat making, should be given serious consideration.

The problems common to the older types of wood panels, warping and splitting in particular, would not be as likely to occur with cabinet-grade or marine-grade plywood, especially if they were properly braced on the back. There are specialty companies that make these kinds of panels specifically for artists' purposes. They are well worth looking into. The bracing just mentioned is advisable for pressed-wood panels as well. These would be susceptible to damage at the corners otherwise.

The traditional wooden panels also remain a viable option; however, the choice of wood is fairly critical. Well-aged hardwood panels from old furniture or doors are worth seeking and acquiring for use as painting panels. The denser varieties with no knots would be preferable. It would be well to consult an expert on wood, such as a luthier or violin-maker, in these decisions. It should be understood that traditional wood panels are subject to the development of all of the problems that have befallen old panel paintings: warping, splitting, and being eaten by beetle larvae. However, canvas has its problems, too. It is up to the artist to weigh the advantages and disadvantages of each possibility in determining which support best suits his or her intentions and needs.

COMBINATION SUPPORTS

Many painters who prefer the texture of canvas under the brush but wish to avoid the long-term ills that too often befall paintings on stretched canvas supports are attaching their canvases to rigid panels. This option is favored by some painting conservators who restore old paintings on a regular basis. In addition to stabilizing the paint layer, and thereby reducing the likelihood of cracking, it allows the canvas to be more easily removed from the panel with the painting surface intact, should the panel itself ever develop problems and require replacing. This option would mitigate, to a great degree at least, the critical nature of most of the other choices of materials in a given painting.

Conservators often glue old canvases to honeycomb aluminum or other rigid panels in order to arrest the cracking of the paint layer and extend the life of old paintings. The adhesive used in such instances is always one that allows for future removal of the canvas from the panel without harm to the painting itself. The advantages of using honeycomb aluminum rather than wood are that it is lighter in weight and insects do not eat it. The main disadvantages are its high cost and the difficulty in finding it.

Conservation techniques aside, wooden panels, including braced plywood and braced pressed-wood panels, properly prepared, should suffice for the purposes of most painters. If the adhesive chosen is reversible, the canvas can always be removed from the panel and glued to a new panel of whatever material conservators of the future determine to be best at that time. BEVA is an adhesive currently in wide use in conservation circles. Alternatively, some artists simply stretch the canvas over a braced wood panel without gluing it, instead tacking

it to the reinforcing framework as they would to stretcher bars. Each method has its benefits and drawbacks. A canvas tacked to the panel would be easier to remove for restoration, but it would not immobilize the paint layer as surely as if the canvas were glued in place, and cracking might still occur if the canvas were to grow slack.

With either method, it is advisable to seal the wood of wooden panels before mounting the canvas. This isolates the canvas from the acids in the wood, which would otherwise accelerate the rotting of linen or cotton canvas. Polyurethane is one of the better materials for this purpose. Polyester fabric does not seem to be affected by the acids in the wood in the same way as natural fabrics are and might be considered a preferable support for that reason.

Yet another option is available for oil painters who are concerned about the longevity of their work. Conservation suppliers currently sell a number of types of aluminum panels with canvas of the customer's choice attached with a reversible conservation adhesive. These are expensive but perhaps worth the cost to the painter concerned with the utmost in archival quality. They are expected to last into the next millennium.

Sizes and Grounds

Progressing upward from the support, the next materials to look at are sizes and grounds. There are a number of choices to make—more for the contemporary painter than there were for the oil painter of centuries past. There is some confusion over the terms *primer* and *ground,* with the two in wide usage more or less interchangeably, with the same meaning. Some writers feel that this is too imprecise and insist that *ground* should be recognized as the correct term, arguing that *primer* could conceivably include sizing and perhaps whatever imprimatura or isolating varnish might be applied in addition to the ground itself. Where the word *primer* is used in this book, it should be understood to mean only the ground, as a synonym, and not to include sizes, imprimaturas, or isolating varnishes.

The first oil painting ground was the same ground that had been in use previously with egg tempera painting. It consisted of hide glue[3] melted in a double boiler, with either powdered chalk, slaked plaster of paris, gypsum, or whiting stirred into the melted glue while warm.[4] This mixture was applied, while warm, to the panel. Several coats were usually required for adequate coverage. The initial coats might have consisted of a coarser-textured gesso, but the later coats would have been of a finer grain, each sanded or scraped smooth before the next coat was applied, until a smooth white surface was achieved.

This kind of glue-chalk ground is only really suitable for rigid panels, as it is insufficiently flexible for use on stretched canvas. It is also very absorbent and for optimum performance should therefore be sealed with an isolating layer

before oil paints are applied. Many of the Old Masters used varnish to seal the ground and sometimes toned it with whatever color they wished to dominate in the painting, for a transparent imprimatura. This practice was sometimes employed in the Flemish technique. The imprimatura was added to the support after the artist had transferred the drawing onto the white ground and strengthened it with ink.

Contemporary oil painters might prefer to use acrylic gloss medium, thinned with water, to seal the absorbency of the glue-chalk gesso. However, the more widespread practice is to simply use acrylic dispersions grounds in place of the traditional gesso. Note that the term *gesso* is often incorrectly used in reference to acrylic dispersion primers/grounds, which is the cause of considerable confusion. Gesso is the traditional ground that is made from hide glue (sometimes called rabbitskin glue) and gypsum, slaked plaster of paris, or white chalk as the pigment. The acrylic grounds are not the same thing, technically speaking, so they should not be called "gesso," in the interest of clarity. They differ in performance, most notably in that the acrylic grounds are quite flexible, whereas glue-chalk gesso is not.

Some conservators feel that acrylic grounds are probably suitable for panels, but there is still much debate over their use on stretched canvas, as a ground for oil paintings. The concerns are that these acrylic grounds may be too flexible to be appropriate under a layer of oil paint, which can become brittle after seventy years or so, leading to excessive cracking, and that the bond is physical only, as acrylic and oil paint are too dissimilar chemically to form a chemical bond. In addition, at least some of the acrylic dispersion grounds are quite absorbent and may draw so much oil from the lower layer of paint that it creates an underbound layer at or near the interface between the ground and the upper layers of paint. This has been postulated as a potential cause of delamination. Conservation scientists are studying these matters, but the issue is complicated by the fact that there is significant variability among acrylic primers from different manufacturers regarding their relative degrees of flexibility, absorbency, protection from support-induced discoloration, bleed-through, etc. The best grades of acrylic primer may ultimately prove to be more or less ideal as a ground for oil paintings, but it currently remains an open question.

If acrylic primers are to be used as grounds for oil painting, proper preparation could well make the difference. Acrylic grounds/primers may contain surfactants, flow improvers, and/or other additives in their formulations. These substances tend to migrate to the surface as the primer dries and cures and are best removed from the surface with a damp, soft cloth after the primer has had sufficient time to cure. Once these impurities are removed, the water used in cleaning should be allowed to completely evaporate, before painting commences. These additional steps could conceivably improve the situation and make for an acceptable bond between acrylic primer and oil paint.

The only ground for oil paintings on stretched canvas that has proven itself by enduring for centuries is white lead ground in linseed oil. It is sufficiently flexible to resist cracking under the normal degree of movement associated with canvas, yet stiff enough to reinforce the paint layer. Its chemistry is basically the same as that of the paints, thus allowing a better chemical bond than is created between acrylic primer and oil paint. However, before this kind of ground can be applied, the canvas itself must be sized so as to protect it from the acids in the linseed oil, which would otherwise initiate or accelerate the rotting process.[5] It is not to be handled carelessly, as lead is toxic. (See adjacent sidebar.)

Traditionally, the preferred size was a weak solution of hide glue, spread very thinly and evenly over the entire canvas and allowed to dry completely before priming. However, conservators have recently identified hide glue as a cause of cracking in old oil paintings on canvas and no longer recommend it for sizing canvas. The glue is hygroscopic and subject to a high degree of expansion and contraction in reaction to changes in humidity. It also loses its grip when the relative humidity is above a certain level[6] or when it becomes wet for whatever reason. These tendencies, coupled with its brittleness, are believed to be the cause of many of the problems in old oil paintings.

Some people claim that hide glue is less problematic when prepared at the proper strength and applied no more heavily than is absolutely necessary. However, if we accept the idea that the painters of the seventeenth century knew the proper strength and thickness, and the means of applying hide glue sizing, then we must not overlook the fact that many of their paintings are cracked. We may therefore reasonably conclude that it is the nature of the material, more than these other variables, that causes hide glue to behave as it does.

In recent years certain synthetic substances have been developed that are better suited than hide glue for sizing canvas supports, namely buffered (neutral pH) polyvinyl acetate (PVA) and various acrylic preparations. These materials have proven to be superior in preventing strike-through, pinholing, and oil absorption, among other things, on stretched canvas supports. In addition, they are easier to prepare and apply correctly, so there is no longer any good reason to continue to size with hide glue.

The concerns over the toxicity of lead have compelled manufacturers of artists' canvas to replace lead grounds with various combinations of titanium dioxide, zinc oxide, and barium sulfate or calcium carbonate, in an oil or alkyd binder. It remains to be seen whether these primers will hold up as well over the centuries as white lead in linseed oil. However, the indication thus far, from actual performance over many years, and in accelerated aging tests conducted by conservation scientists,[7] is that the better alkyd-based primers, properly prepared and applied, may prove to be the best option. The alkyd-titanium preparations would not carry the same dangers as lead, but it is still

Handling Lead Grounds Safely

Several firms still offer white lead primers bound in linseed oil, sold in cans, but the concerns over lead's toxicity could end that at any moment. Artists who prefer lead grounds might be prudent to stockpile a lifetime supply while it is still available; however, the danger of lead poisoning must be taken seriously. When applying the white lead ground, and especially when sanding or scraping the surface after the ground has been applied, every precaution should be taken to minimize the chances of ingesting airborne particles or inadvertently allowing lead to find its way into the mouth, nose, or cuts in the skin. Particle filter masks and surgeon's disposable rubber gloves should be worn during these procedures. Hands and face should be washed often and the gloves replaced with a new pair as soon as they become contaminated. Lead-detection kits are available at paint stores and should be used in any artist's studio where lead-based paints or grounds are used or prepared.

important to avoid breathing the vapors from the solvents in those grounds while they are drying, as there are other health risks associated with breathing vapors of any volatile solvent. These operations are best carried out in a well-ventilated outbuilding, away from the living space.

Rather than trust the manufacturers of pre-prepared canvases of unknown materials, cautious artists may want to size and prime their own canvases, using buffered PVA or an acrylic material as a sizing, and white lead ground in linseed oil or an alkyd-based primer as a ground. These methods appear to offer the greatest probability of producing the most permanent ground for oil paintings on canvas. Also, avoiding the unnecessary or widespread use of impasto in the painting itself contributes to maintaining the flexibility of the paint layer for a much longer time. It is reasonable to expect paintings sensibly executed on canvas properly sized and primed and kept at a fairly constant tension to hold up even better than the older paintings on display in museums today.

Several examples of tubed oil paints.

The Paints

The paints used by the Old Masters were, in most cases, quite different from the tubed paints available today. Some insight into the differences may be gained by grinding (mulling) one's own paints and comparing them to store-bought paints. The author sometimes grinds his own yellow ochre (as well as other colors) with water-washed, sun-bleached, cold-pressed linseed oil. The paint thus produced has an extremely high tinting strength, apparently because it contains a very high concentration of pigment and nothing else, besides the oil. It is a long paint, unlike most sold commercially, and is probably more like the paints used by the Old Masters than the preponderance of store-bought paints of today,[8] which are all short. Long paints brush out like enamel.

Modern tubed paints generally include stabilizers and other additives. Most companies add a soap called aluminum stearate to prevent oil separation in the tubes and to make stringy (long) paints more manageable. Ultramarine blue requires quite a bit of aluminum stearate to overcome its natural stringiness. Too much aluminum stearate makes for a pasty paint, difficult to control precisely with the brush, as the stearate changes the oil from a fluid to a more colloidal, or jellylike, consistency. This pastiness can be overcome by adding medium to the paint. However, this makes for a more chemically complex formula, carrying more potential for problems. Some companies also add alumina hydrate, an inert pigment used in the transparent dye colors such as alizarin, rose madder, the phthalocyanines, Indian yellow, and some other synthetic pigments, for various reasons, sometimes as an extender, sometimes to improve texture, paint rheology, etc. And some add barium sulphate as a filler and/or to lighten certain colors. All these additives affect the paint's brushing characteristics.

The Old Masters' paints did not contain these modern ingredients. This is not to say that their paints were necessarily better overall than the best of the

modern commercial paints, only that they were different. Shelf life was not a consideration for the Old Masters, as paint was made shortly before it was to be used. There are reasons to believe that the best oil paints[9] currently commercially available could outperform any paints ground with a muller on a slab, as far as permanence is concerned. Modern stabilizers such as aluminum stearate act as plasticizers and help oil paint films retain their flexibility and thereby resist cracking. Most manufacturers also use driers to bring about more uniform drying rates throughout their selection of oil paints. The Old Masters used various methods to control drying times, including choosing oils and pigments for their natural drying qualities, according to the speed they preferred.

Paints vary in consistency from one manufacturer to the next, because of the difference in the type of oil used, fillers, driers, degree of fineness to which the pigment is ground, and the use of stabilizing agents. It remains for the artist to determine which of the commercially prepared paints constitute the best. A wide variety of paints, representing a considerable range of quality, are available to the contemporary oil painter. The selection can be overwhelming, and the choice is individual. However, it is possible to find what suits us best if we keep trying out different brands, one or two tubes at a time, and especially if we look for ASTM information on the packaging, to see what the pigments, binding oils, and stabilizers are. The following qualities should be considered when choosing what paint to use and when: lightfastness, type of oil used, ratio of oil to pigment, drying rate, tinting strength, consistency, and the degree of opacity/transparency.

LIGHTFASTNESS

The most important quality to consider when choosing a paint is the lightfastness of the pigment itself. Will the paint hold its color, or will it fade or change in some other way? Paint manufacturers generally provide this information on request, if it is not printed on the tube. Those rated ASTM Lightfastness I may be considered reliable. ASTM Lightfastness II is considered sufficiently lightfast for fine art painting. Anything with an ASTM lightfastness rating of III, IV, V, and so on can be expected to fade or change color in an unacceptably short period of time and should be avoided. All paints mentioned in this chapter may be considered permanent unless otherwise noted.

The reader is encouraged to test any paints whose lightfastness is suspect. Some manufacturers do not use the ASTM standards, and in those cases it may be warranted to do your own testing. That is not to say, necessarily, that brands lacking ASTM lightfastness ratings are of inferior quality, but only that the ASTM standards are a reliable indicator of what we have. When they are absent, we have more of a mystery situation. Lightfastness testing is easily accomplished by placing panels containing sample smears in a south-facing window (or a north-facing window if you live in the southern hemisphere) for at least three years and periodically comparing their color to that of fresh paint from the same batch and/or to portions of the same samples protected from the sun by a mask.

Detailed procedures for conducting lightfastness tests on artists' paints may be found in ASTM Standard D 4303 and D 5398, available from ASTM International.

TYPE OF OIL USED

When evaluating tubed paint, the second concern is the type of oil used. Common oils contained in contemporary paints include linseed, safflower, poppy, sunflower, and walnut oil. Linseed oil produces the strongest paint film, with the greatest resistance to cracking. Paints ground in linseed oil are also less apt to be adulterated with driers, as linseed oil dries better than the other oils. As a trade-off for its superior film strength and durability, linseed oil has a tendency to yellow with age. The yellowing is most pronounced on short-term aging, however, and begins to reverse itself in a few years in normal lighting. Exposure to sunlight for two or three half-days in a row will bleach the initial yellowing appreciably. Some colors, such as the blues and whites, are more affected by the yellowing than are other colors. Browns, reds, oranges, and yellows are not noticeably affected.

Some artists' paint makers today use safflower or poppy oil for their blues and whites, rather than the more expensive walnut oil more commonly used in centuries past. Of these, safflower oil yellows the least. It is misguided to favor poppy oil over linseed out of concern over yellowing, as the differences in yellowing between the two are negligible after a few years; poppy oil is also much more prone to cracking. Safflower is superior to linseed and poppy oil in its resistance to yellowing; its film strength is not as great as that of linseed oil, although perhaps it is better than poppy oil. Poppy and safflower oils dry slowly and require the addition of driers during manufacture to produce a paint that will dry at an acceptable rate. These driers carry their own consequences, including premature embrittlement. Sunflower oil shares all the defects of poppy oil and requires even more drier, or it will not dry completely. For that reason, artists are advised to avoid paints ground in sunflower oil altogether.

In the end, it may be best to choose paints ground only in linseed oil for all colors except blues and the whites to be used in the final layer of paint. For those whites and blues, a safflower or walnut oil binder might be preferable, as far as the short term is concerned. However, since the yellow visible in blues and the whites made with linseed oil tends to disappear after a few years in normal indoor light, this may not even be necessary at all.[10] The simplest choice, and the most structurally sound one, is to use linseed oil paints exclusively.

If the Venetian technique or any variant of it is going to be used, or any technique that includes painting over dried paint layers, only paints ground in linseed oil should be used, for best results, at least until the final stage is reached. Linseed oil forms stronger films than the other oils. It is risky to use a given paint in an underpainting if its binder is not known. The presence or absence of linseed oil and poppy oil are usually detectable by their respective

characteristic odors, and safflower oil by its lack of odor. Safflower and walnut oil paints are suitable, perhaps even preferable, in the final stage of the painting.

Methods of extracting the oils may also be a factor to consider. There is an ongoing controversy over whether cold-pressed linseed oil is a better binder for oil paints than alkali-refined linseed oil, or vice versa. Some artists feel that paints made with cold-pressed oil possess certain qualities relating to paint handling that they contend are lacking with alkali-refined oil. If one wishes to generalize, it might be said that these handling differences are negligible and that they come with the trade-off of increased yellowing with cold-pressed linseed oil. In truth, such generalizations may be wide of the mark in many instances. These are natural products that vary from crop to crop, season to season, and from one growing region to another. So it is not so simple a matter as one always being better than the other. Personal preferences are more the issue. There may or may not be any sound basis for these beliefs regarding whether cold-pressed is better than alkali-refined, or vice versa. Alkali-refined linseed oil imparts the same film strength as cold-pressed and seems to create less yellowing. Each painter will have his or her individual preferences and needs. A bit of practice brings knowledge and familiarity, steps on the road to mastery.

RATIO OF OIL TO PIGMENT

The next consideration when evaluating tubed paints is the ratio of oil to pigment. The well-known advisory to always paint "fat over lean" means simply that paint containing a lower percentage of oil (lean) should be laid down first and not used to cover areas of dried paint that contain a higher percentage of oil (fat). The oils used in making paint are subject to a certain amount of shrinkage as they age. The higher the percentage of oil (the "fatter" it is), the more it can be expected to shrink. Painting over a fat layer with a leaner layer could lead to wrinkling or cracking at some point. This rule is not important if the entire painting is done in one sitting, because there will only be one layer of paint. However, if subsequent overpainting is desired, it is advisable to add a bit of oil to any normally lean paint intended to be used for the upper layers.

The degree of absorbency of the ground used to prime the support is a factor that must be considered in regard to the fat-over-lean issue. With an absorbent ground, an overly lean first layer of paint could be rendered underbound if the ground were to draw too much oil from it. This scenario could cause problems with adhesion between layers. To guard against this possibility, it is wise, when painting on an absorbent ground, to avoid making any of the paint layers too lean. With the ground drawing some of the oil from the first layer, the first layer might then be absorbent enough to draw some of the oil from the second layer, and the second from the third, and so on. As long as none of these layers is rendered underbound by this process, all should be well. It should be noted that the paints of the Old Masters quite likely had higher percentages of oil than the tubed paints of today, as roller mills and pebble mills produce leaner paint than hand-mulling.

An Important Note Regarding Flake White Paint

The references to flake white throughout this book are intended to include all single-pigment lead-based white oil paints pigmented with basic lead carbonate, those labeled "Flake White" as well as Cremnitz (Chremnitz, Kremser, etc.) White. Today, all the paints so named use essentially the same pigment, despite historic origins of the names, which referenced different lead white pigments than those in use in modern times. The toxicity of lead is a serious health concern, and should not be discounted. It is not the intention of this book to recommend the use of toxic pigments, but rather to explain their properties, desirable as well as undesirable, to better equip the reader with the knowledge to make informed choices that best suit his or her intentions. It should be noted that lead whites containing additions of zinc oxide are sometimes labeled "Flake White" by their manufacturers, and these can be expected to possess different properties from single-pigment lead whites, especially as regards long-term performance, since zinc oxide is a problematic pigment in oil paints.

Oil-to-Pigment Ratios

When working with oil paints, it is important to paint "fat over lean." In other words, paint containing a lower percentage of oil (lean) is best used in the early stage of a painting, followed increasingly by "fatter" paints (paints with a higher percentage of oil) in the latter stages. Flake white is the leanest of all oil paints and works well as the main ingredient in any underpainting.

Relatively lean oil paints:

chromium oxide green
cadmium-barium reds
Venetian red
cadmium reds
Indian red
cadmium vermilion
vermilion
cadmium-barium yellows
cobalt violet
cadmium yellows

All of these paints are lightfast as well.

Moderately lean oil paints:

yellow ochre
Naples yellow
deep ochre
Mars violet
phthalocyanine blue
phthalocyanine green
ultramarine blue

All of these paints are lightfast as well.

High in oil content:

cadmium orange
ivory black
raw umber
raw sienna
burnt umber
Mars yellow
burnt sienna
Mars orange
caput mortuum
Mars brown
green earth
Mars black
cerulean blue
Prussian blue
rose madder
alizarin crimson

Except for alizarin crimson and rose madder, all of these paints are lightfast.[11]

Very high in oil content:

cobalt blue
viridian
manganese violet

All of these paints are lightfast.

The leanest of oil paints is flake white, or chremnitz white, sometimes simply referred to as lead white, or white lead. It was the only white paint available until the discovery of zinc white in 1850 and was the white used by all of the Old Masters. Because of its leanness and density, it is the basis for the underpainting employed in the Venetian technique.

Flake whites ground in poppy, walnut, or safflower oil are not the best choices for underpainting, which requires the greater film strength and the faster drying qualities of linseed oil for optimal performance. However, with the possible exception of poppy oil and sunflower oil, which make weak paint films, flake whites ground in alternative oils such as safflower or walnut oil are perfectly acceptable, and perhaps preferable, for the final layers. As mentioned previously, oil should be added to any flake white intended to be used over a fatter passage.

All lead-based paints, including flake white, are toxic and should be handled carefully. Surgeon's gloves should be worn while preparing and cleaning the palette. If there are any cuts or scratches on the hand, the gloves should be worn while painting as well. (See sidebar on page 121 for additional safety tips when handling lead-based grounds.) The reader may ask why he or she should even bother to use a toxic pigment if there are other, nontoxic, alternatives. This is a choice for each individual artist to make, after weighing the advantages and disadvantages of each possibility.

Flake white, being mostly lead, is highly resistant to the action of ultraviolet (UV) light, which causes the embrittlement of materials that were initially flexible, including human skin. The technical term for this embrittlement is *cross-linking*. It is part of the complex process by which oil paint dries. The oil undergoes a molecular change, turning into a leathery substance called linoxin, which continues to change for hundreds of years after the paint is considered dry, becoming less and less flexible. Flake white withstands the ravages of time better than any other oil paint, owing in part to lead's natural resistance to UV action. It is also very dense, yet somewhat flexible, as lead is a dense yet soft element. These properties make it the ideal oil paint. Generally speaking, oil paint films formed with white lead are structurally superior to the films produced with zinc white, titanium white, and titanium-zinc mixed whites, whose pigments lack lead carbonate's affinity for oil, and which perhaps do not offer the same resistance to UV rays as lead.

Problematic Pigments

For many years alizarin crimson was considered essential to the palettes of most oil painters, and as such was often recommended in books and articles and by famed painters. However, it is not a lightfast pigment. True alizarin is dihydroxyanthraquinone (PR 83). It was originally thought to be less fade-prone than rose madder (NR 9), for which it was developed as a substitute, but late in the twentieth century it was discovered to be less permanent (at ASTM Lightfastness III) than rose madder (at ASTM Lightfastness II). Natural rose madder[12] is acceptably fade resistant when applied in body, full strength, unmixed, but less so when used as a glaze or in mixtures with white. Formulations of paints are subject to

change. Thus it behooves artists to seek out the current formulations of any material they may consider using. Most, but not all, manufacturers are now either adjusting their formulations of alizarin crimson to improve its lightfastness or are offering substitutes made from more reliable pigments.

The author has all but dropped burnt umber from his palette, owing to its high degree of absorbency when dry, which causes varnish to sink in, leaving chalky-appearing "dry spots." It can be useful as a minor ingredient in a paint mixture when faster drying is desired, such as in instances where raw umber would not produce the right color. Both burnt umber and raw umber are essentially clays,

which have a natural tendency to shrink when dry and swell when saturated with a fluid. However, since burnt umber undergoes a heating process in its creation, it is the worse of the two in that regard. Raw umber does not seem to be quite as problematic.

Zinc white has recently been discovered as a cause of delaminations in oil paintings. For this reason, mixed whites or colors containing zinc oxide are best avoided, along with zinc white itself. This includes combinations of titanium dioxide and zinc oxide as well as lead carbonate and zinc oxide. It is especially problematic on stretched canvas primed with acrylic grounds.

The major drawback of using lead-based products is, of course, the potentially harmful effects on the artist using it, and indeed on anyone who inadvertently ingests enough of it, be it in the artist's studio or in the facility where it is manufactured. The toxicity of lead is peculiar in that it produces no symptoms until it reaches a certain level of concentration in the body. It is a cumulative poison, which, once ingested, does not normally or easily leave the body. It is known to cause brain damage and can cause birth defects to children born of mothers with high levels of lead in their bodies. It may also cause various skin problems and, at higher doses, death. It has been suggested that malic acid, present in wine as well as in grape and apple juice, may help remove lead and other heavy metals from the system and reduce the likelihood of harm, but chelation therapy is at present the best treatment known. It is better to exercise sufficient care in the first place than to expect medical science to correct the consequences of our carelessness.

The dangers of lead were not known years ago, and its use was much more prevalent than it is today. Lead white was a component of certain facial cosmetics and was reportedly used by England's Queen Elizabeth I. White lead powder may also have been used to powder women's hair in Europe around the time of Marie Antoinette. An unconfirmed report maintains that during this period women were becoming "simpleminded" at relatively young ages, presumably from inhaling the lead powder.[13] As the story goes, the French painter Elisabeth Louise Vigée-Lebrun was commissioned to paint the portrait of a beautiful young marchioness, whose natural hair color was a lovely chestnut brown. Madame Lebrun, an artist with an eye for beauty, realized that the young woman's natural hair color was far more beautiful than the fashionable white powder, and she convinced the marchioness to pose without powder on her hair. The resulting portrait was reportedly so lovely that it created a sensation and brought to an end the fashion of powdering women's hair. Subsequently, women stopped developing dementia at such an early age and began to live longer.

The dangers of lead poisoning are slight in the case of flake white in the form of oil paint, as distinct from loose powder, as long as it is kept out of the mouth and nose and away from cuts in the skin. It cannot be inhaled, as its particles are encased in a film of oil and bound together by it. Nevertheless, it is advisable to treat all oil paints as if they were poisonous and take sensible precautions with them.

The Sennelier paint company cautions against using any lead-based paint in combination with ultramarine blue or any of the cadmium colors, as they contain sulphur in one form or another. Sulphur can cause lead white to turn black under certain circumstances. However, as long as the paint is properly ground, the actual likelihood of problems developing is very low, because oils in the paint isolate the pigment particles from one another. In paints hand-ground by the artist, the chance of chemical reactions among pigments might

be greater, as it is virtually impossible with a muller and human hands to
achieve as thorough a grind as is found in paint ground on rollers or pebble
mills by professionals. The homemade product could conceivably contain
unground particles that could prove problematic. Varnish should provide
adequate protection from atmospheric sulphur.

DRYING RATE

Unlike other painting media, oil paints dry at varying rates. In the interest of
avoiding structural problems in the paint film, the artist should understand
these differences and consider them when painting. Slower-drying paints
should not be painted over with faster-drying paints, at least until they are dry
beneath the surface, as well as on the surface, or wrinkling could occur. The
danger is greater in thick layers of paint than in thin layers.

It is not advisable to attempt to accelerate the drying of the slower paints by adding driers, as the action of driers continues after the desired objective is reached and prematurely ages the paint layer. Early cracking and/or darkening can result from the use of driers. Some paint manufacturers attempt to speed the drying of the slower-drying paints by adding driers in judicious amounts, calculated to keep risks to a minimum. Adding more drier could increase the risks.

Better methods can be used to accelerate drying. If a slow-drying paint is to be mixed with white, choosing flake white will effectively adjust the drying of the slower pigment. Similarly, creating a mixture with an umber, burnt sienna, phthalocyanine blue or green, or Davy's gray, depending on the color desired, will have the same effect, without causing premature aging. Alternatively, a small amount of an alkyd-based medium may be mixed into the slower-drying mixtures on the palette, if fast drying is desired. Adding too much may speed drying more than is wanted, however, so caution is advisable.

Some manufacturers grind their faster-drying pigments in slower-drying oils, such as poppy or safflower, or a mixture of linseed oil and a slower-drying oil, in an attempt to adjust the drying rates. Driers are used judiciously with the slower-drying pigments in virtually all the major manufacturers' top-quality lines of oil paints. These formulations change from time to time. It is important to know what one's materials are, in order to use them correctly. Some paint makers print the information regarding driers and other additives and types of oils used in their paints on the tube. Others are more secretive, but most have literature available on request. If they do not provide this information, it may be best not to use their products.

TINTING STRENGTH

The next major characteristic of oil paint to be considered is tinting strength. As the name implies, tinting strength means simply how much of a given paint is needed to tint a mixture the desired amount. This is easily enough discovered through experience, but it deserves some attention. The phthalocyanines are among the strongest of all paints in regards to tinting strength. One tube of phthalo blue will probably last most artists a lifetime, unless they waste it.[14] A contemporary painter, Daniel Greene, is fond of saying, "Phthalo blue is the paint your cat will walk in." Anything it touches seems to be permanently stained blue, including the bristles of the brushes it is used with, and perhaps a cat's feet. Needless to say, a little goes a long way.

Venetian red, Mars black, and the cadmiums are other high-tinting-strength colors. Pigments of high tinting strength are useful in underpainting, mixed in small quantities with flake white. Because the amount of a high-tinting-strength color required to produce the desired hue and value is very small, the amount of oil introduced is negligible. The main volume of the mixture remains flake

Drying Rates

Problems can occur when faster-drying paints are used over slower-drying paints. The following are approximate rates of drying of various pigments ground in oil.

Fast-drying oil paints:

burnt umber
raw umber
phthalocyanine blue
phthalocyanine green
Prussian blue
flake white
burnt sienna
Davy's gray

Average-drying oil paints:

Naples yellow
cobalt blue
cobalt violet
chromium oxide green
viridian
all Mars colors
raw sienna
most earth reds

Slow-drying oil paints:

the ultramarines
cerulean blue
green earth
yellow ochre

Very slow-drying oil paints:

the cadmiums
vermilion
rose madder
ivory black
titanium white

Opacity and Transparency

Each pigment has its particular degree of opacity or transparency. These characteristics may be exploited to good effect by artists who understand their paints well.

Transparent oil paints:

viridian
green earth
ultramarine blue
ultramarine violet
rose madder
manganese violet
ivory black
cobalt violet
Indian yellow
quinacridone gold
transparent oxide red
Prussian blue
transparent oxide yellow
phthalocyanine blue
transparent oxide brown
phthalocyanine green
green gold

Except for rose madder and Indian yellow, all of these paints are lightfast.[15]

Semitransparent oil paints:

burnt sienna
Davy's gray
raw sienna
cobalt blue
transparent gold ochre
aureolin
(some) burnt umber

Except for aureolin, all of these paints are lightfast.

Semi-opaque oil paints:

(some) raw umber
yellow ochre
greenish umber
vermilion
(some) burnt umber
deep ochre
burnt green earth
gold ochre

Except for the poorer grades of vermilion, all of these paints are lightfast.

Opaque oil paints:

flake white [16]
Mars black
titanium white
Mars yellow
Naples yellow
Mars orange
(some) cadmium yellows
yellow ochre
cadmium reds
Mars red
cadmium orange
Mars violet
Venetian red
Mars brown
Indian red
brown ochre
light red
caput mortuum
English red
Pozzuoli earth
terra rosa
red ochre
chromium oxide green
cerulean blue

All of these paints are lightfast.[17]

white, and thus quite lean. This ensures that the underpainting will offer the greatest strength, durability, and leanness.

OPACITY VERSUS TRANSPARENCY
One characteristic of oil paint that is generally overlooked in modern times is the degree of transparency or opacity of the pigment. In the early centuries of oil painting, this aspect was common knowledge among painters, as the natural tendency of each pigment had to be exploited to its fullest potential in order to compensate for the small number of reliable pigments available for artists' use. While we have a much wider range of colors available to us today, it is still useful to put the knowledge of opacity and transparency of our pigments to work for us. The nature of each pigment is most easily discerned by examining

the powder from which the paint is made under a microscope. Opaque pigments resemble little colored rocks, while transparent pigments are tiny crystals, through which light rays can pass. There are also varying degrees of transparency.

By distinguishing between transparent and opaque paints, one can employ them systematically to expand the range of effects possible when painting in oils. This is precisely what the Old Masters did and is one reason why their works are so convincing in conveying the illusion of three-dimensional depth. (The methodology for the aforementioned systems is explained in greater detail in chapter 6.) When setting up the palette, it may be helpful to isolate the transparent paints from the opaque.

For painting passages with the highest degree of transparency, the best choices are, naturally, the truly transparent pigments. For opaque passages and scumbles, opaque pigments are most effective. For semiglazes, the choice would depend on whether the area to be altered by the semiglaze represents an area lit by direct light, reflected or secondary light, or shadow. Opaque paints are most effective in areas representing solid surfaces illuminated by direct light from the primary (strongest) light source. Transparent paints are used for the deepest shadows, darks in the foreground, and special effects.

Artists who fully understand their paints' tendencies and how to use them have a few more tricks in their repertoire than those who do not. In a language that transcends words, as painting does, this amounts to an expansion of the vocabulary.

Mediums

The purpose of an oil painting medium is to modify the paint in one way or another, to make it more suitable for the desired effect than paint as it comes from the tube. Many tube paints have a stiff, pasty consistency, owing to the aforementioned use of stabilizers. This pastiness is not agreeable to all artists, as the paint tends to flow poorly under the brush. This leads painters to look for mediums that can be added to these paints to improve their brushing characteristics. However, it might be more to the point to look for paints that are closer to the right consistency to begin with, before we assume that a medium is the best solution to the problem. Less stiff oil paints are available on the market. These require little or no medium to be added in order to be controllable under the brush. The need for medium would be obviated or greatly reduced by eliminating overly stiff oil paints from our palettes, if their consistency is unsuitable. The paints of the seventeenth-century and earlier oil painters most likely were ground to the proper painting consistency with linseed or walnut oil and rarely needed to be adulterated with anything else. We can come closer to this ideal by beginning with the right paints than by looking to mediums to render stiff tube paints more controllable.

Proper Use of Mediums

Problems are avoided by limiting the use of mediums to no more than is absolutely necessary for the desired effect. Glazing is better accomplished by manipulating transparent paint into very thin layers by the means of application, such as by heavy brush pressure or by stippling, than by diluting it to a thin consistency with large amounts of a transparent fluid medium.

Too high a percentage of oil or medium, and too low a percentage of solid matter (pigment), will result in a weak paint film, which will be susceptible to the development of a number of problems in the years to come, for several reasons. An understanding of the principles at work may be gained by using masonry as an analogy. In masonry, the strongest structure is one in which the stones fit together well and only a minimum of mortar is used. A structure with poorly fitting stones and much mortar will crumble more easily. The particles of pigment in a paint film are comparable to the stones in our analogy, and the binder/medium is the mortar. Too much medium and too few pigment particles to bolster them with solid substance make for a weak paint film.

In situations where greater transparency of certain paints is desired, it may be wise to add body by mixing a bit of an inert pigment into the paint as a transparentizer, to reduce the amount of medium necessary to produce translucence. Rembrandt is known to have used chalk (calcium carbonate) and ground glass, perhaps for this purpose, among others. By making full use of pigments whose nature it is to be transparent, the knowledgeable painter can employ transparent and translucent effects without resorting to too liberal use of mediums.

The modern alkyd mediums are currently becoming popular, and these show promise. It must be stressed that they, too, should be restricted to no more than is absolutely necessary for the effect sought. If one is to use alkyd mediums, it may be advisable to add a small amount to the paints in every stage of the development of a given picture, in the interest of chemical consistency and to reduce the likelihood of painting a faster-drying passage over a slower-drying one.

Mediums can be helpful, but it is important to use them wisely. (See the adjacent sidebar, Proper Use of Mediums.) When working with oil paints, it is always best to keep the amount medium used to a minimum, to maintain the structural soundness of the paint film. This is true of any oil painting medium. One of the many reasons why oil painters add mediums to their paints is to make them more transparent, for glazing. This can actually be accomplished in other ways, however, that are less likely to cause problems with the paint layers. If we select only paints that are by nature transparent for transparent passages, less medium is required to produce a satisfactory glaze, and the risk of harm is eliminated or greatly reduced.

Too much emphasis is focused on mediums, and too much is expected of them. The belief that one particular medium will enable us to paint better than we could without it, or than we could with some other medium, is misguided. Talent does not reside in any medium. The ever-popular quest for the magic medium that will unlock the long-lost secrets of the Old Masters is seductively romantic but ultimately must be recognized as no more realistic than any other fantasy. The primary purpose of a medium is simply to thin the paint to a brushable consistency. If the paint is not too thick to begin with, no medium is needed, and this is perhaps the best-case scenario.

Oil is the most essential ingredient in mediums. It is often used alone, although it can be mixed with other things (such as balsams, wax, resins, and solvents) to produce more complex mediums. In instances where a more fluid paint is sought than what has come from the tube, a drop or two of oil, added to the paint on the palette and mixed in well with a palette knife, is often all that is needed. Linseed, walnut, and poppy oils are the oils most frequently used in oil painting mediums, either in raw form or polymerized in one way or another. Stand oil is one form of polymerized linseed oil that is commonly used in mediums. Its properties are quite unlike those of raw linseed oil, enough so that it bears discussing separately, even though it is technically a linseed oil.

Linseed Oil

Linseed oil is the best oil for making oil paint. Its film-forming properties, adhesive strength, and drying time are all superior to the other oils commonly used in oil painting. Its tendency to turn yellow is not as great a problem as is widely believed, as long as it is used in the proper proportion with the pigment. The yellowing of linseed oil is most pronounced on short aging, after which it begins to bleach on exposure to light. After ten years or so, the yellowing is no longer noticeable, except perhaps where the oil has been added too liberally as a painting medium. Alkali-refined linseed oil seems to yellow less than cold-pressed linseed oil, although advocates of cold-pressed linseed oil assert that it has other qualities that make it preferable to alkali-refined oil.

Stand Oil

Stand oil is a polymerized linseed oil, produced by cooking at high temperatures in the absence of oxygen. Its consistency is long and stringy, like honey, owing to the reorganization of its molecules during the cooking process. As an additive in mediums, it imparts long brushing characteristics to the paints. Stand oil is slightly yellow in color but does not darken appreciably with age. It must be thinned with a solvent to overcome its syrupy thickness before it can be added to paints. It adds strength and flexibility to paints to which it is added and increases resistance to solvents, once cured.

If there is a drawback to using stand oil, it would be that it adds gloss to the paint layer. Also, since it is an oil, it must be used with the appropriate cautions to avoid violating the "fat-over-lean" rule. If the amount of stand oil used is kept to a minimum, the gloss is not usually increased enough to be objectionable, at least in smaller paintings. The thick consistency of stand oil necessitates thinning it with solvent. If the amount of solvent is excessive or if too strong a solvent is used, the binding power of the paint can conceivably be weakened. Odorless mineral spirits (OMS) would be the least likely to cause problems. A popular medium for oil painters is a 50/50 mixture of stand oil and OMS.

Washing and Sun-thickening Oils

Cold-pressed or other raw oils may be improved, for artists' purposes, by "water-washing," a process used by artists of centuries past to remove water-soluble impurities from oils to be used in painting. The procedure is fairly simple. Equal volumes of oil and distilled water are placed in a clean bottle (clear plastic works well), leaving space for air as well. The bottle is capped, shaken vigorously for at least one minute, then allowed to settle overnight. A layer of scum will form between the water and the oil. The scum is what has been "washed" from the oil: water-soluble impurities. The oil should be carefully removed without allowing any of the scum or water into the new container for the oil. This can be done most simply by cutting a hole in the bottle at the appropriate level to allow the purified oil to drain out without disturbing the scum and water layers. The process can be repeated as many times as necessary, until no scum layer is formed. The oil will then be as pure as it can be made and can be used for grinding paint, made into sun-thickened oil, or utilized as an ingredient in a painting medium.

Sun-thickened oil is made by washing the oil as above and then, after the final shaking, replacing the cap with a porous cover, such as cheesecloth, and placing the bottle in full sun in a window. The water is left in with the oil. The bottle should be shaken every few days, with the cap repositioned, and then replaced with the cheesecloth again afterward. After several weeks, the oil will have become bleached and thickened. The oil is then separated from the water and placed in an airtight bottle. A small amount of alum or diatomaceous earth may be added to absorb any water remaining in the oil. It will settle to the bottom and the oil will clear. Marbles should be added to raise the level of the oil to displace all of the air in the bottle. More marbles are added as the oil is used.

Sun-thickened Linseed Oil

Sun-thickened linseed oil is very similar to stand oil. It is produced by exposing cold-pressed linseed oil to the sun over a layer of water for a period of weeks, or months, after removing the impurities by a process called "water-washing." (See adjacent sidebar.) Sun-thickened linseed oil, like stand oil, is polymerized (long), but dries faster than stand oil and may not resist yellowing quite as well. Sun-thickened linseed oil may be used in place of stand oil when faster drying is needed. However, sun-thickened oil is pre-oxidized, unlike stand oil, which is heated in the absence of oxygen, so it is likely to be inferior to stand oil in long-term performance. Like stand oil, its consistency is thicker than raw linseed oil, and thus it is generally used in conjunction with a solvent, such as turpentine or mineral spirits.

Other Oils

When a short (as opposed to long) painting medium is called for, the best oils are walnut, poppy, and safflower. Leonardo da Vinci is known to have used walnut oil. All three are similar, but walnut oil dries faster than the other two. Many modern-day paint manufacturers prefer safflower oil as a binder, but there are exceptions. Painters interested in working with walnut oil can probably find it at health food stores and through art materials suppliers and can "wash" it with water, just as Leonardo did, if they wish to. Water-washing removes some of the impurities and improves the clarity and resistance to yellowing.

BALSAMS

Balsams are the saps of coniferous trees, including various firs, larches, and pines. They have a long history as additives to paints to impart an enamel-like brushing consistency and self-leveling tendency. The most widely known of these balsams are Venice turpentine, Strasbourg turpentine, and Canada balsam. The term *turpentine* in this case predates the use of that term for the solvent distilled from these balsams. Canada balsam is very similar to Strasbourg turpentine and Venice turpentine, except that it dries faster. It is available from chemical supply houses, its more common use being as an adhesive for the glass slides used with microscopes.

Balsams are sticky substances. Adding small amounts of them to oil painting mediums creates a long brushing quality, which works well with soft-hair brushes and "liners," among others. They facilitate the introduction of sharp, precise strokes into areas of wet paint. Some people have postulated that the use of balsam was one of the tricks of the Flemish Masters' technique.[18] Pine resin, a balsam, has been detected in certain passages in some seventeenth-century Dutch and Flemish paintings, most frequently in conjunction with heat-bodied oil, apparently used as a medium for transparent glazes and perhaps other special effects.

It is important to note that the presence of balsam in a paint layer increases its solubility in solvents used in removing old varnish in restoration and thereby increases the possibility of accidental removal of some of the paint during these processes. Its use is best restricted to certain special effects, rather than general. Balsams are useful in conjunction with stand oil or sun-thickened linseed oil in special effects long mediums used for linear strokes such as in signing an artist's signature. Like stand oil, sun-thickened oil, and resins, balsam adds gloss to the paints in which it is an ingredient. The proper solvent for balsams is gum turpentine.

WAX

For a general-use matte medium, beeswax is recommended by some authors. It can be melted in a double boiler with gum turpentine or mineral spirits and then added in very small amounts to a medium containing stand oil, walnut oil, or both. Walnut oil is short and will slow the drying rate somewhat. The beeswax will help mitigate the glossiness of the stand oil; however, too much wax in the paint will lower its melting point and make for a generally softer paint film. What amount would be too much is sometimes difficult to determine, and for that reason it might be wisest to avoid wax altogether as an additive to oil paint.

RESINS

There is considerable interest in natural resins, and mediums featuring them as principal ingredients, as there has been at least as far back as the mid-eighteenth century. Resinous mediums remain widely popular today, owing in large part

to the writings of several authors who recommended the use of one or another of them and who postulated that the Old Masters used them extensively. Scientific discoveries made since the books in question were written make it necessary to examine these long-held views in a new light. The enduring popularity of these mediums and the attendant beliefs call for lengthy discussions here, along with discussion of the resins themselves.

Four types of natural resins are used in modern times in oil painting mediums: damar, mastic, copal, and amber. Some painters use resins to add transparence to the paints; others use them to adjust the flow characteristics of the paint to suit their individual preferences. These objectives are not difficult to achieve with resinous mediums. Some writers have expressed concern over possible wrinkling of the paint film in instances where too much oil is added to the paint; this tendency would be mitigated to some degree by the addition of a resin. However, each resin has its advantages and drawbacks, which should be understood by any artist who considers using any of them.

Damar

Perhaps the most popular resin in current use is damar, or dammar. It is a soft resin from Southeast Asia, widely used in the twentieth century as a final varnish and as a component in resin-oil mediums. Recipes for these mediums were provided by Ralph Mayer in *The Artist's Handbook*, first published in 1940. The rationale behind Mayer's advocacy of damar seems to have been primarily that it was better suited than mastic or copal as an ingredient in oil painting mediums and that the tendency of oils to shrink and possibly wrinkle as they cure and age needed to be checked. These premises are essentially correct, but whether adding resins to oil painting mediums is the best solution is a question that needs to be asked, as there are other possibilities worth considering.

One of the drawbacks of damar is that it darkens over time. The darkening may be less than with mastic, copal, or amber, but it is a matter of degree only. Unlike the darkening of oil films, the darkening of damar resin is not reversible.[19] Used in small amounts, damar might not cause problems. The question would then be, How much is too much? Another disadvantage of damar is that it is soluble in turpentine and other relatively mild solvents and remains so for many years. The potential for harm here is that if the painting requires cleaning and revarnishing at some point in the near future, the solvent used to remove the original varnish may also remove some of the paint, if damar is an ingredient. Again, this may not occur if only a small amount is used, and if the final varnish applied over the dry painting is one that does not yellow and is soluble in, and *remains* soluble in, milder solvents. A third potential problem with damar is that it is brittle, and this could lead to premature cracking of the paint layer. Whereas a cracked or darkened final varnish can be removed by expert restorers in order to reveal the painting more or less as it appeared when it was freshly painted, there is no comparable treatment for these problems when the

varnish resin is in the paint layer. With paintings on rigid supports, the flexibility issue would not be of any major concern; however, it might well be significant where the support is stretched fabric.

Mastic

Mastic, the sap of the pistachio tree, is a somewhat soft substance, easily resoluble for many years in solvents commonly used in removing old varnish. Its presence in a paint layer increases the chances of the painting losing some of its paint along with the varnish when the painting is de-varnished in restoration. For conservators charged with the responsibility of restoring old paintings, it presents problems. Mastic becomes very brittle with age and darkens. It also has been known to turn cloudy, or "bloom," discolor, and develop blisters. Its use as an ingredient in works of art is therefore not advisable if archival quality is a concern.

As Ralph Mayer was more or less the champion of damar, Jacques Maroger[20] was the twentieth century's most outspoken advocate of mastic resin as an ingredient in oil painting mediums. Maroger (1884–1962) was a French artist who studied at the Louvre around 1907, when he realized that the paintings of the Old Masters contained transparent passages, unlike copies painted from them at the time, and were seemingly impossible to duplicate by any method then known to him. He became obsessed with solving the mystery of the differences between contemporary works and those of the Old Masters, as Reynolds had in the eighteenth century, and he began experimenting, in search of the secrets of the Old Masters. Maroger published a book in 1948 called *The Secret Formulas and Techniques of the Old Masters*. The medium that today bears his name is made from what he calls "black oil," mastic resin, and gum turpentine. Black oil is linseed oil cooked with litharge (lead monoxide) at high temperatures for a specified length of time, until the lead is incorporated into the oil.

Maroger is perhaps correct in his assertion that black oil was used by some artists of the past. Its use was most likely as a drier, and it may have been the best thing available for that purpose at the time of its invention. When black oil is mixed with mastic resin in the presence of gum turpentine, it forms a soft gel. This medium does, indeed, greatly improve the brushing qualities of oil paint, when used according to Maroger's instructions. Furthermore, it has a pleasant smell and is fascinating to prepare, bordering on alchemy. Variations of the basic Maroger medium are named after the Masters who were alleged to have used them, such as, "Rubens's Medium," "Van Eyck's Medium," and so on. Whether these painters actually used the mediums bearing their names is an open question. Science has not confirmed Maroger's contentions, and the more testing that has been done on old pictures painted by the artists named, the more doubt has been cast upon these claims.

Jacques Maroger is perhaps correct regarding some of the painting techniques outlined in his book, insofar as they work well, and he may even be correct in

his formulations in some cases. But the premise that one cannot paint well without his medium has been disproved by enough fine painters of the past and present to lay that particular notion to rest. The superiority of these mediums lies in the improved brushability of the paint, but there are reasons to expect a tradeoff in longevity.

Copal

Just as Ralph Mayer favored damar, and Jacques Maroger championed mastic, copal resin had its chief advocate in Frederic Taubes. An excellent writer, Taubes was a Bauhaus alumnus who immigrated to the United States and authored at least forty books on art. His books are a curious mixture of insightful opinions eloquently expressed, dubious judgments expressed with equal eloquence, and technical advice, some of which is perhaps sound and some of it highly questionable. Taubes, Maroger, and Mayer seem to have had a sort of rivalry or enmity among them, and the writings of each contain criticisms of the others' pet views, although usually without names being mentioned. The reader with a sound understanding of artists' materials and techniques can perhaps sift through Taubes's writings without running the risk of being misled, and can possibly benefit from it, as long as everything is considered suspect. The danger is that unless one has read enough opposing views, Taubes's eloquence could persuade the reader that some of his worst ideas are better than they really are, with potentially detrimental effects on the works subsequently produced following his advice. The same may be said of Maroger.

The main point of the advocates of copal is that soft resins such as damar and mastic are not the best things to use in oil painting mediums, owing to their resolubility and the attendant danger of overcleaning; copal is therefore preferable by virtue of being highly resistant to the action of all but the strongest solvents. This view is generally correct, with certain qualifications. Hard resins are thought by some to have been used by early Flemish oil painters. This remains unproven, however.

The name "copal" is applied to a number of resins having little in common beyond the name. Some of these are much softer than the Congo or Sierra Leone copals favored by Taubes. It is possible to obtain a product labeled "copal" that shares the faults of most copals without the advantages. The reported faults of copal are a tendency to darken, become very brittle, and dry slowly. The slow drying compels some manufacturers or users to add driers, which then add the ill effects of another concoction to the formula. The hard, fossil varieties of copal must be melted at high temperatures before they can be incorporated into boiling oil or diluted with solvents. The result is a much darkened substance, in most cases black, or nearly so. The same is true of amber.

Discussion of copal is largely irrelevant today, because the best grades are no longer widely available. The deposits are located in areas of Africa subject to

periodic outbreaks of political unrest and the violence that always accompanies these problems. Thus the mining of copal is sporadic, and examples on the specialty market may not be what they are represented to be. Synthetics have been developed that may prove to be superior in a number of ways, thus reducing demand for the natural product.

Alkyd, a synthetic resin, is similar to copal in its resistance to solvents, reportedly without the disadvantages, at least in the formulations with oil as sold as fine artists' materials. There are several alkyd-based painting mediums currently on the market, any of which might be considered an acceptable substitute for copal. If there is a drawback to the alkyds, it is that the drying time of some of them may be too fast for some artists' preference. Problems could occur if a fast-drying passage were applied over an incompletely dried area consisting of a slower-drying paint. If the area in question were large enough, and the superimposed layer too evenly distributed and/or too heavily applied, wrinkling or cracking could take place at some point. As when using any medium, it is always best to keep the amount added to the paint to a minimum, to maintain the structural soundness of the paint film. The "rules," as it were, allow greater latitude when the paint layers are thin. There are varying opinions on the prognosis for the longevity of alkyds in fine art oil painting mediums. Early indications suggest that, properly employed, they could conceivably outlast any of the materials they are used to replace.

Amber

Amber need not be gone into in depth here, in light of the fact that virtually everything that has been said about copal is also true of amber. It is a fossilized resin, older than the fossil varieties of copal, but essentially possessing the same properties. Like all of the natural resins, it has its advocates, who swear by its use and are steadfast in their belief that it is the secret of the Flemish Masters. The underlying fallacy with these reasons for using natural resins in oil painting mediums is the notion that the excellent results achieved by the Old Masters are attributable to a significant degree to the mediums they added to their paints. It is more likely that the principal factors that enabled the Old Masters to paint as well as they did were accurate observation, thorough training, and a great deal of practice, beginning early in life, with no shortcuts. The other factor was a complete understanding of the capabilities of their materials and the methods of employing them.

SOLVENTS

The solvents most commonly used in oil painting today are gum turpentine and odorless mineral spirits (OMS). OMS is a twentieth-century addition to the artist's materials market. Gum turpentine is still preferred by many painters, for a variety of reasons. The highest quality of gum turpentine is generally considered to be double-rectified distilled spirits of turpentine, sometimes called English distilled turpentine. The more highly refined, the fewer impurities it will contain.

Before OMS entered the picture, most painters used gum turpentine where solvent was required, with a few exceptions where oil of spike lavender or alcohol was used instead. Another solvent that is coming into use today is the distilled essence of citrus peel oil, called limonene or d-limonene. Some general points should be made before we get into specifics of the individual solvents, however.

It is likely that at least some of the painters of centuries past painted without solvents, although we cannot know with certainty either way. Aside from the health concerns associated with using solvents, there are important considerations regarding the painting itself. Solvents affect vegetable oils in more than one way. This includes dried films of oil paints bound with vegetable oils, as conservation literature demonstrates. The specific effects of specific solvents on dried oil paint films is too complex an issue to go into here. Different solvents do different things. It is sufficient, at this point in the discussion, to state that solvents change things and to realize that it is not a situation analogous to thinning watercolor paints with water. It is a much more complicated chemistry where oils and solvents are concerned. To what extent oil paints can be thinned with solvent before they are adversely affected is open to speculation, but we can be certain that they will not be affected by them at all if no solvents are introduced into our paints whatsoever.

There is a widespread belief that thinning with solvent makes the paint leaner, and that this is therefore desirable in the early stages of a painting. This practice could well cause adhesion problems between layers, as the excessive amounts of solvent normally used in this procedure could weaken or destroy the binding power of the vegetable oil in the paints thus thinned, leaving an underbound layer between the ground and subsequent layers of paint. Perhaps if the next layers contained sufficient percentages of oil, enough could transfer to the lay-in layer and/or the ground to bind things together adequately, but this must be regarded as a questionable practice.

A similar danger accompanies the use and overuse of mediums in which a solvent is a major component. In the popular damar–stand oil–gum turpentine mediums, the solvent must be gum turpentine, as mineral spirits will not completely dissolve damar. Turpentine is a stronger solvent than mineral spirits, thus its action on the oil in the paint is more profound. Its vapors are also more harmful to the health of those who inhale them. If one must use a liquid medium, a simple mixture of stand oil, OMS, and perhaps linseed oil would be an improvement over the damar–stand oil–gum turpentine mediums.

Citrus peel solvent, known as limonene or d-limonene, has been recently introduced as a solvent in art materials. While its odor is more pleasant, it must not be assumed to be any safer to use than gum turpentine. It is advisable to look into the latest health information before deciding to use a new material.

Health Risks with Solvents

It is common to see oil painters, including highly accomplished ones, painting with an open container of solvent, dipping the brush into the container to rinse it off or pick up some of the solvent to thin the paint. While this practice is fine for water-based media, whose solvent is water, it involves health risks to the painter and to everyone who breathes the air contaminated with the solvents normally used with oil paints. Whereas water vapor is harmless to the health of humans, the vapors of turpentine, citrus, and petroleum distillates most definitely are not. Methods of painting in oils without solvent are detailed in chapter 6. The reader is urged to take these cautions to heart and to try the suggested methods, in the interest of the health of the artist, the model, the students, and any air-breathing person or animal sharing the same air space.

One caution should be issued here regarding OMS. Its absence of odor should not be construed as an absence of health risks. Its odorless nature can lead the artist to prolong the exposure to its vapors, thereby increasing the likelihood and seriousness of health consequences.

Varnishes

Oil paintings require protection in order to last. This is perhaps the best use of resins in connection with oil painting. One hundred years ago, varnishes were essential for protecting oil paintings from pollutants prevalent in the air. The situation is not quite as drastic as it was in the days when the only white pigment used in oil painting was white lead, and when homes were heated and industries powered by the burning of coal, which pollutes the air with sulphur compounds. White lead and other lead-based pigments can turn black when exposed to sulphur. Today, coal is less extensively used in industry and home heating, and artists have other options for white paints, so the problems are

alleviated somewhat. However, for optimum archival performance, it is still advisable to varnish oil paintings after the paint layer has had sufficient time to cure. This can vary from six months to one year, depending on how thin or thick the paint layer over the majority of the painting is, on which pigments and mediums have been used, and other factors.

Until the relatively recent development of synthetic resins suitable for use in picture varnishes, the best varnish for oil paintings was damar resin in solution with gum turpentine, in what is referred to as a five-pound cut. This varnish is still in wide use, owing to its excellent optical properties and to the fact that it has been around for a century or so. It is not without fault, however, as it does turn yellow and ultimately brown and grows increasingly brittle and thus crack prone, which makes it necessary to remove it and replace it every thirty to fifty years. The longer damar varnish is left on a painting, the darker and more brittle it becomes, and the stronger the solvents required to remove it. This has led conservation scientists to look for something that shares damar's optical properties without its problems. The ideal varnish would not yellow or embrittle, would remain removable in mild solvents, and would have a refractive index comparable to damar.

There are perhaps two synthetic varnishes worth considering, both of which show promise of outperforming damar over the long term. One is based on mineral-spirits-soluble acrylic (MSA) resins, and the other is based on a synthetic resin in the vinyl family called regalrez. The latter was developed by conservation scientist René de la Rie and is currently being marketed by Gamblin Artists' Colors under the name of Gamvar. MSA varnishes are currently sold by Golden, Liquitex, Winsor & Newton, and perhaps other firms as well.

It is important for a varnish to be easily resoluble in mild solvents largely because it is possible that unforeseen defects, such as darkening, cracking, or clouding from cross-linking or bloom, might develop with the varnish at some point. In this case the varnish would have to be removed in order to restore the picture's appearance. The milder the solvent that can be used to accomplish this removal, the less risk there is to the painting.

Varnish adheres best when the surface of the painting is clean and dry. It is advisable to clean the surface the day before it is to be varnished, using a soft, lint-free cloth dampened slightly with OMS. Probably the ideal time to apply varnish is in the middle of the day, on the hottest, driest day of the year. Moisture is not good for oil paintings. A sign painter's cutter brush works well for varnishing, with the painting lying flat. Spray application also works well, although this method involves increased risks of inhaling varnish particles, which are harmful to the health unless one wears a particle filter mask, and potentially increased inhalation of solvent vapors. Practice will bring finesse with either brushing or spraying. One coat is usually sufficient, as long as even coverage is achieved.

Brushes

The best oil painting brushes have changed little throughout history. The two main types have always been those made from stiff bristles from the backs of hogs and those made from soft hair that comes from animals such as sables. Cennino Cennini, in his fourteenth-century treatise on painting, described how soft-hair brushes were made from the tails of minivers, and stiff-bristle brushes from the hairs of a hog. (A miniver is a small weasel, or sable.) Cennini described brushes that had flat tips and others that formed a point. The ferrules were sections of goose quills into which the tied bundles of hairs were inserted and glued on one end, and into which the wooden handles were inserted and glued on the other. Both ends were then wrapped and tied with string. Artists made their own brushes, at least until they had taught their apprentices how to do it properly.

Artists of today have a few more choices, including flat brushes, made possible by the use of metal ferrules, which came into popular use in the nineteenth century. In addition to the various types of natural hair, there are now several kinds of synthetic bristles from which brushes are made. However, the highest-quality soft brushes are still made from weasel hair (i.e., sable—essentially the same as miniver—and kolinsky sable) and stiff brushes from hog bristle.

The filbert shape is perhaps the most significant development in the evolution of oil painting brushes, as it may be the most versatile brush of all. With their rounded tips, filbert brushes resemble well-worn flats but are capable of creating a more precise stroke, because the natural point of the hair is still present. Turned sideways, a filbert makes a narrow, linear stroke similar to that of a much smaller round but with softer edges. Used full width, its stroke is broad, like that of a flat, but without the sharp edge characteristic of a flat. Filberts are particularly useful in portrait and figure painting. The most commonly used filberts are made from hog bristles, but soft-hair filberts are also available. Ox hair, sometimes called sabeline, makes an excellent filbert brush, capable of creating the most subtle effects in oils. Sables are also available, including the extremely expensive kolinsky. Kolinsky's superiority is greater in watercolor brushes, where its unique springiness is used to great advantage. In a thicker medium such as oil paint, there is less of an advantage. Ox hair works nearly as well in most cases and seems to last longer.

Each type of brush hair has specific applications for which it is more well suited than the others. Hog-bristle brushes work well with short paint on medium- to coarse-textured canvas. They hold more paint than softer brushes and more readily accommodate a heavy application of paint. Impasto touches are also best applied with hog-bristle brushes.

Soft-hair brushes work best in combination with long paint on smooth-textured canvas or panels. They are also useful in painting over areas where the paint

Top:
These hog-bristle brushes are (from left to right) round, bright, flat, and filbert.

Above:
This simple brush holder was made by drilling holes into a lumber scrap. The holes allow it to accommodate many brushes with different colors on them, which helps keep them from soiling one another the way they might in a jar or can.

Caring for Brushes

The life of a paintbrush is greatly extended by proper care and cleaning. It is advisable to avoid overloading the brush with paint to the extent that paint reaches the ferrule. Paint is very difficult, perhaps impossible, to remove from under the ferrule, and if allowed to dry there, it creates a "shear point" on the shaft of each bristle, just above the ferrule. The dried paint stiffens the hair it encases, and the bristles eventually break off as a result. By carefully restricting the paint to the forward half of the exposed bristles, and by thoroughly cleaning the brushes after each use, the artist can keep them in optimum condition for many years.

Turpentine should not be used for cleaning brushes unless its gummy residue is then washed away with soap and water. Soap and water alone will remove oil paint, or if a solvent rinse is desired, OMS is a better choice than turpentine, as it leaves no sticky varnish in the brush. Old-time sign painters prefer kerosene, as the tiny amount of non-evaporating oil left behind is absorbed into the bristles and acts as a conditioner. Vegetable oil can be used, for that matter. If used while painting, it would be best to use walnut or safflower oil, or some other oil that is commonly used as a binder in oil paints. After the painting session is ended, any kind of vegetable oil would work just as well, as long as the brushes are washed out with soap and water afterward and allowed to dry before being used again. The oil conditions the bristles and extends the life of the brush. Washing brushes without solvent minimizes the artist's exposure to harmful vapors.

A large coffee can, or any large can with a tightly fitting cover, makes an ideal brush washer. Hardware cloth, sometimes called rat wire, may be bent, cut, and folded into the shape of a cylinder with a flat top and placed inside the can, with the flat surface up. The can should then be filled to just above the wire screen with the solvent of choice. The brushes are gently rubbed on the screen, just below the surface of the oil (or solvent) until they are clean enough. The solid matter sinks to the bottom of the can as the oil or solvent near the surface clears. All brushes should be periodically washed with soap and lukewarm water, even though no paint may be visible on the bristles. Dried paint can be removed by washing with soap and water and then leaving the lather on the bristles for several hours to soak into the old paint, rinsing and repeating the process as many times as necessary until all the dried paint has been rinsed out. In extreme cases, this may take days, but the brush can be saved. If freshly washed brushes are hung by the handles to dry, bristles down, the water will not be as likely to reach the wooden handles. Water causes problems with wood, including warping, splitting, and rotting.

By understanding the relative strengths and weaknesses of the many materials available, and the best means of employing them, the artist can create works that will last for centuries. Posterity is the ultimate judge of an artist's worth. Those whose works decompose rapidly are destined to lose by default.

has become too tacky to continue using the stiffer hog-bristle brushes, if the artist has not reached a stopping point by that time. Note that paint applied at that point should be more newly squeezed than the tacky paint onto which it is added, for good adhesion. Used in conjunction with a long medium (one that contains stand oil or sun-thickened linseed oil and/or a balsam, such as Venice turpentine, Canada balsam, or Strasbourg turpentine), a soft-hair brush in a skilled hand can make crisp strokes through areas of wet paint without picking up any of the underlying color.

Each brush has at least one type of stroke for which it is supremely suited. Beyond what has been discussed here, this knowledge can only be gained through much practice. Generally speaking, however, a brush that seems too large for the intended application will do the job better, and produce a more agreeable stroke, than a small brush, once the artist has gained precise control of it through a great deal of practice.

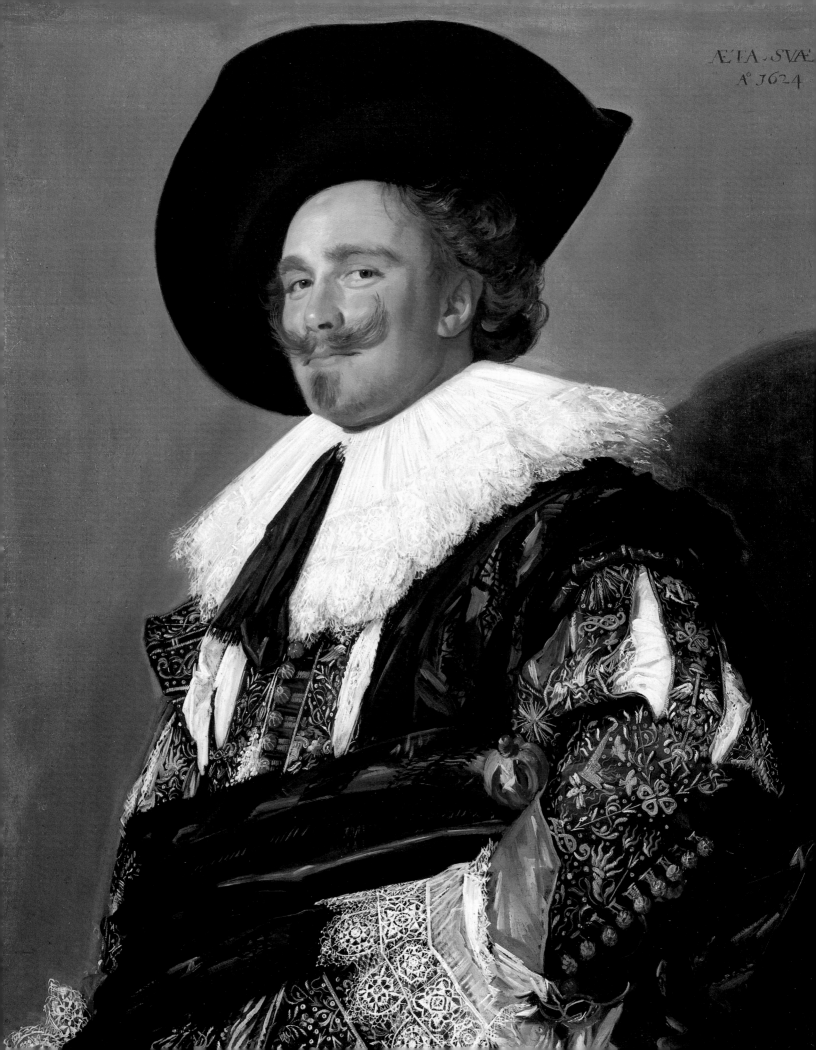

Chapter Eight

PORTRAITURE

WHEREVER A GIVEN ARTIST'S greatest interest lies, the study of portraiture should not be overlooked. The human face and form can add immeasurably to the power of a painting, and the challenge of mastering the subject forces artists to expand their capabilities and hone their powers of observation to the highest degree possible. Mastery of portraiture improves the artist's ability to paint any subject. Many of the world's greatest masterpieces are portraits: Leonardo's *Mona Lisa*, Velázquez's *Las Meniñas*, Lawrence's *Pinky*, Gainsborough's *Blue Boy*, Rembrandt's (so-called) *Night Watch* and *The Syndics of the Drapers Guild* (sometimes called *The Dutch Masters*), Titian's *Man with a Glove*, Holbein's *Henry VIII*, and Frans Hals's *Laughing Cavalier*, to name only a few.

Portraiture in modern times has been maligned in many ways, one allegation being that it is a lesser form of art. The reader is encouraged to pay no heed to these notions when they are encountered, as they are without foundation. The greatest artists throughout history have painted portraits, and at least the best of these are unquestionably great works of art. To create great works of art is what we should strive to do ourselves, whatever our chosen subject for a given painting may be.

Artists have always been called upon to paint portraits, and the practice has sustained many of history's greatest painters. Just as still-life paintings have

Opposite:

FRANS HALS (Dutch, circa 1582/1583–1666), *The Laughing Cavalier*, 1624, oil on canvas, 32 5/8 x 26 3/8 inches. Reproduced by kind permission of the Trustees of the Wallace Collection, London.

The subject is neither a cavalier nor is he laughing, but his confident bearing comes through so strongly that we feel we know this man and like him. This was Frans Hals's special talent. Despite all the finery of the costume, the face and its personality dominate the picture. We are looking up at him from a somewhat lower position. His body language reinforces the attitude of pride and self-assurance. The original title is unknown, as is the identity of the dashing young man who seems to be amused by something we just said.

Left:

TITIAN (TIZIANO VECELLIO) (Venetian, circa 1488–1576), *Man with a Glove*, circa 1520–1522, oil on canvas, 39½ x 35 inches, Louvre, Paris.

The hands, and the jewelry partly revealed by the opening in the jacket, function as elements of secondary interest. Our attention is drawn first to the face, and then to the hand with the glove. The ungloved hand catches our attention next, and then we notice the locket and gold chain, which lead us back to the man's face. This is elegant simplicity.

Photo Credit: Scala / Art Resource, NY

Opposite:

DIEGO RODRIGUEZ DE SILVA Y VELÁZQUEZ (Spanish, 1599–1660), *Portrait of Pope Innocent X* (1574–1655), 1650, oil on canvas, 55⅛ x 47¼ inches.

The pope is reported to have commented that this portrait looked too much like him. The shimmering crimson cloth appears to be painted over an opaque underpainting, with opaque lights laid into transparent glazes while they were wet, as in the Venetian technique. The darks are rendered transparently, and the lights are opaque, throughout the picture. The hands are simplified, for selective focus.

Photo Credit: Galleria Doria Pamphilj, Rome, Italy / The Bridgeman Art Library

always been done as "potboilers"—that is, a means by which to provide something for the artist's soup pot—so have portraits provided a means for many an artist, including famous ones, to pay the bills. No matter what the current craze in the art world may happen to be, an artist who is capable of painting portraits well should be able to find patrons. Once his or her reputation is established, the patrons will seek out the portraitist. It is worthwhile for every artist to learn to do portraits well. It was once understood that an artist should be capable of painting any subject with mastery. An education in art did not neglect one subject in favor of another. One's specialty was decided after the general art education was complete, and the choice was made on the basis of interest, not of limitation.

The study of the human head allows the student to develop his or her eye to a higher degree than any other subject and enables the instructor to more accurately assess the ability and progress of each student. The slightest inaccuracy in a rendering of a head is immediately apparent and cannot be overlooked. The need for correction is obvious. If the subject were a tree or an apple, it would still appear to be a tree or an apple if some of the angles were misjudged,

or if the relative proportions were somewhat inaccurate. The deficiency in perception would be more likely to go undetected, and thereby go uncorrected. Artists grow by continually challenging their ability. The study of portraiture provides many challenges and, as a result, many rewards.

Course of Study

The practice of painting head studies from life develops many of the skills necessary to paint portraits. Note that there is a difference between a head study and a portrait. A head study is concerned only with visual accuracy and helps the artist gain an understanding of flesh tones and various types of facial structures. A portrait should convey something of the sitter's personality and give the viewer the impression of being in the presence of the subject. It should show the sitter at his or her most characteristic best. The head study is not concerned with personality.

The art student's introduction to the study of the human head should begin with casts of heads, including replicas of the heads from great sculptures, rendered without color, in charcoal or pencil. A strong light should be positioned near it to create distinct patterns of light and shadow. A very good method is to use charcoal and white chalk on gray paper. The charcoal is used for the shadows, the gray of the paper is left for the middletones, and chalk is used to render the lights. (See chapter 3 for more on mass drawing.) The same exercise should also be done with a skull,[1] drawn from every angle until the shapes become so familiar that it can be drawn from memory.

The first living model one should attempt to draw is a man with dark hair and beard, as it is easier to achieve a satisfactory likeness with such a subject. A dark beard and moustache provide very distinct shapes to use as reference points for locating everything else in the face. As in the studies of the drawing casts and the skull, a strong light should be positioned fairly close to the subject so that definite shapes of light and shadow are created. A man's face can be painted reasonably well with somewhat wider steps between values than would be used for a female face. A female or a child subject contains greater subtlety of values and should only be attempted after one has developed a good eye for form and value by studying simpler subjects. The idea is to increase the difficulty of the lessons in small steps, generally, though the more courageous students should be allowed to attempt more difficult assignments from time to time, as long as the basics are not neglected.

The first studies in oil should be done using only white and black, and grays made with them, on small panels, canvas-textured paper, or canvas boards primed a light gray (value 7 on the Munsell scale). This allows the student to concentrate on values without the distraction of color. Color is best added to the palette only after one has gained control over the tools and materials and has learned to read values well.

The first studies in color should be color sketches, wherein no detail should be attempted, using a limited palette of white, ivory black, raw sienna (and/or yellow ochre), and red ochre,[2] on small panels toned a warm brown (value 6 or 7 on the Munsell scale). All human complexions, regardless of race, are composed of varying combinations of three pigments: red, yellow, and black. Thus these three, plus white added to indicate less dense concentrations of pigment, form the basic foundation of the portrait painter's palette and are sufficient to render heads by themselves, as Velázquez demonstrated so ably. One should learn to do as much as possible with the limited palette before complicating things with more colors.

Only large brushes should be used in executing these color sketches. The objective of this exercise is to as closely as possible match the colors of the model's skin and hair, in both light and shadow. Detail should be completely ignored and the eyes left out. Any attempt to render detail will cancel the student's ability to read color and value. Once an eye is added to a picture, it becomes difficult or impossible to ignore, and there is the compelling tendency to forget about everything else until the eye is perfect. This interferes with the reading of colors and values in the rest of the face. The eye socket area is best rendered as a general area of shadow for color sketch purposes.

At some point the palette may be expanded, one or two pigments at a time. Raw umber and burnt sienna—followed by cadmium red light or vermilion; yellow ochre; and possibly cadmium orange—should be added before any blues. Grays made from ivory black and white will read as blue in a warm picture. Greens may be made from ivory black and yellow ochre (or raw sienna) or gray and yellow ochre, and violets from red and black or red and gray. These colors will be in the low-chroma range and so will not disrupt the harmony in a predominantly warm picture the way brighter blues, greens, or violets would.

Once the ability to read flesh tones well is developed, one may begin to attempt to add detail in head studies. The urge to render detail in any picture or study should be resisted until all values and colors, and all the larger shapes, are absolutely correct. Then, only the most important details should be rendered, wet-into-wet, with a larger brush than one is comfortable with, to avoid the appearance that they were drawn on as an afterthought. The large brush ensures that the details will become integrated into the form. Practice with large brushes develops greater skill at paint handling and allows the creation of more pleasing painterly effects.

A small, pointed sable brush was once referred to as a "pencil." The mark it makes is linear and sharp on all sides. Nature rarely provides us with sharp lines but rather with shapes, which we see with softer edges than those characteristic of the strokes of a "pencil" brush. The result is that strokes made with a small, pointed sable tend to destroy the illusion of reality, except in extremely tight areas such as the eyes, and in some cases the creases between the upper eyelid

Virgil Elliott, *Cast Drawing*, 2005, charcoal and white chalk on gray paper, 9¾ by 6½ inches.

This is an example of a training exercise. The objective of cast drawing is to record more or less everything the student observes, without selective editing. This allows the instructor to assess how well the student's powers of observation are progressing. It should be stressed that this is only a student assignment, and not necessarily the way to create a work of art. An artist creating a work of art does better to employ selective editing to omit or simplify whatever is not essential.

and the skin of the eye socket. The stroke of a larger brush will have a softer edge and thus will not accidentally destroy the illusion of reality. The urge to paint with small brushes stems from the use of a pencil in line drawing; in oil painting this is a bad habit that is best broken. Mass drawing and oil studies with large brushes are the best exercises for breaking this habit.

In addition to making studies of the head, the student must master the subjects of anatomy and drapery, as well as landscape and still life, to become proficient at portrait painting. Some portraits require a landscape background, or accessories in an indoor setting, with perhaps objects of symbolic or personal significance depicted as parts of the ensemble. And more often than not, the subject will prefer to be depicted wearing clothes. A mannequin is useful in rendering clothing. The folds in the cloth tend to change shape whenever a live sitter resumes the pose after a break. A dummy requires no breaks, so the folds remain as the artist wants them for as long as it takes to paint them. The head and hands may then be painted from life.

The student should avoid the use of photographic reference entirely. A photographic image differs in many ways from the image registered in the human brain from light entering two eyes. It is the latter image that is of interest to the painter. (See the section on photography on pages 51–52 for a more detailed explanation.) Only by working from life for years can the student/artist develop the understanding of visual phenomena necessary to avoid being led astray by photographic reference.

Compositional and Aesthetic Concerns

A portrait is successful only to the degree to which it conveys the psychological impression of meeting the subject of the portrait in person. It is very important that the artist understand precisely how various painterly devices influence the viewer psychologically to register the desired impression. The true subject of a portrait is the personality of the sitter. Recognizable likeness is important, but the essence of the person is what brings it to life. There is where the greatest portrait painters have always shown their genius.

POSITION OF VIEW

As the head is the focal point of a portrait, its position on the canvas is of primary importance. The dignity of the subject is diminished by placing the head low on the canvas and increased by placing it higher. A child, for example, is not a subject we would endow with dignity. Its head should be placed lower on the canvas than that of an adult. A venerable authority figure would be most appropriately positioned with the head very high on the canvas. Likewise, the position of the head in relation to the horizon influences the viewer's impression, as the horizon is always at the viewer's eye level. By placing the horizon below the head in our portrait, we create the impression that the viewer is looking up at the subject. This creates a connotation of importance.

VIRGIL ELLIOTT, *Color Sketch of Annie Lore*, 1988, oil on canvas mounted on panel, 16 x 12 inches.

This was done as a classroom demonstration painted in one brief session. Details are unnecessary for this type of color sketch, as its purpose is simply to record the subject's coloring to serve as reference material to aid in the painting of a portrait. However, the procedure is essentially the same as for *alla prima* portraiture, the difference being that one would continue to develop the color sketch beyond this point in order to turn it into a portrait.

A word of caution is in order, however, as this device, carried to extremes, can cause the portrait to read falsely. The horizon is at the level of the painter's, and thus the viewer's, eye. It must not be arbitrarily lowered, in a blatant attempt to flatter the sitter, below the actual position of the painter's eye in relation to the subject, or a visual anomaly will occur. A lower horizon demands a certain degree of foreshortening of the figure, and an adjustment to the subject's eyes, to read convincingly. The proper way to achieve a low horizon is to actually position the sitter on an elevated platform while painting the portrait, or otherwise provide for the artist's eye level to be below that of the subject, so that nothing need be falsified.

A sitter whose personality is informal, relaxed, and friendly is perhaps best portrayed with the horizon somewhere near his or her eye level. A child is usually best portrayed with the head below the horizon, unless the objective is to show the subject from the viewpoint of another child, or perhaps if the child is a member of a royal family. A respected figure's head should be above the horizon. Portraits of kings and emperors have traditionally employed very low horizons, with the position of the head quite high on the canvas or panel. Note that the position of the horizon is indicated by the geometric perspective of the scene, whether the actual horizon is visible or not. Thus is it always important for the painter to be aware of the horizon to maintain consistency in the perspective of the picture, even when the horizon itself is hidden from view.

VIRGIL ELLIOTT, *Alla Prima Head Study,* 1997, oil on canvas panel, 14 x 11 inches.

This was a classroom color sketch demonstration, carried a bit beyond the minimum necessary for color sketch purposes at the insistence of the students, who "wanted to see eyes."

HEAD SIZE

The size of the head should also be given consideration. The greatest portraitists have generally avoided painting the human head larger than life-size. The reasoning is simple. The illusion created by an image slightly smaller than life-size is the illusion of three-dimensional depth. Objects appear smaller as they recede from our vantage point; thus, a slightly reduced image conveys the impression that the canvas is a window, on the other side of which is the person depicted. An image painted larger than life must convey the impression that it is in front of the canvas—that is, closer to the viewer's eyes than is the canvas. This is a more difficult illusion to create convincingly. The blown-up image is peculiar to photography and should remain its exclusive province. A different set of aesthetic principles applies to painting than to photography. This is not widely understood. The exception to this principle is the depiction of biblical, historical, or mythological subjects, which are often painted larger than life to inspire awe or to accommodate being viewed from a greater, less intimate, distance. Real people, as a rule, should not be painted larger than life in portraits.

Further, it is generally necessary to reduce the size of the head in relation to the body. A peculiar phenomenon occurs when we paint our subject with the head in exact mathematical proportion to the rest of the body. The head usually looks too big. Why this is so is open to speculation, but it is a fact that the portraitist must acknowledge, otherwise his or her paintings will not "look right."

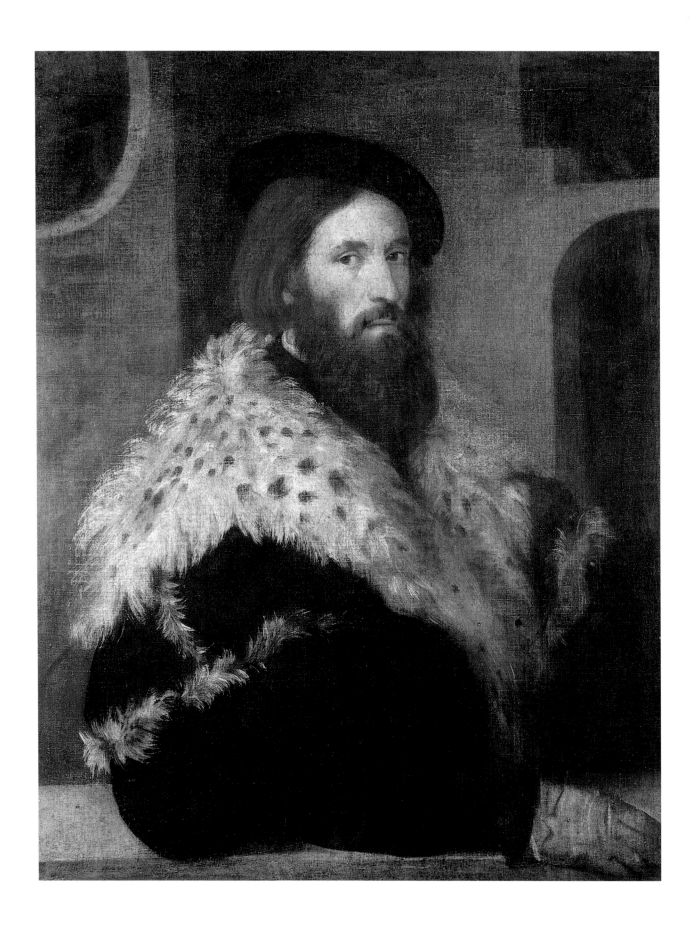

It may be that the brain, in performing its editing function of all sensory data, magnifies certain features it considers more important, such as the head in a portrait. It does not question whether the proportions seen in a living person are correct, obviously, nor does it usually question those represented in photography, since it is the product of a machine,[3] but paintings are viewed more critically.

It is a mistake to doggedly stick to measured proportions and then verbally defend the picture, with a tape measure as backup. The painting will, in all likelihood, outlive the painter and the subject and will find itself without a defender one day. The fact is, if it "looks right," no one will ever question it and will therefore not bother to measure. To make it look right, we must reduce the size of the head in relation to the body.[4] The ancient Greeks understood this psychological phenomenon very well and in their sculpture reduced the relative size of the head approximately 10 percent as a matter of course. A portrait is an impression of a person, not necessarily a mathematical record of his or her dimensions. We must alter what is, to achieve a realistic *impression* of what is, where the two are at odds with one another. No one ever notices that the head is slightly undersized, because it "looks right." Of course it is possible to carry this too far, as many artists have, but as long as the reduction is in the range of 5 to 10 percent, it will seem to be correct, even though it is not.

SELECTIVE FOCUS

A sharp-focus rendering of an entire head, with every wrinkle and hair registered in high detail, reads falsely despite its topographical accuracy. It ignores the personality and violates the principle of selective focus. (See chapter 4 for a more complete discussion of this principle.) It is the mark of an amateur. It is easy to fall into the trap of registering too much detail, for as we paint an area, we look at it, and when we look at it, we see it in sharp focus. The natural tendency is then to paint it as we see it. And yet when we are done—that is, with no detail left to add—the picture does not work. It does not correspond to visual reality, for we cannot see the entire scene in sharp focus at once in reality. This is why it is very important that the artist understand all of the principles of visual reality, including the principle of selective focus. It is the least understood of these principles in modern times.

A camera, lacking a brain, does not understand this principle and registers detail equally on everything within its focal plane. A painted portrait should convey the impression received by the brain when viewing the living subject in person rather than the impression one gets when looking at a photograph. They are two different impressions. This established, the question is how to retain the likeness while at the same time omitting, or suppressing, details contained in the subject's features, which we are able to see in sharp focus when we look closely at them. The answer is that often the likeness is actually lost or diminished by the inclusion of too much detail.

TITIAN (TIZIANO VECELLIO) (Venetian, circa 1488–1576), *Portrait of a Man (Girolamo Fracastoro?)*, oil on canvas, 36 3/8 x 28 1/2 inches, National Gallery, London.

This is among the earliest examples of oil painting in which the principle of selective focus was observed. It lends credence to the idea that Titian might have been the first artist to discover it.

Photo Credit: National Gallery, London

Etiquette prevents anyone but an artist from examining a person's features closely. One does not stare at someone's nostril or count the pores and wrinkles in the skin. These details are generally not noticed unless we are looking for them. The likeness in a portrait depends more on the large shapes than on the details. We recognize people we know when we see them at a distance, even though we cannot see any detail in their faces. This is because we recognize the larger shapes. If we begin our portrait with large brushes and concentrate initially on the large shapes only, beginning with the darks, we should have a likeness almost immediately. If we do not, it is because the large shapes are incorrect. The first stage of the likeness is the image we would see, and recognize, at a distance. Once that is successfully captured, we may add things that would become apparent if we were a little closer, as if we were approaching the person from the distance. We approach the likeness in the same way.

At times, there are details that cannot be entirely omitted without losing the likeness but that should be minimized for one reason or another. It may be an unattractive feature, but one that is not as noticeable when we are engaged in conversation with the sitter, and possibly a feature that indicates a mood or personality not characteristic of the person. If given consideration early enough, the problem feature can be dealt with simply by choosing a position that shows less of it or by adjusting the angle of the light so as to place it in shadow. The focus can be softened by blending the edges and by diminishing the contrast in values. It is best to be judicious in the recording of details. When in doubt, leave it out.

The Features

Although it is not advisable to rely too heavily on standard approaches, there are a few basic points specific to portrait painting that should be touched upon in the interest of thoroughness. Some of these might be regarded as tricks of the trade—aspects of painting portraits that make the artist's task somewhat less difficult. There will always be tests of our mettle sufficient to keep it challenging, or at least there should be, even with all the fine points of the genre mastered and committed to second nature. It is time to look into the eyes.

EYES

The eyes are always the focal point of a portrait—the "windows of the soul," as the saying goes. The success of a given portrait can be gained or lost by the difference of a thousandth of an inch, or an equally subtle gradation of value, in an eye. This fact is so obvious and so universally understood that to mention it may seem unnecessary. The natural tendency for the novice is to begin by painting (or drawing) the eyes and then adding the rest of the face around them. A master draftsman can do this successfully, but otherwise the most common result of this approach is that at least one of the eyes will be subsequently discovered to be in the wrong position in relation to the other features. This is almost unavoidable when one insists on painting the eyes before establishing

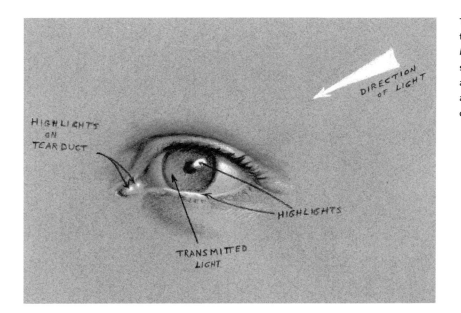

The iris of an eye is lightest directly opposite the point of entry of the light. This is *transmitted light*. The highlights are reflections of the light source itself on the moist surfaces of the eyeball and the tissues in contact with it. The upper lid and lashes cast shadows on the eyeball. Shading on the eye is the same as with anything round.

the points of reference that the rest of the face provides. The problem is then such that the painter experiences emotional trauma over the prospect of scraping out and repainting an eye that he or she has spent so much time meticulously rendering. The tendency is to look for a way to adjust the rest of the face, to find a way to save the eye that the painter has "fallen in love with," and usually to no avail. The eye must go. It must be repainted, or the picture will fail. This predicament may be avoided simply by waiting to paint the eye until all the planes of the face are satisfactorily established. With so many points of reference available for guidance, it becomes obvious exactly where the eyes belong.

There are misleading words in common usage, which often lead the novice painter astray. One such term is the "white of an eye." To paint the "white" of an eye white will give the impression that the subject is a jack-o'-lantern, with a light bulb inside the skull shining through. The eye is a globe and should be shaded with that idea in mind. The eye closest to the light source will be lighter than the one farthest from the light source. On the white of an eyeball, the point closest to the light source will be lighter than the rest of it. If the light is from above, the eyelashes will cast a shadow on the eye. Accurate observation will show that the white of an eye often contains color as well. Warm grays made with raw umber and white are generally useful in depicting the white of an eye. Sometimes there is a slight yellowness, sometimes pink, or cool or neutral grays. These should be recorded accurately.

Another misleading term is "blue" eyes. What we refer to as blue eyes can be most effectively rendered, in most cases, without the use of blue pigment.

Cool grays made with white and ivory black will read as blue when surrounded by the warmer tones of the face. A neutral in a field of color appears to be the complement of the surrounding color. Most "blue" eyes are in fact gray but, positioned in a field of dull oranges, reds, and yellows, appear to be the complement of orange, which is blue. Thus, we paint them the same way. If we were to use blue paint, the irises would be too intense a blue to appear real. The exception to this would be when the subject is wearing blue clothing near the face, which would reflect in the eyes, or in a picture with a cool dominant hue, perhaps against an expanse of blue sky or water. In such a case, a small amount of a blue should be added to the gray. A gray becomes blue by mixing in a tiny portion of blue. In a predominantly warm picture, blues are represented by grays, and no blue pigment is usually needed.

For the iris of an eye to appear real, it is necessary for the painter to adjust the values to indicate transmitted light. The iris, like a glass of wine or a grape, is transparent, with a rounded surface. Light enters from one side, yet registers on the side opposite the point of entry. In other words, if the light source is from the left at a position of ten o'clock, the lightest portion of the iris will be on the right at four o'clock. This is called "transmitted light." It is actually the reflection of the light source from the *inside* of the transparent iris, as from the inside of a glass of wine, 180 degrees from the point of entry. In addition to the transmitted light, there is the highlight, or gleam, which is actually the reflection of the light source on the moist surface of the eye. Its position is at the point where the angle of incidence from the source to the viewer's eye places it. If the light is at ten o'clock, then the highlight will be at ten o'clock. How close or far from the center of the eye at ten o'clock would depend on the exact position of the light. The more in front of the subject the light source is, the closer the highlight will be to the center of the eye.

HAIR

The hair in a portrait should be rendered as a soft mass, the darks painted first as one shape, corresponding to the shape of the entire mass of hair, and the lights then added wet-into-wet. The darks in dark hair should be somewhat transparent. The lights are best applied with a ragged brush containing only a small amount of paint. The first stroke of light should be of an opaque mixture only slightly lighter than the transparent dark and should follow the direction of the hair as far as the light extends. Subsequent strokes should be of progressively lighter (opaque) mixtures, each stroke shorter than the one that preceded it, and inside it, to depict the lighter portions of the highlights. The edges of the hair mass should be blended into the wet background color on the outside and with the flesh color where it meets the face. Sharp edges are best avoided. The overall effect of the hair must be simplified over what we see when we are focusing our eyes on it. In keeping with the principle of selective focus, the hair should be rendered as it appears when we are focusing on the face, not on the hair.

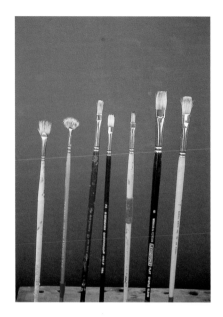

Ragged brushes are useful for painting hair, beards, moustaches, eyebrows, and grass.

Mood and personality are indicated not only by the face but also by the position of the body and the hands, in reality and likewise in portraiture. A high degree of expressiveness resides in the hands especially, and also in the subject's posture, including the angle at which the head is held. The artist's powers of observation must be so finely honed as to border on a psychic sense in order to do full justice to this extremely important, and often neglected, facet of portraiture.

This faculty is the result of innate intelligence, extreme sensitivity, and long, intense study of not only drawing and anatomy but of people in general. The posture can indicate such personality traits and psychological states as pride, humility, intelligence, introvertedness, honesty, integrity, joy, sadness, deep thought, fatigue, energy, confidence, graciousness, and humor and as such can reinforce the mood and personality expressed by the face. An excellent example is Velázquez's *Surrender of Breda* (see page 3), wherein the chivalrous and gracious attitude of the victorious general, and both generals' respect for one another as fellow soldiers, are expressed eloquently in their postures and gestures as well as in their facial expressions. Although the respective armies of these men had been previously engaged in a brutal war in which many were killed, the aspect Velázquez chose to emphasize in his painting was the humanity of the leaders once the hostilities had ceased. The best qualities of human nature are those worthy of commemorating in works of art. There is a story being told in this painting and a moral message expressed in a most agreeable manner.

Rembrandt's *Portrait of Joris de Caullerij*, shown on the following page, projects confidence, pride, and capability most powerfully in the pose of the subject, a military leader and war hero, through the attitude of his body as well as the face. Each strengthens the other. The face is so powerful that it dominates the picture without being the sharpest-focus area. The collar catches our attention next, and holds it as we marvel at the fine execution and its stunning realism. The rest of the painting is quickly and sketchily rendered, yet reads realistically from a few feet away. Notice the way the hair is rendered, in simplified manner utilizing both transparent and opaque darks, blended into the background softly at the edges. Rembrandt probably posed the costume on a mannequin, and then added the head in live sittings. It's likely that the mannequin's arms were shorter than those of the sitter. The flesh tones range from warm reds to cool yellows, which read almost greenish next to the warmer colors near them, an interplay of warm and cool. Rembrandt was twenty-six years old when he painted this magnificent portrait.

Whereas the importance of this fine point of portraiture cannot be overstressed, the actual essence of it cannot be taught adequately but only learned by individuals possessing all the right mental equipment necessary to grasp it, along with the obsession and dedication to study it until it is mastered. It cannot be conveyed in books or college courses. Instructors and authors can stress the

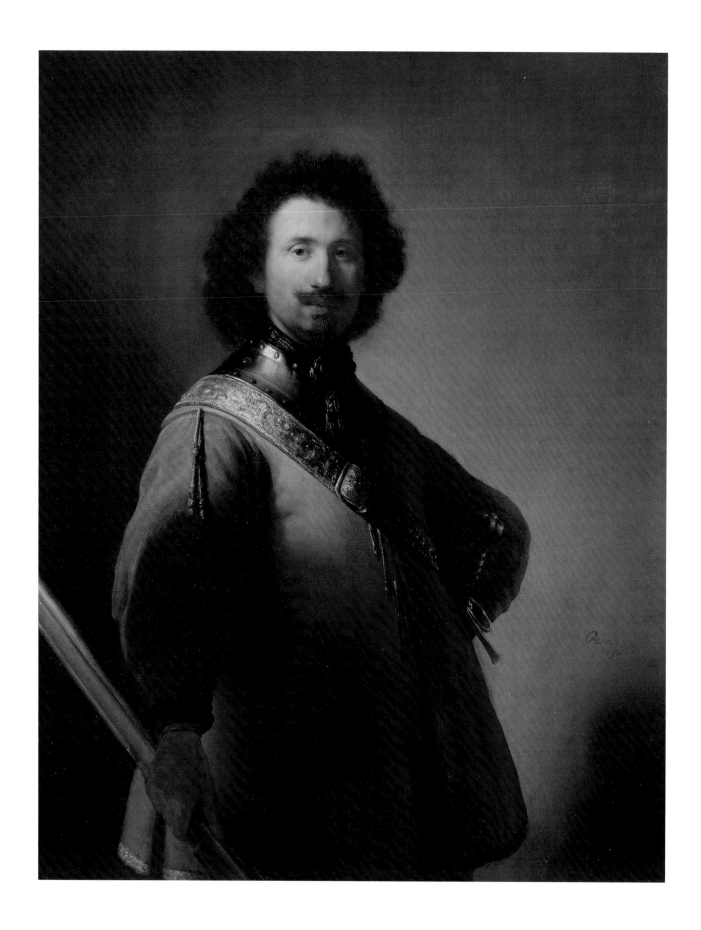

need for this understanding, and can direct the student's/reader's attention toward it in various ways, but it can only register after a great deal of observation and practice rendering it, and only then in the most sensitive of intelligences. One must observe and gain insight into living people in real life, as well as study great works of art in which the artists utilized their own insight to convey whatever they wished to convey by means of the body language in their subjects. It is a lifelong study, as there will always be room for improvement. The aspiring artist can do no better than to study with a teacher whose own work demonstrates mastery and then work as hard as possible to learn everything, both in the presence of the Master and alone. The self-education process should continue well beyond the association with our teacher or teachers and should be an ongoing pursuit throughout life.

AREAS OF SECONDARY INTEREST

To hold the viewer's attention for as long as possible, we add areas of secondary, and sometimes tertiary, interest to our pictures (portrait or otherwise). The hands normally fall into this category, as would any jewelry, insignia pins, military medals, family crest medallions, or other objects specific to the subject. These may be rendered in sharp enough focus to be identifiable, but they must not be allowed to compete with the face. Ideally, these details should catch the viewer's eye only after it has taken in the primary subject— that is, the head. It is best to arrange the areas of secondary (and tertiary) interest in such a way as to lead the eye back to the area of primary importance eventually. In this way, the viewer is enticed into looking at the painting for as long as possible and ignoring whatever else is around, including other paintings done by other artists.

Procedures for Painting Portraits

The amount of information the artist must read in a human subject, to paint a high-quality portrait, is awesome. To attempt to tackle everything at once, including composition, value, shape, line, likeness, color, and personality, can be an overwhelmingly difficult task. "How did the Old Masters do it?" we ask. The answer is that in most cases, they did not attempt to address all the problems at the same time but rather broke them down and approached the portrait systematically, in stages.

Often, studies were made, to be used as visual aids once the portrait itself was underway and to familiarize the painter with the subject before attacking the final painting. Value studies were done in shades of gray and white, to establish the shapes through light and shadow. These were sometimes done in charcoal and white chalk on gray or brown paper and sometimes in oil paint. Color studies were then done, in oil paints, to record the colors of the subject in whatever light was chosen for the portrait. Detail is unimportant in a color study. The value study will contain the details. Individual studies of the hands were often done in addition to those of the head.

Opposite:
REMBRANDT HARMENSZ. VAN RIJN (Dutch, 1606–1669), *Joris de Caulerij*, 1632, oil on canvas transferred to panel, 40½ x 33³/₁₆ inches, Fine Arts Museums of San Francisco, Roscoe and Margaret Oakes Collection, 66.31.

Rembrandt was the ultimate Master of selective focus. Here, he has taken the unusual approach of depicting the metal collar in sharper focus than the face, to add emphasis to it as an element of secondary interest.

The modern-day portraitist is well served by following the procedures of the Old Masters in those respects. All studies should be painted from life only, with the colors, shapes, and values being read directly by the eyes of the artist for the best results. The final portrait may be executed following the Venetian technique, which is the method most widely used by the Old Masters from the time of Titian and Giorgione, and possibly earlier, or in the direct painting technique, or some variant of one or the other. The Flemish technique, in its strictest interpretation, might realistically be considered a more tedious method, although the ultimate results may be considered sufficiently stylistically preferable to justify the additional trouble, in the eyes of some artists and their patrons. It really boils down to a matter of personal taste.

VENETIAN TECHNIQUE

The Venetian technique is described at length in chapter 6 but bears further explanation here regarding its specific application to portraiture. The process is best begun with studies executed on separate canvases, paper, or panels. The idea is to solve as many of the problems as possible before touching the final canvas, so the artist knows where he or she is going. Too many corrections can bog one down once the painting is underway.

After the studies are done, and the best of them selected for use in the painting of the actual picture, the final canvas is addressed, initially, in charcoal. The drawing on the canvas may be done following lines traced from a full-size cartoon, from a smaller study by means of a grid, or freehand. Once the drawing is satisfactory, the excess charcoal is blown or dusted off, and the remainder may be "fixed" by a very light spraying with a retouch varnish or fixative. It is not absolutely necessary to "fix" the charcoal.

The next step in this method is to go over the drawing with ink or very thin oil or alkyd paint, tracing the lines with a ruling pen or liner brush. Shadow areas can be indicated by scrubbing them in thinly, in a sort of drybrush manner, with a hog-bristle filbert brush. The author generally uses burnt sienna alkyd paint for strengthening the drawing, as its binder has somewhat greater adhesive power than oils and dries more quickly.

Once the first stage is dry, the entire canvas is given a very thin coat of a light gray made with flake white and Mars black. Mars black is chosen for this purpose because of its high tinting strength. Only a tiny amount is needed to turn white into gray, thus ensuring that the underpainting is fairly lean. Flake white is the leanest of all oil paints. Ivory black or raw umber may be used in place of Mars black, but the underpainting will be less lean, owing to the necessity of adding more of a fat paint to achieve a given shade of gray. Both ivory black and raw umber are very fat paints, with lower tinting strengths than Mars black. However, they were used quite successfully for hundreds of years

Note the expressive hands, a van Dyck specialty. The composition is triangular, with directional flow from the lower left corner to the subject's head. The marvelous red robe and the hands serve as elements of secondary interest. This portrait seems to have taken a cue from Velázquez's portrait of Pope Innocent X.

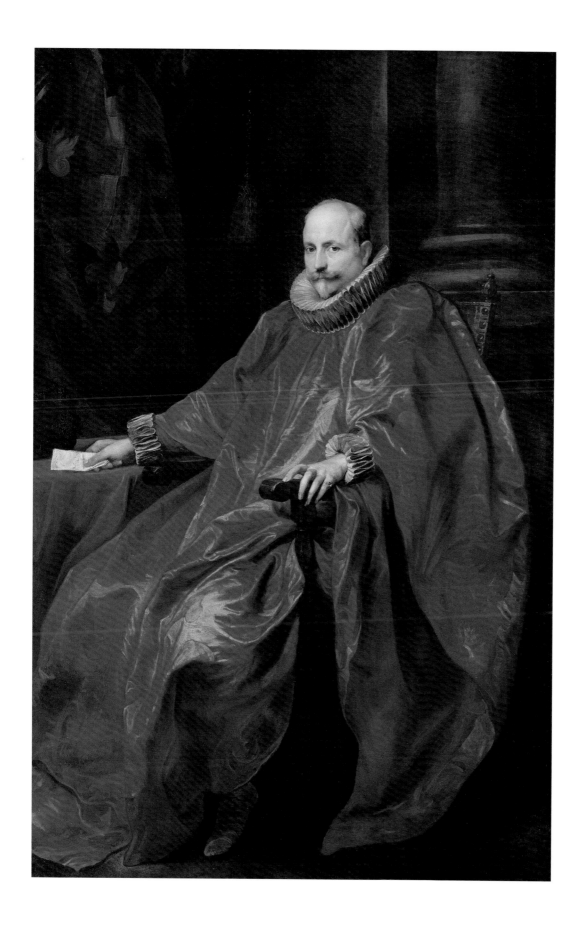

before artists had Mars black available to them and will of course still work just as well today as they did then. Raw umber will speed the drying and thus allow overpainting sooner. Little or no medium should be used at this stage, except perhaps a small amount of mineral spirits, or subsequent layers might not adhere as well. However, it is important to avoid adding too much solvent to the paint, or the binding power of the oil will be weakened and the paint layer will be underbound. This could cause problems at some point in the future.

The initial layer of gray must be spread thinly enough that the strengthened drawing is visible through it. The shadow areas may then be added, following the underdrawing, with a gray slightly darker than the initial coat, working wet-into-wet. The lights may then be added, using pure white or a light gray followed by pure white. The lights will be darkened by the wet darker grays as they are mixed on the canvas, so it may be necessary to load the brush with a lighter value than the one desired, in anticipation of this effect. In the first sitting of the gray underpainting stage, the painting should be carried along as far as possible while the paint is wet. It is not necessary to have the sitter posing at this point if the studies executed from life previously are accurate and show the sitter in the right pose, etc. It is best if the underpainting is finished with at least one live sitting, however, before we begin the color stage. Corrections, touch-ups, and further refinements in the underpainting may be done after the initial coat of gray is dry, as much as is needed. Subsequent coats should be warmed slightly by adding a small amount of raw sienna to the grays. If this is not done, the new grays will appear cooler than the first coat. The addition of the raw sienna also ensures that the bottom coat will be leaner than the ones painted over it, in accordance with the "fat over lean" rule. (See chapter 7.)

The underpainting should generally be lighter in value than the intended final effect. In fact, it should be as light as possible, or the colors painted over it will appear duller, and the illusion of depth in the transparent shadow areas will be somewhat compromised. Corrections may be made ad infinitum in the gray stage without fear of creating mud. All the problems should be solved at this stage except color, because correcting in color can lead to mud. After the underpainting is finished, it must be allowed to dry for at least a week—the longer the better, for optimum permanence. In a variation on this technique, an earth red, such as Indian red, is used instead of black or raw umber.

The color stage in the grisaille underpainting version of the Venetian technique may be begun with transparent paints, spread thinly over the fully modeled underpainting with stiff brushes. The modeling of the underpainting should be fully visible through the transparent color at the beginning of this stage, although before the paint is dry the areas of primary light, at least, should be covered with opaque paint. Once the middletones and shadows are covered with transparent colors, the opaque paints are introduced into them, wet-into-wet. A good place to begin painting opaquely is at the edges of the shadow accents

nearest the middletones. The darkest opaque mixture must be as dark as, or darker than, the transparent darks in the shadow accents (aka core shadow) and must be blended with them where they meet. This provides a transition zone between transparent dark and opaque middletone. If this is not carried out properly, the edges of the lights or middletones will exhibit a milky appearance where they merge with transparent darks. We avoid this problem by blending transparent dark with opaque dark, then opaque dark with opaque middletone, and opaque middletone with opaque light, all wet-into-wet.

From the transition between shadow and light, then, the progression should be to proceed to the darker middletones, then to the lighter middletones, and then to the highlights, all painted with opaque paints, wet-into-wet. We may then address the secondary lights in shadow as we see fit and add touches of greater subtlety where more refinement is needed. This is how to achieve a most convincing representation of light and shadow on a solid form. The modeling of the underpainting is visible in the shadow areas through the transparent darks, to a greater or lesser degree, and will manifest itself in the lighted areas to some extent as well, despite their being covered by opaque paints. The paint is built up more heavily as it approaches the lightest lights, which should be the point(s) at which the paint is thickest. The reason for this is that the lightest lights must be totally opaque, not only when the picture is new but for as long as possible thereafter. Oil paints become more transparent as they age. Highlights heavily applied will remain effectively opaque for centuries.

Opaque paint is used to represent direct light reflecting from a solid surface and reaching our eyes. If the paint is opaque, the light will bounce from its surface to our eyes, just as it would from the surface of the object it is intended to represent. If it is not fully opaque, some of the light will penetrate the surface and become refracted from something below, and a different optical effect will result. There are places where such an effect is desirable, and in those places this may be done intentionally. The appearance of soft skin is created by lightly scumbling over the light areas with a still lighter mixture of opaque paint, thinned to translucence with brush pressure and perhaps a slight addition of oil or other medium. This trick is also useful in imparting greater softness to the apparent texture of cloth. Skies may be made to appear overcast by the same method. This technique is an innovation of the Venetians, probably Titian and/or Giorgione in the Italian Renaissance. Note that a scumble in any passage representing human flesh is most effective if applied over an area that is itself painted solidly in opaque color. The scumble must be only slightly lighter than the middletones and lights it is intended to modify, or the illusion of solid form is destroyed.

Paintings executed in the Venetian technique were generally finished with glazes and scumbles, after the color stage was dry, as final refinements. By using this method, or some variant of it, the artist is able to create perhaps the most

convincing illusion of reality of all painting techniques. The problems are solved in stages, rather than all at once, and this gives the painter time to give as much individual consideration as might be needed to every aspect of the portrait, from the general compositional layout to the color scheme, value range, likeness, proportions, mood, details, and the overall visual impact. There are other ways of painting a good portrait, but the Venetian technique allows the many issues to be addressed one or two at a time, with many opportunities to make corrections that will be undetectable in the finished work.

DIRECT PAINTING TECHNIQUE

The direct painting technique is more widely used in modern times than any other. Its appeal is not, like the Venetian technique, that it fools the viewer into believing a living person is there instead of canvas and paint, but rather that it possesses a certain charm precisely because the viewer can readily see the brushstrokes, the globs of paint, etc., that go into the creating of the image. The method is not hidden from the viewer, who is then able to feel a little closer to the artist and thereby may enjoy the picture all the more. In any event, it is the most challenging method of painting portraits, because it requires that the artist solve all of the problems at once, with failure possible at any point. One's powers of observation must be honed to a very fine edge to work in this method. Likewise a sense of design and composition, and an attitude of absolute confidence and courage, are prerequisites for painting successfully following this approach. These abilities are developed by painting many studies, some in grisaille and some in color, from life, from memory, and from imagination.

As in all oil painting techniques, the general rule is to begin with the shadows, thinly, and work our way from dark to light, wet-into-wet. By beginning with the thin application of darks, and using a rag or cheesecloth as an eraser, we can establish the forms reasonably well before introducing any lighter colors. This helps avoid mud. By correcting the dark shapes with a rag, we carry the picture beyond the point at which the greatest amount of correction is necessary before we add any light paint and thereby reduce the likelihood of making mud.

Once the forms are established as far as can be done with shadows and the dark shapes, the middletones are introduced with opaque paint, applied more heavily than the shadows and extending into areas of light. The larger masses are blocked in first, and details and refinements postponed until later, after the large masses and shapes are deemed correct. As in the final stage of the Venetian technique, the opaque middletones are fused, wet-into-wet, with the edges of the shadows, and the lights are then worked into the wet middletones with a fully loaded brush to complete the modeling of the forms. The artist may then add refinements and details, working wet-in-wet as much as possible. It is very important that the large masses be painted in one sitting, from dark to light, while the paint is wet, or the illusion of solidity will likely suffer. Details and refinements can be done after the initial coat is dry, if necessary.

JOHN SINGER SARGENT (American, 1856–1925), *Caroline de Bassano, Marquise d'Espeuilles*, 1884, oil on canvas, 62⅞ x 41⅜ inches, Fine Arts Museums of San Francisco. Gift of Mr. and Mrs. John D. Rockefeller 3rd, 1979.7.90.

This portrait was done in the direct painting technique. Sargent's seemingly effortless effect of bravura brushwork was, ironically, actually the result of a carefully considered approach that involved much effort. He worked with great care on the faces, and went for a sketchier appearance in the clothing. The subject here appears to be impatient with being made to pose.

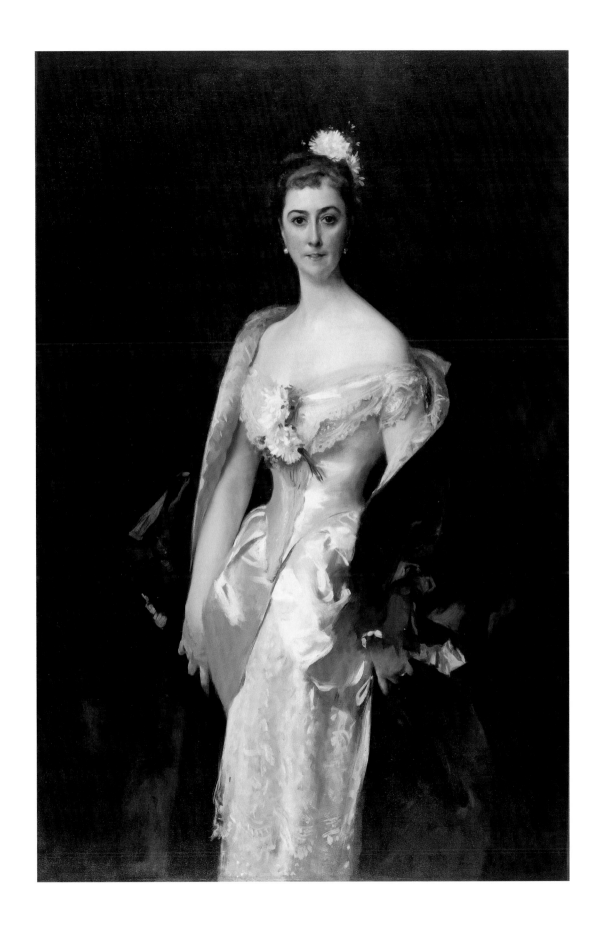

Of course, it then ceases to be *alla prima*, technically, as the result of the first stage may then be considered an *ébauche*, or underpainting, but the concern is to paint a good portrait above all, not necessarily to restrict oneself to any particular method of execution.

The procedure for working over dried paint may begin with a thin application of a painting medium or oil to the area being addressed, to match the colors perfectly. It is important to wipe off the excess medium with a rag or cheesecloth, so that only the thinnest film is left to lubricate the surface. New paint should then be applied exactly matching the color, value, and chroma of the dry paint, so that any changes are done wet-in-wet, for pictorial unity. The best lighting for absolute precision in color matching is direct sunlight. Once the dried paint is renewed with fresh wet paint, the painter and canvas can be returned to the studio for the refinements. Working too long in direct sunlight can harm the eyes. It is not always necessary to cover the dry layer with oil or medium when resuming work on a dry painting. An alternative method would be to cover the entire area in question with a thin, transparent or semitransparent layer of paint, scrubbed thin with a stiff bristle brush, and then to commence painting wet-into-wet.

Each time a layer is added, there must be a slight increase in the amount of oil in the paint, to avoid violating "fat over lean." It is possible to carry a painting to a very high degree of finish following this method; however, a certain amount of the painterly charm of *alla prima* painting may be lost in so doing. The direct painting method is most effective if the rough edges are not entirely obliterated, and the viewer can imagine the painting in progress. Frans Hals, Sargent, Zorn, and Sorolla are probably the best-known Masters of the direct painting method.

NO SHORTCUTS

Portraiture, being the most demanding of all fields of art, poses many difficulties to the aspiring painter. These difficulties can seem overwhelming at first, and the natural tendency is to seek some sort of crutch to compensate for one's technical limitations. There seems to be an increasing desire in modern times to always look for an easier way to do something, to avoid anything difficult.

This line of thinking is totally inappropriate in art. As the saying goes, "Genius is an infinite capacity for taking pains." So it is, and so it should be. Avoid shortcuts. Avoid the frame of mind that urges people to seek them. The quality of the work, the degree of satisfaction derived from it, the sense of accomplishment, and the respect of one's peers are all diminished in direct proportion to the degree to which one has resorted to shortcuts. Art is a field that existed prior to the Industrial Revolution, and it has always depended on extreme degrees of dedication, mental discipline, and great pains in the creation of its finest examples. This is the only legitimate reason it is so highly prized.

JOHN SINGER SARGENT (American, 1856–1925),
*Mrs. Fiske Warren (Gretchen Osgood) and
Her Daughter, Rachel*, 1903, oil on canvas,
60 x 40³/₈ inches, Museum of Fine Arts, Boston.
Gift of Mrs. Rachel Warren Barton and Emily L.
Ainsley Fund, 64.693.

Sargent's special charm is in the way he delights
the eye with so many marvelous textures,
shimmering light, and unusual color harmonies,
while giving the appearance of having wasted
no time on superfluous details. In this double
portrait he has solved the problem of two
subjects in a masterly way by posing them as
he did here, in a pyramidal composition. The
Golden Mean from the left edge runs through
the daughter's face and hand. Sargent worked
sight-size from life in his portraits.

Photograph © 2007 Museum of Fine Arts, Boston

No one who truly cares about art would risk cheapening it. No one who would
cheapen it deserves to be called an artist.

The best advice for an aspiring artist faced with seemingly insurmountable
difficulties is simply this: study harder. That being said, the subject of photo-
graphic reference in portraiture must be addressed here, in realistic recognition
of the powerful temptation to use it and the fact that its use is currently
widespread. Of course, one would be hard-pressed to paint a posthumous
portrait of a stranger without at least studying photographs of the subject.

It is necessary to place the issue in its proper context to avoid misunderstandings. A Master artist (i.e., one fully equipped with a complete understanding of the principles of visual reality, anatomy, and all else an artist must know to reach Master level) will be able to work with photographic reference and still do good work, without the result giving the appearance of a copied photo. However, a painter unable to do good work *without* using photography will likewise be unable to do good work using photographic reference, although the result may well be deemed acceptable to those who do not know any better.

It is advisable to go to great lengths to work as much as possible from direct observation, even in posthumous portraits. Use mannequins for posing clothing and perhaps have living relatives or other models closely resembling the subject sit for the portrait, and then alter the facial features by extrapolating from the photos just how the subject would have looked in that particular light, noting the differences between the living model and the intended subject. This is a great challenge, but the results are apt to be better and more artistically satisfying than if we simply copy a photograph. If our subject is living, but unavailable for much live posing, we may employ these methods to good effect as well. In these cases, it is still best to at least execute a color sketch quickly from direct observation of the subject's head in a short sitting and a value study in grisaille oil or in charcoal and chalk on gray paper, whichever medium allows us to work most quickly, in which all the details will be recorded accurately, perhaps in a separate short sitting. This also provides an opportunity to gain insight into the sitter's personality. The Old Masters often worked in this manner, of necessity when commissioned to paint a monarch, pope, or

other busy and important person, in the days before photography. These studies and sketches would then be used as reference material to aid the artist in painting the portrait in the absence of the sitter, perhaps to be finished with one or two final live sittings if the subject were available.

Mannequins were most often used for painting the clothing, and the setting could usually be done from direct observation, except in fanciful pictures, where the artist's imagination would be called upon to a greater extent. Note that the substitution of photographs for reference material drawn and/or painted by the artist for that purpose is more likely to yield less artistic results, as the camera lacks an artistic sense. Unless the artist is fully aware not only of the specific ways in which the photo is inaccurate but also in which ways it is unartistic, the shortcomings of the photograph are apt to find their way into the painted portrait. One develops the understanding of these essential aspects of art by working from direct observation, memory, and imagination only, until Master level is reached, and by long and intensive study of the art created by the greatest Masters who ever lived, observed firsthand. One may make good use of photographic reference after these sensibilities are fully developed and so thoroughly assimilated as to become second nature. The difficulty is in determining when this point has been reached. One indication would be when one is so acutely aware of how inadequate and inaccurate photographs are that there is little desire to use them as reference at all. If we are not fully aware of these faults in photographs, not able to spot them with crystal clarity, then we are not yet ready to use them.

In our time, portraiture has gotten a bad name, and the reason behind it is that the field is currently saturated with painters who are slaves to the camera, who are essentially limited to copying photographs, with all of the faults of the photo included. The general level of quality in these inartistic copies of photographs is such that it serves to sully the entire genre, as the profusion of bad examples provides much grist for the detractors' mills. The ability to copy a photo is an elementary skill. It is several light-years shy of being enough to make someone an artist and certainly not enough to justify setting oneself up in business as a portrait painter. For unqualified individuals to present themselves as professional artists serves to diminish the prestige of the entire profession, and that is something that no artist who cares about art can possibly condone.

Art is intimately tied to culture. Its special standing depends on its association with the concept of quality. Let every artist strive to uphold that standard forever, with no compromises, out of an overriding and abiding love of art.

Chapter Nine

LANDSCAPE PAINTING

LANDSCAPE IS PROBABLY THE MOST popular subject for painters in any medium today. There are, of course, many good reasons to want to paint landscapes. Every artist has been presented with a scene that cries out to be painted, a masterpiece too moving to pass up, at one time or another. All that is needed is the time and ability to capture it on canvas. Photographers try, within the limitations inherent to that particular medium, to do the scene justice, but a well-trained oil painter can come closer to realizing that goal, as we can see in the works of Albert Bierstadt, Frederic Church, Thomas Cole, Thomas Moran, Claude Lorrain, and other Masters of landscape. The oil painter has a much wider range of optical effects available with which to address the infinite variety of visual impressions nature presents us than does the photographer. By taking advantage of the qualities of opacity and transparency in a systematic way, an oil painting Master can come much closer to creating a convincing illusion of reality than is possible by any other means. Of course, the key to it all is mastery of every aspect of painting in oils.

Along with the many good reasons for painting landscapes, unfortunately there are some bad ones as well. There is a general feeling that portraits and figures are difficult to learn to do and that landscape painting must be easier.

This is a mistaken belief, but it lures many artists and would-be artists who might be afraid to tackle the human form into trying landscapes. Although it may be easier to do a mediocre landscape than a good portrait or figure, it is at least as hard to do a good landscape as a good face or figure. It's true that a misplaced or misjudged tree will still look like a tree, more so than a misplaced or misjudged nose will go undetected, but a landscape artist must deal with a number of problems that are specific to that field of painting. A painter who is capable of executing a well-rendered portrait will be able to paint a better landscape than one who is not, all other factors being equal. To paint any subject convincingly requires a good eye. One does not develop a good eye by neglecting the one area of study that makes the greatest demands on the powers of observation—the rendering of the human head. Thus it is important for the art student to learn to do everything well before deciding on a specialty. To neglect any area of study results in weak work. This has been stated elsewhere in this book, but it is an important point that bears repeating. The wrong reason for turning to landscape painting is that we might think it's easier than painting people. The right reason is that we love it.

FREDERIC EDWIN CHURCH (American, 1826–1900), *Rainy Season in the Tropics*, 1866, oil on canvas, 56¼ x 84¼ inches, Fine Arts Museums of San Francisco. Museum purchase, Mildred Anna Williams Collection, 1970.9.

Church studied with Thomas Cole and worked in much the same way. Unlike Cole, however, he is known to have employed a photographer to accompany him on his field-sketching expeditions to remote locales, to generate supplemental reference material to aid him in painting his large pieces like this one in his studio. Of course, there was no color photography in Church's time. His training under Cole was traditional, and did not include photography at all.

Techniques of the Masters

The problems presented by the constant movement of both the sun and the earth require the landscape painter to be extremely clever to achieve a convincing result. The methods employed by the best practitioners of the genre differ from one another very little, at least in the initial approach. They are essentially dictated by necessity, which rules out the more tedious and time-consuming techniques of the early Flemish and Venetian oil painters. The Flemish or Venetian methods might well be pursued back in the studio, after the field sketches and studies have been done to initiate the process, and indeed they were by various Masters of previous centuries and still are by living painters. But the field sketching procedures would vary very little from one artist to the next, and would involve working in the direct painting technique, where one goes for the full-color impression immediately. The following is an account of the practices followed by Claude Lorrain, Thomas Cole, and most of the better landscape painters whose names are less well known.

To fully appreciate the landscape paintings of the aforementioned artists, it is important to note that they were able to achieve marvelous results without the aid of the camera. They went to great lengths, sketching on location, to record all the information they would need to execute the masterpiece in the studio.

THOMAS MORAN (American, 1837–1926), *Venice*, 1894, oil on canvas, 5 x 8 ½ inches, Fine Arts Museums of San Francisco. Memorial gift from Dr. T. Edward and Tullah Hanley, Bradford, Pennsylvania, 69.30.144.

The tiny size suggests that this is a field sketch done on location, or a *modello* done from imagination (an *esquisse*, as the French term it). It could well be either. It is an excellent example of the steelyard principle of composition. The domed building is also very close to the Golden Mean.

The sketches done from direct observation of the scene were small, as the constant movement of the light source, as well as other logistical concerns, such as wind and portability of equipment, made working on large canvases outdoors impractical. Once a vista was selected, the first sketches would be done in pencil or charcoal, often on toned paper (Claude Lorrain favored blue paper for these sketches), usually heightened with white. Only the shapes and contours were drawn in, in line. Light and shadow patterns were not added until the sun was in the right position, at which point the shadows would be quickly noted with charcoal and the lights with white chalk, watercolor, or some other white paint. Important details would be captured in as many small studies as were needed, to serve only as visual aids in the creation of the actual painting. Small color sketches were also done from nature, usually in oil paints, to record the colors of the scene quickly, with no attempt at capturing detail. Perhaps several studies of skies would be rendered on successive days, to provide the artist with more choices when planning the masterpiece.

The artists needed more time to give careful consideration to the creative arrangement of the shapes and colors than was possible on location. Thus, aesthetic concerns were not important in the small studies. Their purpose was simply to record information accurately. A major opus requires a great deal of thought and should not be rushed. Once back in the studio, under conditions more conducive to painting, the artist could plan the composition carefully, looking over the studies and sketches with a critical eye and deliberating at length on the arrangement of the various elements until the best possible design was worked out. More studies might be needed during this phase and would be drawn or painted in the studio from the information gathered in the field, remembered as well as noted down.

The most important part of the process, for these Masters of the past and for us now, is the critical analysis of the essence of the scene—what gave it its magic, what made the subject worthy of being immortalized in paint. As artists, we must maintain the memory of our first impression of the scene uppermost in our consciousness at all times during the execution of the final painting, and never lose sight of it. That element, whatever it may be, must be present in the painting, or our efforts are wasted. There must be a concept for the painting, and it should be clearly understood before we approach the canvas. Whatever it was that made that particular scene memorable, the essence of the impression, is the concept for the painting—the objective to be striven for. This essence is seldom present in photographs. It must be recorded in the artist's memory and analyzed on the spot from direct observation, whether it is being sketched at the time or not, to make certain that its special quality will be present in the painting. That special quality must be understood to be the real subject of the painting. It is as true for artists today as it was for the great painters whose methods we are discussing.

Opposite:

ALBERT BIERSTADT (American, 1830–1902), *View of Donner Lake, California*, 1871 or 1872, oil on paper mounted on canvas, 29¼ x 21⅞ inches, Fine Arts Museums of San Francisco. Gift of Anna Bennett and Jessie Jonas in memory of August F. Jonas, Jr., 1984.54.

This small sketch is typical of the type used by Bierstadt as reference material, or perhaps a *modello* for one of his huge paintings of California vistas. Note his effective use of atmospheric perspective.

Everything in the picture should be engineered toward advancing that concept. The success of the painting will depend on its eliciting from the viewer the same emotional response that the scene itself stirred in us. Often, it becomes necessary to distill the various components of the vista to convey to the non-artist viewer the desired impression. Artists, we may presume, are more sensitive and experience a heightened appreciation of visual stimuli. Therefore, some creative rearrangement in the picture is usually necessary to move the non-artist in the same way as we were moved by the scene itself. Shapes may be altered, enhanced, eliminated, added from the imagination, or whatever, in the course of designing the picture. The primary consideration, every step of the way, is to present the essence of our subject in the best possible manner.

Often, we are presented with one of nature's spectacular visual displays when we are unprepared to paint, and we must simply observe and analyze what is before us and determine how we would approach the rendering of the scene in paint. Thus the value of memory training becomes apparent. The magical

effects we witness sometimes last only a few minutes, as the sun moves to a different position, the mist rising from the lake evaporates, the clouds move away or in, and we are left with nothing but a memory. To a well-trained and creative artist, this is enough. The wheels will have been set in motion, and soon the artist will have devised a means of recording that wonderful effect, to show the world what it was that moved him or her so profoundly.

The means of re-creating the scene usually include returning to the same location the next day, equipped with sketching and painting materials. Our arrival at the chosen spot must anticipate the magical time and allow us to have everything at the ready if we are lucky enough to be served the same view two days in a row. Certain things will be more or less the same, and we can and should sketch them, to capture the actual shapes and contours, in small studies in line. Only when the time is right should we add shadows and lights to our sketches and record the colors precisely in separate small oil studies. The palette will have been prepared in advance, the easel set up, the canvas or panel placed in position, and the brushes and knives readied for the Magic Moment. Sometimes it will not occur, as the atmospheric density will be different, the weather conditions might change, etc. Nature does not always cooperate. Still, we must capture what we see in our sketches and return again for more sketches and studies. Whether we are fortunate enough to witness a repeat of the original scene, we must maintain a vivid memory of it in our mind's eye. If our picture is to be successful in showing the world what moved us so, we must be guided by that memory when planning it and painting it, every stroke of the way.

Plein-air Sketching and Painting

Many painters prefer to paint the entire painting on location, for a number of reasons. For some, the experience itself is as important as the paintings that result from it. There is an aspect of adventure to it, of forgetting about the rest of the world for a few hours and entering The Zone, where one is alone with a mighty task to tackle, monumental problems to solve, difficulties to overcome. It is a form of meditation. Or if done in groups, it is a social event, sharing an experience of working in the great outdoors with fellow artists. And when one is good at plein-air painting, the resulting pictures usually possess a special quality that sets them apart from works executed in the studio. This difference is often apparent even in works by the same artist, when plein-air works are compared with that person's studio paintings. That factor is what compels many painters to do as much work outdoors as they can. The likelihood is that the reader is already well aware of all this, however, and so it is time to proceed to discussion of the nuts and bolts instead of the whys and wherefores.

Whether the artist intends to execute the entire painting on location or only record information in sketches to be used as reference material when painting a larger picture in the studio, the procedures and equipment for painting in the field are essentially the same. The main differences are the quality of the paints

CLAUDE LORRAIN (French, 1604 or 1605–1682, active in Rome), *Seaport with the Embarkation of the Queen of Sheba*, 1648, oil on canvas, 58¾ x 77⅜ inches, National Gallery, London.

Claude Lorrain is among the few artists who could paint the sun and do it well. This imaginary scene shows what can be done when an artist is fully equipped with knowledge. The horizon is on the Golden Mean as measured from the top, and the sun is very close to the Golden Mean as measured from the right edge. The vanishing point for the geometric perspective is precisely where the Golden Mean from the vertical crosses the horizon. The composition is laid out three-dimensionally as well. Color harmony is blue-yellow, with blue dominant. The overall effect is outstandingly beautiful.

Photo Credit: National Gallery, London

and the canvas or panel used. Field sketches and studies may be done using paints and supports of lesser quality, as their only purpose is to aid the artist in executing a larger painting in the studio.[1] If what is to be painted in the field is to be the actual work of art, however, the materials should be of the highest quality possible, for the utmost in permanence.

BASIC EQUIPMENT

In the interest of portability, the plein-air artist's equipment must be condensed to a manageable package. A French easel, or sketchbox easel, contains a box for the paint tubes, a compartment for brushes, and a small palette. Attached to the box are usually three folding legs, a canvas rest, and an extendable upright for securing the top of the canvas. It might also be advisable to obtain a box with slots for carrying several canvasboards or panels, to solve the problem of transporting wet paintings or studies. Claude Monet pressed his children into service as bearers who carried his canvases and equipment to and from the locations he chose to paint. Many artists outfit a vehicle, such as a van or camper, as a traveling studio. This increases the amount of paraphernalia they may carry but restricts them to locations near roads. The creative mind will solve whatever problem it is faced with, if the determination to paint outdoors is strong enough.

Most of the gear necessary for plein-air painting can be carried inside the French easel. Individual preferences may vary, but generally plein-air painters require a very large flat brush, two and a half or three inches wide, to block in the large expanses of color. Hog-bristle brushes, in the larger sizes and an assortment of shapes, are better suited to fast painting than are soft-hair brushes such as sable and ox. A sign painter's mahlstick, consisting of three screw-together sections that allow it to fit in the brush compartment, is also useful. Some plein-air painters prefer to simplify their gear by painting more with a palette knife than with brushes. Whatever the artist's preference might be, a great many wonderful effects can be easily and quickly rendered with a painting knife/palette knife. Other useful tools are natural sponges, used for quickly stippling in areas of foliage; various fan brushes, for adding clumps of leaves in certain types of trees; wads of paper towels, etc., for creating the irregular textures of large areas of leafy vegetation; and a variety of specialty brushes, particularly in the larger sizes. Rags, of course, are always needed.

Plein-air painters should avoid direct sunlight, as it can have both short- and long-term consequences. One such consequence is that it can distort a painter's ability to accurately read the values, both in the scene itself and in the painting on which he or she is working. It can also have harmful effects on the artist's eyesight, as ultraviolet light is very strong in sunlight and accelerates the deterioration of nearly everything exposed to it, including human eyes. Some plein-air painters feel that a hat with a brim, or a sun visor, provides adequate protection. Others prefer to shade their painting area with a large umbrella,

staked in place with guy ropes or wire. And still others simply find a shaded spot or paint under the awning of their mobile home/studio. Claude Monet, who painted outdoors for many years, developed cataracts in both eyes. This may be another reason to paint the actual painting in the studio, under less harsh lighting, and restrict our plein-air painting to the generating of reference material. In any case, it bears consideration.

THE LANDSCAPE PALETTE

Given the limited amount of space in the paintbox of a French easel, and the great number of colors needed to do justice to nature, small tubes of paint may be more appropriate for the portable painting apparatus. Most manufacturers have sample-size tubes considerably smaller than the normal or studio sizes. Since paintings done in the field are usually small, and the sessions are by necessity short, there is little likelihood of needing more of any one color than is contained in a small tube during any one session. Perhaps two or three small tubes of white could be included, as white is used more than anything else.

Artists of today have the advantage of a much wider array of pigments than artists of previous centuries had. These include quite a few bright, high-chroma colors with powerful tinting strengths, which expand the possibilities considerably. Some painters prefer to limit the number of paints to a few high-tinting-strength

ALBERT BIERSTADT (American, 1830–1902), *California Spring*, 1875, oil on canvas, 54¼ x 84¼ inches, Fine Arts Museums of San Francisco. Presented to the City and County of San Francisco by Gordon Blanding, 1941.6.

Bierstadt provides a prominent example of landscape painting on a monumental scale. This painting, seven feet wide, is among the smaller of his studio paintings. His procedure was to work on location, and then use those sketches as reference for grand-scale vistas on huge canvases back in his studio.

transparent colors, plus white, from which they can mix all the colors they'll need. Such a palette might include two versions of red, two of blue, and two of yellow. A reddish blue (ultramarine) would be used to mix with a bluish red (a quinacridone crimson) to make violets; a greenish blue (phthalocyanine) would be mixed with a greenish yellow (Hansa yellow) to make greens; an orange-red or scarlet (there are many from which to choose) would be mixed with a yellow-orange to make orange, and complementary colors would be mixed to make colors of lower chroma. White would be added as needed.

Some painters prefer to do less mixing and to work with a wider variety of colors instead, as mixing many colors from a few takes time that could be spent putting paint on the canvas. Those artists will have many piles of paint on their palettes, as close to a full spectrum of individual colors right out of the tubes as they can manage, to increase the likelihood that the color they need for a given stroke will be right at hand.

The choice of palette is a matter for each artist to consider, however, and may be influenced by many things. The following is a list of paints the author has found to be useful in painting landscapes.

titanium white	permanent alizarine [2]
flake white	green earth
ivory black	viridian
peach black	greenish umber
Naples yellow	chromium oxide green
cadmium lemon	ultramarine blue
Hansa yellow	cerulean blue
yellow ochre or Mars yellow	cobalt blue
cadmium orange	Mars violet or caput mortuum
raw sienna	cobalt violet
burnt sienna	manganese violet
red ochre or Mars red	ultramarine violet
pyrrol red	raw umber
cadmium vermilion	burnt umber

All of the above may be considered permanent, with the exception of Hansa yellow. Hansa yellow is less lightfast than the cadmiums but within a range generally considered acceptable for permanent painting. Permanence, as stated before, need not be a concern in sketching, in which case even alizarin crimson (for which permanent alizarine is substituted in the list above) is acceptable. However, lightfastness should be a primary concern with plein-air painters who intend their field paintings to be considered works of art in themselves.

Hansa yellow is a synthetic pigment, similar in hue, value, and chroma to cadmium yellow light but more transparent. In mixtures with white, transparent

Virgil Elliott, *Monte Rio*, 1983, oil on panel, 24 x 16 inches.

This was painted quickly, from a charcoal sketch and written notes done on location in Monte Rio, California, following a plan conceived on the spot. The redwood trees' foliage, lit by the sun from behind, is rendered transparently over a gold ochre-toned white ground, while the dappled light on the road is opaque with the shadows glazed over a gray underlayer.

Photo Credit: Alpha Color, Santa Rosa, California

LANDSCAPE PAINTING

synthetic colors such as Hansa yellow produce cleaner, brighter tints than do opaque colors like cadmium yellow. The chroma remains higher in a mixture of transparent color plus white than in a mixture of opaque color plus white. Light in nature is much brighter than what is possible with paint. When we attempt to lighten our mixtures to match what we see, the white washes out the color, resulting in a lower chroma than what we see in the subject itself. We may overcome this handicap to a certain degree by tinting our white with more transparent colors such as Hansa yellow for the lightest values. The Old Masters, who lacked many of these pigments, dealt with the problem by simply painting the lights darker than they actually were, in order not to diminish the chroma of their colors. The darkest darks were then generally painted darker still, in transparent color, which absorbs more (and reflects less) light, to maintain the contrast between light and dark, and all values in between were adjusted accordingly. This is one reason why many old paintings are dark, or contain very dark passages, especially in the backgrounds. Without such dark darks, the lights would look less light. Relativity is the key.

Painters of today are still faced with the limitations of the pigments, but to a lesser degree than the Old Masters, in light of the availability of brighter, modern synthetic colors. Most synthetic pigments are transparent and high in tinting strength and thus are able to produce very light tints with white while maintaining higher chroma than the older pigments in the lighter values. Some transparent synthetic pigments are listed below.

phthalocyanine blue	ultramarine blue
phthalocyanine green	quinacridone reds
Indian yellow	dioxazine violet
Hansa yellow	indanthrone blue
quinacridone gold	alizarin crimson

Unfortunately, not all of these are lightfast. (Refer to page 123 for a more complete discussion of this matter.) Some varieties of Indian yellow currently on the market are fugitive dyes. The exceptions are made with diarylide yellows, isoindoline yellows, nickel dioxine yellows, and/or synthetic iron oxides, all of which are in ASTM lighfastness category I. True alizarin crimson, as has already been stated, is fade-prone. The quinacridone reds, phthalocyanines, and ultramarines may be considered acceptably lightfast. Hansa yellow (except Hansa yellow light, which is Arylide Yellow 10G, PY3, and Arylide Yellow 10GX, PY98, aka Hansa yellow 10GX) is acceptably lightfast under normal conditions. Alizarin crimson, discovered in 1869, was considered acceptably lightfast for more than one hundred years, until it was discovered to be more fugitive than originally thought. Other similar discoveries may lie ahead.

Used in weak tints with white, many transparent pigments fade more readily than in stronger mixtures or when used straight. There are also a number of

slightly different pigments with the same name, and some varieties may be more resistant to fading than others. For permanent painting, it is advisable to stick to the pigments known to be totally lightfast as much as is possible and only resort to using those of the next lower rating when the desired effect cannot be achieved without them. The ASTM lightfastness ratings are very helpful in determining which paints we can trust.

PROCEDURES

Speed is of the essence in plein-air painting. The only sensible approach is to block in the larger shapes as quickly as possible with whichever tool will do the job most expeditiously and attend to the details afterward, if there is time. In other words, in painting a green forest, we would block in the whole area of green first, then work back into it to indicate the differences in hue, value, and chroma within that larger area, rather than paint the trees one at a time until we had a forest.

Many artists tone the upper two-thirds of the canvas with a blue and the lower third with a brown beforehand, to facilitate faster painting on location and to allow greater accuracy in judging values in the first few strokes. A pure white canvas makes the first strokes appear darker than they really are, and darker than they will appear after the white is covered. This often fools the artist into making the first application of darks too light. Subsequent values, judged against the first darks, are then also apt to be too light. This is easily avoided by painting on a toned canvas. The tone should not be darker than a value 7 on the Munsell scale. A transparent tone, which allows the white primer to shine through from beneath it, will allow the colors painted upon it to exhibit their full degree of brightness and to remain bright for a much longer time than if the initial tone were opaque, even when the value of the opaque tone is no darker than the transparent tone. Colors painted over an opaque primer of a value 6 will be duller than the same colors painted over a value 6 transparent tone with a white opaque primer shining through it. The colors painted over the opaque value 6 will become still duller as they age, whereas those painted over the transparent tone will not.

Opaque toners no darker than a value 7 on the Munsell scale will usually allow satisfactory results, but for very bright, colorful scenes, a light transparent tone, or imprimatura, may be best. The artist should consider whether the picture he or she has in mind will require the highest degree of brightness in deciding which type of toner to use. Nature's colors are not as bright—that is, high in chroma—as the brightest of our pigments. The slight dulling effect of an opaque toner at value 7 may be desirable, as it is in many other types of paintings. The Old Masters got excellent results with it. The darkening problems only occur when the toner or primer is too dark—that is, appreciably darker than value 7. The toned surface, with its value approximately that of our middletones, or perhaps slightly lighter, allows the image to appear as

JOSEPH WRIGHT OF DERBY (English, 1734–1797), *Grotto by the Seaside in the Kingdom of Naples with Banditti, Sunset,* 1778, oil on canvas, 48 x 68 inches, Museum of Fine Arts, Boston. Charles H. Bayley Picture and Painting Fund and other Funds, by exchange, 1990.95.

Wright is too often overlooked as a landscape artist, perhaps because he was a Master of other genres as well. In all probability this is a made-up scene. The deeper transparent darks in the foreground, inside the cave, create a remarkable contrast with the opaquely painted view beyond. The atmospheric perspective is rendered with masterly simplicity for a stunning effect. Color harmony is yellow dominant, with blue adding interest.

Photograph © 2007 Museum of Fine Arts, Boston

soon as we have placed our dark shapes upon it, with the values within the entire picture already closer to truth than if the primer were white. This facilitates quick painting and accurate judgment of values at the same time, both of which are crucial in plein-air painting.

Each brush, knife, or other tool has at least one particular stroke or effect for which it is better suited than any other. We learn which tool does what best only through much practice. The more we practice, the more we learn. Once we have reached a certain level of familiarity with all the tools, materials, and procedures, the process becomes less difficult, the impossible becomes possible, and the image begins to develop more and more quickly. Our sketches become more accurate with each session as our knowledge advances. We cannot expect to learn it all in a few outings. Master level is reached by taking many, many tiny steps. There will be a giant step from time to time, but only if we have taken enough baby steps to get us to that point.

Landscape Painting in the Studio

It is not impossible to paint a great landscape masterpiece on location, to be sure, but the task is made more difficult by the problems inherent in plein-air painting. The difficulties increase when our vista demands a larger scale to do it justice. It may be argued that the difficulties are not insurmountable, that a clever enough artist will devise ways of solving the various problems involved. Perhaps, however, in most cases, it is reasonable to expect artists to do their best work under ideal conditions. We have more control over our working environment in our own studios and should therefore be able to produce better work on a more consistent basis than if we were to only work outdoors. The outdoor work must still be done, to generate the many studies and sketches, as well as the mental images, but most of us need more time to consider the aesthetic aspects of the scene than is available on location. It must also be taken into consideration that the painting will be hung indoors and will be viewed in a different light than that under which it was painted, if it was painted outdoors, and that its appearance will be somewhat different as a result. We may choose the most appropriate lighting in the studio and make whatever adjustments may be required to produce the desired effect under normal indoor lighting.

In the field, artists are more often than not compelled to use the direct painting technique, with all its attendant limitations, and to work on a smaller scale. Under more controlled circumstances, we may work however large we choose, according to the dictates of the subject itself, and are free to determine which technique best suits our concept for the picture. In order to create the most convincing illusion of three-dimensional reality possible, we must fully exploit the qualities of transparency, opacity, and the varying degrees of these tendencies of our paints and employ them systematically to indicate the effects of the atmosphere at different distances from the viewer's eyes. The optical sensations created by the techniques of glazing, scumbling, and opaque painting must be

Troyon was one of the Barbizon landscape painters of the nineteenth century. Here we see depth created by atmospheric perspective, a Troyon specialty. The lights are opaque and the darkest darks are transparent.

combined in the same painting if we wish to give the viewer the most convincing impression. These effects must be applied following a system that corresponds to the principle of atmospheric perspective, or the illusion will fail. It is not as difficult as it sounds.

The key to the problem is to understand that the air through which we view anything is clearer the shorter the distance and hazier as the distance grows. This phenomenon is also discussed in chapters 4 and 6. The illusion of clarity of the air, to indicate nearness, is created in part by rendering the deepest foreground darks with transparent glazes. The highest degree of clarity is achieved by using pigments that are by nature transparent and perhaps by adding a bit of a transparent medium. The use of opaque or semi-opaque paint thinned with transparent medium will work sometimes, but it will not indicate clear air as well as when the deepest darks are glazed with transparent paint. It should be emphasized that opaque paint must be used to represent light falling on solid forms in the foreground, for the illusion to be complete.

Areas beyond the foreground are best painted opaquely in the darks as well as the lights, with contrast between the extremes of light and dark diminishing as greater distances are indicated. The atmosphere becomes less transparent with distance and robs the darks of their clarity.

The most distant planes may be painted opaquely and then scumbled over, when dry, with a still lighter value to indicate the whiteness of atmospheric haze. A scumble, as mentioned previously, is an opaque pigment rendered semi-opaque by being spread very thinly, applied over a darker passage. The scumbled haze of the greatest distance should also include the lower portion of the sky. The

air contains water vapor and its own density independent of the water, which, when illuminated by the sun, reads as a semi-opaque white through which images appear less distinct, and colors duller and cooler, the more of it we must look through to see something. Less distance means less air, less haze, therefore, more clarity. More distance means more atmosphere, more haze, and less clarity. The cool colors we see in the distance are caused by a color shift that takes place when darker values are seen through a veil of semi-opaque light. The atmosphere filters out more of the warm colors than the blue wavelengths. Scumbling works in the same way, although to a lesser degree. In certain cases a scumble might require a bit of blue or cool gray added to the white to indicate the haze at the horizon or between our eyes and mountains far away. The increase in opacity of the atmosphere over greater distance also accounts for the sky being always lightest at the horizon.

The artist working in the studio is less restricted in his or her use of the aforementioned effects than when working on location and can thereby make the best use of the most sophisticated techniques in the realization of the concept for the painting. It may still be helpful, circumstances permitting, to

JACOB VAN RUISDAEL (Dutch, circa 1628/1629–1682), *Landscape with Waterfall*, circa 1660s, oil on canvas, 39¾ x 56 inches. Reproduced by kind permission of the Trustees of the Wallace Collection, London.

Ruisdael was among the finest of the Dutch landscape painters of the seventeenth century. This painting would have been painted in the studio, perhaps aided by sketches done on location, but the likelihood is that Ruisdael created it from his imagination, relying on his knowledge of visual phenomena to supply its realism. This was the more common practice in his time.

return to the site for the last few adjustments, with the painting in its final stages, at the same time of year and day, and under the same weather conditions as were in effect when the scene first struck the artist's sensibilities. When this is possible we have the best of both worlds.

Outdoor Color

The subject of outdoor color confuses many people because there are several popular theories in circulation that are incompletely understood, misapplied, or simply incorrect in the first place. For instance, the popular axiom, "warm lights, cool shadows; cool lights, warm shadows" is best ignored, as it is only true sometimes, and for different reasons than those alleged. The reader is encouraged to become thoroughly familiar with the ideas discussed in chapter 5. The reader is also encouraged to challenge any and every hypothesis presented, including those in this book, by subjecting them to logical scrutiny and comparing what is said with what is seen. This is the only process by which true understanding can be gained.

The Temptation to Use Photography

Many landscape painters of modern times rely heavily on photography, which one might think would allow them to do better work than artists of the distant past, who had no cameras. Art is made by artists, not machines, and great art is made by great artists. One does not become a great artist by avoiding the very processes by which the necessary knowledge is acquired. For any tool to be used effectively in the creation of art, the one essential ingredient must be the knowledge and aesthetic sense of the artist. Regardless of the sophistication of the devices employed, without the direction of an artist, the end product is not art and will never surpass the limitations of the guiding intelligence behind it. The artistic intelligence required to create great art can only be developed by working with simple tools and by relying most heavily on the artist's own thought processes.

Upon reaching Master level, we may perhaps employ the camera as an aid and still be able to create great art, but at that point we are likely to be so acutely aware of the limitations of photographic images that we dare not rely too heavily on them, nor trust them to tell us the truth. Our eyes and brain are vastly superior viewing devices, once properly trained. Using cameras interferes with this training. (Refer to pages 50–51 for more on this issue.) Though we might at some point possess a great deal of understanding in our field of expertise, we nonetheless learn at least a little bit each time we draw or paint something from direct observation. Whereas a Master's knowledge of the principles of visual reality and mastery of painting should be sufficient to compensate for the shortcomings of photographic reference, it may be argued that even a Master might learn a little more with each session by relying less on such crutches and become a still greater artist. This is for each Master to decide. Those who have not yet reached Master level should not even consider the use of artificial means, or their full potential will never be realized.

Chapter Ten

STILL-LIFE PAINTING

MUCH OF WHAT HAS ALREADY BEEN COVERED in this book applies to still-life painting, but some specifics bear addressing, in the interest of thoroughness. One of the reasons for painting still lifes is the simple fact that it's good practice. No models need be hired, and just about any object can be used as subject matter. So at the very least, it can give us something to paint in between more challenging projects, when logistical difficulties or creative drought might be holding things up. Many artists do them as potboilers, to keep their dealers supplied with pictures to sell and to keep the income flowing. Of course, still-life paintings can be much more than mere practice exercises or potboilers, but those are valid enough reasons for doing them.

At their best, still-life paintings can convey meaning and mood, by the artful arrangement of lighting and composition and by the choices of objects to be used as subject matter, for their symbolism. A bit of imagination could bring many possibilities to mind. It might be likened to instrumental music, which relies on the artistic arrangement of notes and intervals for its appeal, rather than on the use of words to tell stories or express feelings. Henri Fantin-Latour provides many excellent examples. His subject matter, the objects depicted, have no great significance in themselves, but strategically arranged in an ensemble, with their positioning relative to one another given careful consideration, they become more interesting to behold, more beautiful. Therein lies the art.

Opposite:
WILLEM KALF (Dutch, 1619–1693), *Still Life with Ewer, Vessels, and Pomegranate*, circa mid 1640s, oil on canvas, 40 ¾ x 32 inches, The J. Paul Getty Museum, Los Angeles. Gift of J. Paul Getty.

Dynamic tension is created by the plate hanging over the edge of the table, in this otherwise stable triangular composition, which is designed in three dimensions. Note the transmitted light in the glass of wine. The geometric perspective appears to be slightly askew, but each individual object is rendered with a high degree of realism. Note the textures.

Still-life Concepts

Still-life painting, like the other genres, requires careful attention to all pictorial concerns if high quality results are the objective. With this in mind, there are questions to be answered before we begin to gather and assemble the objects or lift a brush. Shall we undertake to do a small, simple piece, or an elaborate arrangement involving many objects? Will there be symbolic meanings attached to these objects, associations between them that suggest a theme, a message of some kind? What kind of lighting best fits the mood we have in mind for this particular picture? What kind of color scheme? Shall we paint it quickly, in a painterly *alla prima* manner, or would a more highly detailed, trompe l'oeil approach serve better? How much should be left to the viewer's imagination to complete, and how much should be rendered in higher detail? The answers to these questions will become the concept for the painting. It is best to have a fairly clear concept in mind before we start to paint.

SETUP

A still-life painting can be so much more than an assemblage of objects. However, a well-painted assemblage of objects can be quite artistic in its own right, if the assembling is done with an artful eye. This is where much of the art in still-life painting lies—in the composing of the scene before a brush is lifted. It is well to do a bit of planning before starting to paint, if consistently good results are important.

A simple picture executed in a masterly way surely ranks above a more ambitious composition rendered with less finesse. A few objects arranged creatively can be every bit as effective as a more elaborate layout. We might, for example, employ a somewhat Zen-like concept, wherein spaces (intervals) are recognized as important elements in the composition. In such an instance we would make the most of the fewest objects for the mood we want to project. Space has meaning, too, and brings in its own connotations, its own suggestive power. To make much with little is a very valid concept. It is worth considering.

Of course, that is not the only way. The opposite extreme might be the Dutch still-life painters of the seventeenth and eighteenth centuries, with their lush layouts of multicolored foodstuffs and flowers, all rendered with painstaking realism with not a brush stroke showing. Between those extremes lie many possibilities. Whatever works, works.

LIGHTING

The still-life painter can employ lighting in many different ways, but the artist's task is made less difficult if the lighting chosen, whatever it may be, does not change. Thus the least satisfactory lighting would be natural light from a window facing any direction but north in the northern hemisphere, or south in the southern hemisphere. The obvious reason is that the light would change throughout the day as the sun moved across the sky, which would continually

alter the positions of the shadows and highlights, as well as the intensity and color of both primary and reflected light. With the window facing north (or south, below the equator), only indirect sunlight—that is, light from the sky—would enter the window. It is even more ideal if that window is positioned high on that north-facing wall, as it provides useful shadows on the subject and does not produce glare on wet paints. This is the light preferred by artists for centuries, for its soft beauty and for its relative consistency throughout most of the day, which accommodates longer working hours.

North light is not perfectly uniform, of course, because some days are brighter than others, and some times of day will have different colors in the sky, which will affect the colors of everything on which its light falls. A frosted skylight would help to even out the natural light from the sky and would give the effect of outdoor lighting on an overcast day, for those artists fortunate enough to have the ideal studio. However, not many artists are so blessed. Fortunately,

Henri Fantin-Latour (French, 1836–1904),
Flowers and Fruit on a Table, **1865, oil on canvas, 23⅝ x 28⅞ inches, Museum of Fine Arts, Boston. Bequest of John T. Spaulding, 48.540.**

Here Fantin-Latour shows us a lyrical arrangement of shapes and intervals in a sort of curved triangle, or perhaps more of a cornucopia-shaped composition, whose vertical axis is on the Golden Mean. Note the variety of texture depicted. Tension is introduced by the knife extending over the edge of the table. This makes things more interesting.

Photograph © 2007 Museum of Fine Arts, Boston

with the advent of the electric light, painters have more possibilities open to them than in the days predating the discovery of electricity. Photographers' lights and lighting accessories are especially useful to artists, as are other kinds of artificial light. They allow us to have a great deal of control over the lighting and make it possible to paint all night if we so choose.

Regarding control of the light, some still-life painters employ a large box, usually with its interior walls painted black, to house their setup and exclude all light from extraneous sources. The light source chosen in these instances is usually a single artificial light of some kind. Its position, intensity, and color do not change as long as the artist needs it, which is a great help in painting from direct observation of the setup. An alternative to the box might be a dark booth, essentially a tent made from dark cloth, which would serve the same purpose as a box but on a larger scale.

It is generally preferred to have one dominant light source illuminating the scene we are painting, to simplify things for ourselves and for the viewer. Too many

VIRGIL ELLIOTT, *Still Life by Candlelight*, 1985, oil on panel, 30 x 24 inches.

This involved painting from memory. The setup was in one room and the easel was in another. This is one way an artist can get some physical exercise. Edgar Degas was an advocate of training the memory in this way.

light sources can present a confusing spectacle and can complicate the situation unnecessarily. Many studio photographers routinely throw light on their subjects from multiple directions, but this effect is arguably best left to the photographers. It is surely appropriate to recognize a different set of aesthetic principles and preferences to distinguish fine art painting from photography. In painting, the scene makes more sense if there is no confusion over the lighting.

Shadows are an artist's friend. They add an element of drama and mystery to a scene and allow the lighted areas to stand out in relief against them. The still-life painter orchestrates the light the way a theatrical production uses it to focus the audience's attention where it is wanted on the stage. The mood of the picture depends on the lighting (and strategic use of shadow) to a great extent.

PROCEDURES

Once the setup has been arranged, and the lighting chosen and set, the painting of the picture can be approached in several different ways. One would be to begin by drawing in charcoal, until a satisfactory basis is established to guide the initial blocking-in of the large color shapes. Another would be to dispense with the charcoal entirely and simply block in the large shapes with oil paint by eye, correcting and adjusting as needed by wiping out with a rag or cheese-cloth, until all the large, general shapes are filled in, and then to work back into them to develop them further while the paint is still wet. Where the subject includes perishable items, such as flowers, fruit, and vegetables, it is especially important to work quickly, to record the appearances before they have had time to change. However, many floral painters begin as was just described and leave the flowers as simple shapes with no particular distinctiveness about any of them until the canvas is covered with paint, at which time they paint each individual flower, one at a time, to whatever degree of detail or focus is deemed appropriate for it relative to the others.

If a flower droops during the early stages of a painting, it is a simple matter to replace it with a fresh one, arranged in the same way, before beginning to paint it with any degree of specificity. The same would apply to other perishable objects. The nonperishable objects in our setup can be attended to later in more detail, while we take care of the things that will change first. For the time being, the pot, vase, bottle, glass, bowl, or whatever, need only be filled in as general shapes of the appropriate color and value until the perishable things have all been painted. We will have as much time as we might need to render these other objects, since they will not wither or change in appearance in any way, whereas grapes will turn into raisins, apples will wrinkle and rot, flowers will wilt and dry up or lose their petals, and so on.

There is little point in executing a grisaille underpainting in still-life painting, because it would delay the progress of the piece with no benefit to warrant it. Where perishable objects are included, there is no time to waste. Blocking in the

shapes simply at first and then working back into them to develop them is the most expedient approach—in other words, painting in the direct painting technique. Whether to draw the design first, before beginning to put paint on the canvas, is for the artist to decide. Some are more comfortable than others with the idea of painting without a drawing to guide them. The more experienced and confident painter might prefer to draw with the brush, using thinned paint, in a rudimentary manner, as sufficient for beginning the picture; whereas if one is somewhat unsure of his or her ability to work in that way without sacrificing accuracy, drawing in charcoal first does provide an opportunity to make corrections before any paint has been applied.

An alternate way to begin is to draw with the brush, beginning with a single color. A brown is often used in this approach, with the other colors delayed until the composition is rendered reasonably well in monochrome. Full color can be commenced while the monochrome is still wet or after it has had time to dry. From that point on, the procedure is fairly straightforward. It is advisable to do as much as possible wet-into-wet. If we are working in stages, then each stage should be executed wet-into-wet to the completion of that stage and then allowed to dry before the next stage begins.

The best results are achieved by working from direct observation of the setup. There really is no good reason to do it any other way. There are painters who routinely photograph everything they intend to paint and then refer to the photograph while painting, or even project it and trace it on their canvas, but this is not to be encouraged, especially in still-life painting. One's ability as an artist advances most, and most naturally, when working from a direct view of the subject. And with a still-life setup, it is right there, so we might as well just look at it and paint what we see.

Trompe L'oeil

Trompe l'oeil still-life painting is essentially a fool-the-eye realism wherein a shallow depth of field is employed in the setup, often a board or wall with small or relatively flat objects pinned or otherwise attached to it. These objects are usually strongly lit from a single light source. The painting is done life-size, from direct observation, with the highest possible level of realism in the rendering of each object depicted. Because the depth of field is only a few inches or less, selective focus is not usually employed in this style of painting. The idea is to fool the viewer into believing that the objects are actually there in three dimensions. Brushstrokes are not left identifiable as such, and all painterly effects are eschewed in the interest of deceiving the viewer and creating the most convincing illusion possible.

The objects chosen for trompe l'oeil paintings have very limited depth, such as ribbons, wristwatches, photographs, cards, sheet music or letters, pencils, pushpins, and small insects such as flies, because objects involving too much

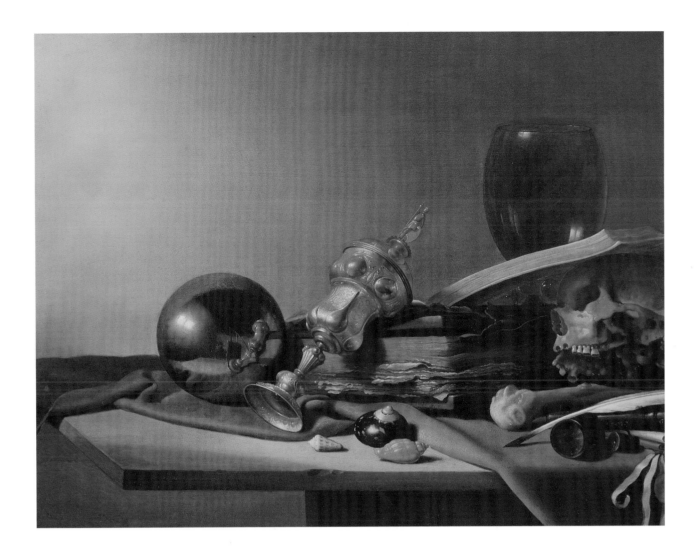

Attributed to PIETER CLAESZ (Dutch, circa 1597–1661), *Vanitas Still Life*, circa 1634, oil on panel, 21 ¼ x 28 ⅛ inches, The J. Paul Getty Museum, Los Angeles.

Note the variety of textures, all rendered with convincing realism. The main key to indicating textures lies in controlling the degree of contrast between the highlights and the middletones.

depth would only appear real to the highest degree when viewed from a single vantage point. From all other angles, the perfect illusion of three-dimensionality would be compromised to some degree, and the effect would be spoiled. As such, trompe l'oeil painting is a trick. It depends on the illusion itself to fascinate the viewer, more so than on the objects chosen, generally speaking.

The objective in this type of painting is not to have the image appear photographic but actually real in three dimensions. For that reason, it is best done from direct observation of the setup rather than from a photograph of it. Once again it is important to draw a distinction between photographic and realistic. This is a distinction that is lost on most people, including many who consider themselves artists, but the well-trained artist knows better than to confuse the two types of image. (See pages 50–51 for more on the differences between photographic images and visual reality.) Painting to a photographic approximation is not realism but photorealism, a type of painting that is outside the scope of this book.

Still-life painting might be seen as an exercise in pure aesthetics, since its subject matter need not be particularly meaningful in itself and no message need be conveyed. Those lofty goals are admirable in the kinds of paintings in which they are the objective, but to simply bring beauty into people's lives is a sufficiently worthy goal for an artist to pursue, at least until a great inspiration comes along. For the world we live in has more than enough ugliness in it already, and without artists to remind people of the concept of beauty, of the ways in which it enhances the quality of life, it could be a truly ugly world indeed. If we believe that there must be a purpose for art to fulfill, for the human drive to create art to have a reason for its existence, surely that is enough right there.

Closing Thoughts

There are many reasons why people paint pictures, and why individual artists prefer one kind of picture over another. Still life, landscape, portrait, or figure; realistic, surrealistic, abstract, or cubist—each has its advocates and its detractors, all of whom argue eloquently to bolster their individual points of view. But the arguments are really beside the point. They are more rationalizations concocted to justify choices already made than the actual reasons behind those choices. We might reasonably acknowledge that there is surely more than one valid way to paint, more than one valid point of view. But whether we even need to concern ourselves over the question of validity is itself a question that might be worth asking.

The trends that dominate the art world, or at least the headlines, change from day to day, as each "new movement" becomes relegated to history as soon as it is superseded by the next craze. This would seem to render the concept of trendiness essentially meaningless. Yet there must be a reason why certain works of art are able to transcend time and historical context, transcend the relevance or significance of the subject matter depicted, to endure through the centuries and continue to move people in a positive way upon viewing, by the pure artistry of the visual ensemble. With these great masterpieces, all other considerations are made irrelevant by the overall pictorial excellence of the image itself. These works of art might be said to have "intrinsic appeal." There is something about them that touches people on a deeper level than can be reached by the superficialities of the trendy tastes of the day. These qualities defy verbal description, yet they are instantly recognizable. There are no words for them, or at least no words that can do them justice. Among the words that come closest might be *beauty, elegance, Quality* with a capital Q, but these words themselves defy specific definition. Indeed, too many words have been wasted in futile attempts to pin these qualities down, to define them, or to persuade people to interpret them differently or disregard them.
The result of this has been to cloud the issue more than clarify it. Yet these instantly recognizable qualities endure, and the greatness of Great Art continues to rest in the intrinsic appeal of the works themselves, no matter what anyone says about them, pro or con.

Our greatest challenge as artists is to come to an understanding of those qualities and to bring them to the works that we create, to give them their own intrinsic appeal. Therein lies the key to greatness.

Overleaf:
ALFRED STEVENS (Belgian, 1823–1906), *The Attentive Listener,* 1879, oil on panel, 20⁹/₁₆ x 11¹³/₁₆ inches, Museum of Fine Arts, Boston. The Henry C. and Martha B. Angell Collection, 19.111.

Alfred Stevens is an underappreciated master of direct painting. He has obviously wasted no time on the dress in this painting, yet its effect is remarkable. The dress serves as secondary interest, and leads our attention back to the young lady's face as we follow the flowing shapes and ruffles upward, after our initial look at the face, to bring us back for a second look.

Photograph © 2007 Museum of Fine Arts, Boston

Notes

INTRODUCTION

1. Old Masters are the great painters of Europe, from Hubert and Jan van Eyck in the fourteenth and fifteenth centuries through the artists of the seventeenth century. The Dutch "Little Masters" are the seventeenth-century Dutch painters who worked on a relatively small scale.

2. This remains largely true of many colleges and universities; however, there are a few academies, ateliers, and individual artists who teach following the traditional approach more or less, and the number of these is currently growing.

CHAPTER 1

1. *The Night Watch* is not the painting's true title but one given to it after the work had darkened with age and was mistaken for a night scene. The name is more easily remembered than *The Militia Company of Captain Frans Banning Cocq and Lieutenant Willem van Ruytenburch,* so it continues to be popularly known as *The Night Watch.*

2. Whether this corresponds to the Golden Mean may be checked by multiplying the smaller segment of the 40-inch whole (15.28 inches, arrived at by subtracting 24.72 inches from 40 inches) times 1.618. If the result is 24.72, the ratio is correct. In fact, 24.72 multiplied by 1.618 equals 40; therefore the smaller segment (15.28 inches) is the same ratio to the larger segment as the larger segment is to the whole. That is the Golden Ratio, or Golden Mean.

3. As Jane Ellice Hopkins has said: "Genius is an infinite capacity for taking pains." From *Work Amongst Working Men,* by Jane Ellice Hopkins, 1870.

CHAPTER 2

1. At least this has been the author's experience.

2. Harold Speed introduced this concept in his book *The Practice and Science of Oil Painting,* which was originally published by Seeley, Service and Company in 1924 and was reprinted by Dover Publications in 1987 as *Oil Painting Techniques and Materials.*

CHAPTER 3

1. The author is also a musician and has taught music for a number of years.

2. John Singer Sargent could sing, and play guitar and piano; Leonardo da Vinci was noted as a singer and musician, and was hired in that capacity by the Duke of Sforza; Giorgione was an accomplished lutenist, among many examples.

3. Or painting, for this method was and is still practiced by many painters, the most famous of whom would be John Singer Sargent.

4. See chapter 4 for a discussion about perspective.

5. Some art schools might have arrangements with local medical or chiropractic schools to allow art students to draw cadavers. If they do not, they should. The author recalls drawing cadavers being dissected at a chiropractic college as an art student in the 1960s, at any rate.

CHAPTER 4

1. As Wassily Kandinsky has said, "To send light into the darkness of men's heart, such is the duty of the artist."

2. This is the author's theory only, not necessarily corroborated by science, which has its own explanation for the blue sky phenomenon. Sooner or later, science will surely realize that the author is correct. In any case, the author's explanation suffices for artists' purposes. The principle is operable as described.

3. Film photography uses three dyes, as stated. With the printers now being used in conjunction with digital photography, black is included as a fourth dye, or pigment.

4. The relatively new field of digital photography may well add new twists to photography at some point beyond the publication date of this book. At the time of this writing, it adds the option of viewing the images on a lit screen and of altering them with various computer programs. However, it does not diminish the importance to the artist of learning to draw and paint without photography before adopting it as an aid. The digital camera is not likely to ever develop artistic sense, taste, etc, nor individuality of the kind that distinguishes one artist's work from that of another.

CHAPTER 5

1. In fact, many entire books have been written about this subject, most notably Josef Albers's excellent book *Interaction of Color,* listed in the bibliography.

2. This phenomenon is the subject of Josef Albers's *Interaction of Color.*

1. The molecules of the oil take on a physically longer configuration when polymerized by heat or the sun or partially oxidized from exposure to the air for a few hours. Scientific analyses reported in the National Gallery Technical Bulletins and elsewhere show both heat-bodied linseed oil and non-heat-bodied linseed oil as binders in a number of examples from the early times of oil painting. The test methods most frequently employed were FTIR spectroscopy and GC-MS.

2. Mentioned in Ernst van de Wetering's book *Rembrandt: The Painter at Work*, pp. 239–240, based on the research of P. W. F. Brinkman, *Het geheim van Van Eyck: aantekeningen bij de uitvinding van het olieverven*, Zwolle 1993; L. Kockaert, "Note sur les émulsions des Primitifs Flamands," *Bulletin IRPA-KIK XIV* (1973/74), pp. 133–139; L. Kockaert and M. Verrier, "Application des colorants à l'identification des liants de van Eyck," *Bulletin IRPA-KIK XVII* (1978/79) pp. 122–127.

3. As reported by Giorgio Vasari, in *Lives of the Most Eminent Painters, Sculptors, and Architects*. This may, however, have been simply Michelangelo's (or Vasari's) misunderstanding of a new approach to painting, in which linear design was not the most important concern, rather than necessarily an indication of any actual deficiency in drawing ability on Titian's part.

4. Vermeer succeeded in violating this general rule in his own very complex variation of the Venetian technique and was able to make it work. There will always be exceptions to any generality or rule.

5. There has been some confusion over what was meant by the term *glaze*, because the word, or its Italian equivalent, was historically used to include what are in this book referred to as scumbles and semiglazes as well as true transparent passages—i.e., true glazes. The confusion arises when older writings in the Italian language are subsequently translated into English.

6. Rembrandt was influenced by Titian and owned some of his works.

7. This is mentioned in Ernst van de Wetering's book *Rembrandt: The Painter at Work*, p. 235, and elsewhere, based on the research of Karin Groen, reported in her paper, "An Investigation of the Use of Binding Medium by Rembrandt: Chemical Analyses and Rheology," *Zeitschrift für Kunst-technology und Konservierung* II (1997), Heft 2 (forthcoming).

8. Or other earth red, such as Mars red, light red, English red light, Italian earth, pozzuoli earth, terra rosa, and Indian red.

9. Salvador Dalí recommends using the fingers, after the paint has become tacky. Most painters use a rag, or cheesecloth, to wipe out the lights.

10. In some of his later canvas paintings, Rembrandt used quartz grounds with a linseed oil binder.

11. This stage was generally referred to as the imprimatura. Later, the French academic painters called it the "frottis" or "frottie." (See page 103.) It is based on the French verb *frotter* meaning "to rub." The term "frottis" generally referred to a thin brown scrub-in without white, the lights instead being simply indicated by leaving the light ground more or less exposed.

12. The ground glass in Rembrandt's paintings was possibly smalt, used as a transparentizing pigment as well as for its drying effects. Mentioned in Ernst van de Wetering's book *Rembrandt: The Painter at Work*, p. 241.

13. Mentioned in Ernst van de Wetering's book *Rembrandt: The Painter at Work*, p. 235, and elsewhere, based on the research of Karin Groen, reported in her paper, "An Investigation of the Use of Binding Medium by Rembrandt: Chemical Analyses and Rheology," *Zeitschrift für Kunst-technology und Konservierung* II (1997), Heft 2 (forthcoming).

14. Smalt exhibits its blue color best when coarsely ground. Ground more finely, it loses most of its color and becomes more suitable as a transparentizing additive for other colors and as a drying agent.

15. This was confirmed in private correspondence between the author and Professor Dr. Jaap Boon, head of the Molecular Painting Research Group, FOM Institute AMOLF—the group who made the discovery. At this point in the research on Rembrandt, this remains an anomalous finding.

16. Bouguereau's earlier technique was more uniformly opaque in the final layer.

17. Camille Bellanger provided the following details concerning Bouguereau's paint application: "His lay-ins were broad and thickly painted. . . . He never left them in this state: as soon as the piece—which to anyone else would have seemed completed—started to solidify, he took up his palette knife and, with incredible skill, would go over the whole, in all directions, evening out, stripping, until the surface had acquired the desired finish and transparency." From *Bouguereau at Work*, the catalog from the Montreal exhibition in 1984.

18. The author sometimes cheats by using a wheelchair, which can be propelled rearward with less effort than it takes to get up and walk to the far end of the room. The main objective is to view the painting at a distance every few strokes.

CHAPTER 7

1. Although this is possible, it is not necessarily advisable—except when the painting in question is still young and flexible and if it contains no widespread applications of heavy impasto. A film of oil paint loses its flexibility after a certain point and will crack if bent or rolled.

2. Vermeer and a few others, who used canvas even for small paintings, are exceptions.

3. Rabbitskin glue is hide glue, and indeed some so-called rabbitskin glues come from other sources than rabbits' skins. The performance of hide glues has more to do with the means of their preparation than the source of the raw material. Essentially, they are all gelatin.

4. Grounds made from these materials are commonly referred to as "gesso," although the term originally meant specifically grounds made from hide glue and gypsum.

5. The acidity of the linseed oil may be neutralized to some degree by adding chalk (calcium carbonate) to the primer, but it must not be assumed that this would eliminate the need for sizing the canvas.

6. Above 75 percent RH, the strength of hide glue deteriorates significantly.

7. In particular, Dr. Marion Mecklenburg, Senior Research Scientist at the Smithsonian Center for Materials Research and Education, Smithsonian Institution.

8. Rublev, a new brand by a small specialty manufacturer, Natural Pigments, is the lone exception. Some of their oil paints are more long than the paints of the larger companies.

9. Low-quality paints are no bargain, as their low ratio of pigment to filler greatly reduces their tinting strength. In addition, these paints include adulterants and inferior grades of oil, both of which greatly increase the possibility of future problems.

10. Another kind of yellowing, sometimes called secondary yellowing, occurs over the long term and is not reversible. It is not as noticeable as primary yellowing, however, and takes place in the other drying oils as well as linseed.

11. The author's test panel indicates only slight fading of a sample of Winsor & Newton's Rose Madder Deep after ten years in a south-facing window, during which time all samples of alizarin crimson (dihydroxyanthraquinone, PR 83) noticeably changed, losing their redness. Ten years in direct sun is the likely equivalent of more than one hundred years in normal indoor lighting, and perhaps more. The author's first test did not include colors reduced with white, however, which undoubtedly would have shown greater fading. A second test was subsequently begun, in which the colors were mixed 50/50 with a white (Winsor & Newton's Flake White #1), which confirmed the fact that rose madder fades more rapidly in mixture with white than it does full strength; however, it still outperforms the synthetic alizarin crimson. It should be noted that some of the alizarin substitutes also faded somewhat when mixed with white, varying in performance from one sample to another. Currently, at least two manufacturers are providing lightfast substitutes for alizarin crimson, which are called Alizarin Permanent, Permanent Alizarine, Permanent Alizarin Crimson, etc., made from mixtures of pigments rated as ASTM Lightfastness I. These are considerably less expensive than real rose madder.

12. Winsor & Newton is currently the only manufacturer offering true rose madder. Their paint chemists have devised a method of ensuring the highest degree of permanence possible from the natural sources of this color.

13. The story was told by one of the docents at the San Francisco Palace of the Legion of Honor. Whether or not it is true, it is at least a good story.

14. Perhaps a slight exaggeration, but the point should be clear.

15. The pigment originally used in Indian yellow was made with the dried urine of caged cows fed on mango leaves and deprived of water. Concerns over cruelty to animals have caused the discontinuation of the manufacture of this pigment. Various other formulations are now used as substitutes, some more lightfast than others. The conscientious painter should pay attention to the ASTM lightfastness ratings.

16. Flake white becomes less opaque as it ages. This is why the Old Masters applied it more heavily in their lighter lights.

17. Flake white can turn black when acted on by sulphur compounds, as are found in air polluted by the burning of coal; however, the likelihood of problems occurring in oil paintings is very low, as the particles of pigment are encased in a protective film of oil. Further protection from the atmosphere is provided by varnish. All oil paintings should be varnished within one year from the application of the last brushstroke.

18. Pine resin has been detected in some of Anthony van Dyck's paintings by conservation scientists at the National Gallery in London, as reported in their *Technical Bulletin*, Volume 20. Whether this practice was in use by Flemish painters prior to van Dyck currently remains undetermined and is open to speculation.

19. Darkened oil films can be bleached by exposure to indirect sunlight for a few minutes a day. There are problems associated with this procedure as well, in that ultraviolet light causes, and accelerates, the aging process known as cross-linking, which increases brittleness and the tendency to crack. However, it is preferable to allowing a darkened painting to remain unreadably dark.

20. Jacques Maroger was on the Conservation Committee at the Louvre from 1930 to 1939. He became Technical Director and professor at the School of the Louvre before immigrating to the United States, where he subsequently taught at the Parsons School of Design in New York and at the Maryland Institute College of Art in Baltimore. Several of his students later established schools of their own, based on his teaching, and others became teachers at various institutions.

CHAPTER 8

1. It is not necessary to go to drastic extremes to obtain one. A replica will do.

2. Or any earth red, such as Venetian red, English red, Italian earth, Mars red, Pozzuoli earth, light red, Indian red, flesh ochre, and terra rosa. All are iron oxide reds, differing more in tinting strength and other properties than in hue.

3. The popular view that the camera does not lie is mistaken. The image recorded by a camera differs in a number of ways from visual reality, yet few people understand this.

4. As always with rules, there are exceptions. In the case of tall, ideally proportioned people, this adjustment may not be necessary.

CHAPTER 9

1. The reason that water-based media are less suitable for field studies is that they tend to change in value—that is, to lighten or darken upon drying.

2. A lightfast substitute for alizarin crimson from Archival Oils. Other companies also offer alizarin substitutes of better lightfastness than alizarin crimson (dihydroxyanthraquinone, PR 83).

Bibliography

Albers, Josef. *Interaction of Color.* New Haven and London: Yale University Press, 1963.

Boime, Albert. *The Academy & French Painting in the Nineteenth Century.* New York: Phaidon Press, 1971.

Bomford, David, Jo Kirby, Ashok Roy, Axel Rüger, and Raymond White. *Art in the Making: Rembrandt, New Edition.* London: National Gallery Company, 2006.

Carlyle, Leslie. *The Artist's Assistant: Oil Painting Instruction Manuals and Handbooks in Britain 1800–1900 with Reference to Selected Eighteenth-century Sources.* London: Archetype Publications, 2001.

Carlyle, Leslie. *MOLART Fellowship Historical Reconstructions of Artists' Oil Paint: An Investigation of Oil Processing Methods and the Use of Medium-modifiers,* Canadian Conservation Institute Report No. 72894.

Cennini, Cennino D'Andrea. *Il Libro Dell' Arte.* 1437. Translated by Daniel V. Thompson, Jr. and reprinted as *The Craftsman's Handbook.* New York: Dover Publications, 1954, 1960.

Cole, Rex Vicat. *Perspective.* London: Seeley, Service & Co., 1921. Reprinted as *Perspective for Artists.* New York: Dover Publications, 1976.

Ellinger, Richard G. *Color Structure and Design.* New York: Van Nostrand Reinhold, 1963, 1981.

Feller, Robert L. *Artists' Pigments: A Handbook of Their History and Characteristics.* Washington, D.C.: National Gallery of Art, 1994.

Feller, Robert L., Nathan Stolow, and Elizabeth H. Jones. *On Picture Varnishes and Their Solvents.* Oberlin, OH: Intermuseum Conservation Association, 1959. Revised edition, Washington, D.C.: National Gallery of Art, 1985.

Gettens, Rutherford J. and George L. Stout. *Painting Materials.* New York: Van Nostrand Company, 1942. Reprint, New York: Dover Publications, 1966.

Gottsegen, Mark David. *The Painter's Handbook: The Revised and Expanded Edition.* New York: Watson-Guptill Publications, 2006.

Hebborn, Eric. *The Art Forger's Handbook.* Woodstock and New York: The Overlook Press, Peter Mayer Publishers, 2004.

Jonker, Michiel, ed. *Vermeer Studies.* Washington, D.C.: National Gallery of Art, 1998.

Journal of the American Institute for Conservation. Washington, D.C.: The American Institute for Conservation of Historic & Artistic Works.

Lack, Richard. *On the Training of Painters and Notes on the Atelier Program.* Minneapolis: Atelier Lack, 1966.

Leonard, Mark, ed. *Personal Viewpoints: Thoughts about Paintings Conservation.* Los Angeles: The Getty Conservation Institute, 2001.

Levison, Henry W. *Artists' Pigments: Lightfastness Tests and Ratings.* Hallandale, FL: Colorlab, 1976.

Levison, Henry W. "Yellowing and Bleaching of Paint Films." *Journal of the American Institute for Conservation* 24 (1985): 69–76.

Luke, Joy Turner. *The New Munsell Student Color Set.* New York: Fairchild Publications, 1996.

Mayer, Lance, and Gay Myers. "Old Master Recipes in the 1920s, 1930s, and 1940s: Curry, Marsh, Downer, and Maroger." *Journal of the American Institute for Conservation* Vol. 41, No. 1 (Spring, 2002): 21–42.

McCann, Michael. *Artist Beware.* Third edition. Guilford, CT: Lyons Press, 2005.

Milner, John. *The Studios of Paris: The Capital of Art in the Nineteenth Century.* New Haven and London: Yale University Press, 1988.

National Gallery Technical Bulletin. London: National Gallery of Art.

Nicolaus, Knut. *The Restoration of Paintings.* Cologne: Könemann Verlagsgesellschaft, 1999.

Parkhurst, Daniel Burliegh. *The Painter in Oil: A Complete Treatise on the Principles and Technique Necessary to the Painting of Pictures in Oil Colors.* Boston: Lothrop, Lee & Shepard: 1898. Reprinted as *The Painter in Oil.* New York: Dover Publications, 2006.

Rakoff, Henry, Freddie L. Thomas, and Lyle E. Gast, "Reversibility of Yellowing Phenomenon in Linseed-Based Paints." *Journal of Coatings Technology* (United States Department of Agriculture) Vol. 51, No. 649 (February 1979).

Rossol, Monona. *The Artist's Complete Health and Safety Guide*. Third edition. New York: Allworth Press, 2001.

Shelley, Marjorie. *The Care and Handling of Art Objects*. New York: Metropolitan Museum of Art, 1987.

Speed, Harold. *The Practice and Science of Drawing*. London: Seeley, Service & Co., 1917. Reprinted from the third edition, New York: Dover Publications, 1972.

Speed, Harold. *The Practice and Science of Oil Painting*. London: Seeley, Service & Co., 1924. Reprinted as *Oil Painting Techniques and Materials*. New York: Dover Publications, 1987.

Thompson, Daniel V. *The Materials and Techniques of Medieval Painting*. Originally published in 1936. Reprint, New York: Dover Publications, 1956.

van den Berg, Jorrit Dirk Jan. "Analytical Chemical Studies on Traditional Linseed Oil Paints," thesis, Fundamenteel Onderzoek der Materie (FOM) Institute for Atomic and Molecular Physics (AMOLF), part of the research program of Molecular Aspects of Ageing in Painted Art (MOLART) of the Nederlandse organisatie voor Wetenschappelijke Onderzoek (NOW), 2002.

Walden, Sarah. *The Ravished Image, or How to Ruin Masterpieces by Restoration*. New York: St. Martin's Press, 1985.

Walker, Mark Steven. "William Bouguereau at Work" published in the catalog of the William Bouguereau exhibition in Montreal, 1984.

Wehlte, Kurt. *The Materials and Techniques of Painting*. First published in the German language in 1967. Translated and published, New York: Van Nostrand Reinhold Company, 1975.

Wetering, Van de, Ernst. *Rembrandt: The Painter at Work*. Amsterdam: Amsterdam University Press, 1997.

Wheelock, Arthur K., ed. *Johannes Vermeer*. Washington, D.C: National Gallery of Art; The Hague: Royal Cabinet of Paintings Mauritshuis, 1995.

The following books are of historical interest. They are recommended, with certain qualifications regarding the accuracy of some of the information contained therein, keeping in mind the level of scientific knowledge at the time they were written. The reader may reasonably presume the procedures described in these books to be more or less accurate and informative as regards practices and beliefs of their time, but perhaps more open to question where the authors speculate on the procedures of times much earlier than their own. Subsequent discoveries made after these books were written should be given due consideration in order to pursue the truth most diligently and to feel that we are most likely to be on the right track. As more time goes by, the same qualification should be applied to the books listed above as well, and indeed to this book also. The quest for the truth is ongoing, in art as in all fields of endeavor. With the above qualifications kept firmly in mind, all of these books are worth reading.

Abendschein, Albert. *The Secret of the Old Masters*. New York and London: D. Appleton and Company, 1906, 1916, and 1927.

Dalí, Salvador. *50 Secrets of Magic Craftsmanship*. New York: Dial Press, 1948. Reprint, New York: Dover Publications, 1992.

This book has entertainment value, as does anything written by Salvador Dalí. His advocacy of amber as an additive to oil paints should be taken with certain reservations, in consideration of what is now known about the long-term performance of natural resins in oil paintings. It is nonetheless worthwhile reading. His dead-wasp medium has no scientific testing to either verify or refute his claims for it, but it is probably harmless in any case.

Doerner, Max. *The Materials of the Artist and Their Use in Painting, with Notes on the Techniques of the Old Masters*. First published in the German language in 1921, with three more revised editions published in German by 1933. Subsequent English translations published by Harcourt, Brace & World in 1934 and 1962 based on the fourth and projected fifth German editions. (Doerner died in 1939.)

Doerner drew heavily on the earlier research and conclusions of Dr. A. Eibner, published in 1909 as *Malmaterialienkunde*. There are certain discrepancies between Doerner and the current knowledge of Old Masters' materials and techniques, with considerable evidence supporting the most up-to-date science, which of course was not available to Doerner in the early twentieth century.

Eastlake, Sir Charles Lock. *Materials for a History of Oil Painting*. 1847. Reprinted as *Methods and Materials of the Great Schools and Masters* (two-volume set), New York: Dover Publications, 1960.

The same qualifications noted above for Doerner apply to Eastlake as well.

Laurie, A.P. (Arthur Pillans). *The Painter's Methods and Materials*. London: Seeley, Service & Co., 1960. Reprint, New York: Dover Publications, 1967.

Maroger, Jacques. *The Secret Formulas and Techniques of the Masters*. New York and London: Studio Publications, 1948. Reprint, New York: Hacker Art Books, 1979.

The techniques of painting described by Maroger work well, whether or not they actually correspond to the methods of the Masters to whom he attributes them, and indeed that is a questionable proposition in at least some cases; however, his chemistry should be regarded with greater skepticism, in light of the current level of knowledge in the field of art conservation. Quite a few of his claims have been placed in a very doubtful light by scientific testing of a great many Old Master paintings in recent years.

Mayer, Ralph. *The Artist's Handbook of Materials and Techniques*. New York: Viking Press, 1940, 1957, 1970, 1982, and 1991.

Vibert, J.G. (Jehan Georges). *The Science of Painting*. Originally written sometime prior to 1892, when the eighth edition was published in French. Retranslated (into English) and revised from the fifteenth edition, London: Percy Young, 1915.

Index